IT HAPPENED AT

Broad Book Press, Publisher

Cover and interior design by Ponderosa Pine Design

Paperback ISBN: 9781737517894
eBook ISBN: 9798985191356

Published in the United States by Broad Book Press, an imprint of Broad Book Group, Edwardsville, IL.

Library of Congress Control Number: 2024908972

Photo and image credits

Alamy Stock Photo: adsR/Alamy Stock Photo: 135; Album/Alamy Stock Photo: Cover, 76, 80, 194, 195; Alpha Stock/Alamy Stock Photo: 21, 41, 44, 50; Archive Pics/Alamy Stock Photo: 63; Archive PL/Alamy Stock Photo: 55, 73, 79; Art Phaneuf/Alamy Stock Photo: 47; Benjamin Clapp/Alamy Stock Photo: 182; Bill Waterson/Alamy Stock Photo: 26; colaimages/Alamy Stock Photo: 56, 84; Dorothy Alexander/Alamy Stock Photo: 199; Ed Rooney/Alamy Stock Photo: 173; E.J.Westmacott/Alamy Stock Photo: 99; Everett Collection Historical/Alamy Stock Photo: 10, 77, 96, 143, 165, 196 ; Frank Nowikowski/Alamy Stock Photo: 198; Glasshouse Images/Alamy Stock Photo: 36, 193, 195; Historic Collection/Alamy Stock Photo: 78; Hi-Story/Alamy Stock Photo: 106; ian barker/Alamy Stock Photo: 140; IanDagnall Computing/Alamy Stock Photo: 27, 71; Independent/Alamy Stock Photo: 203; Jennifer Mason/Alamy Stock Photo: 181; Ken Cavanagh/Alamy Stock Photo: 199; Keystone Press/Alamy Stock Photo: 158; Lebrecht Music & Arts/Alamy Stock Photo: 86; LOC Photo/Alamy Stock Photo: 60; M&N/Alamy Stock Photo: 116; Matthew Kiernan/Alamy Stock Photo: 42, 65; MediaPunch Inc/Alamy Stock Photo: 138; Moviestore Collection Ltd/Alamy Stock Photo: 72, 111; Nicola Kota/Alamy Stock Photo: 98, 104; Nigel French/Alamy Stock Photo: 160; PA Images/Alamy Stock Photo: Cover, 113, 142; Patti McConville/Stockimo/Alamy Stock Photo: 184, 191; PBH Images/Alamy Stock Photo: 196; photo-fox/Alamy Stock Photo: 55, 70, 75; Phillip Harrington/Alamy Stock Photo: 85; Pictorial Press Ltd/Alamy Stock Photo: 62, 123, 137; Retro AdArchives/Alamy Stock Photo: 105, 194; RBM Vintage Images/Alamy Stock Photo: 192; Richard Levine/Alamy Stock Photo: 171, 183; Russell Kord ARCHIVE/Alamy Stock Photo: 127; Science History Images/Alamy Stock Photo: 33, 56, 66; Sergey Nezhinkiy/Alamy Stock Photo: 54; Sherab/Alamy Stock Photo: 197; Smith Archive/Alamy Stock Photo: 192; steeve-x-art/Alamy Stock Photo: 45; Sueddeutsche Zeitung Photo/Alamy Stock Photo: 68, 197; Todd Strand/Alamy Stock Photo: 90; Underwood Archives, Inc/Alamy Stock Photo: Cover, 29, 97; unknown/Alamy Stock Photo: 35; UPI/Alamy Stock Photo: 146, 148, 153; Vindice/Alamy Stock Photo: 193; Vinyls/Alamy Stock Photo: 97; WENN Rights Ltd/Alamy Stock Photo: 156, 163, 164, 198, 201, 202; World History Archive/Alamy Stock Photo: 57; ZUMA Press, Inc./Alamy Stock Photo: 134, 136

Gift of Damien Taylor/New York Historical Society Museum & Library: 107

Library of Congress: 12 (LC-USZCN4-81), 28 (LC-B2- 4387-12), 52 (LCCN: 2016763074), 67 (LC-DIG-ppmsca-69809), 88 (LC-DIG-det-4a09029)

Museum of the City of New York: Alvin Colt/Museum of the City of New York/85.148.314: 109; Anthony F. Dumas/Museum of the City of New York/75.200.77: 30; unknown/Museum of the City of New York/F2017.27.124: 24; unknown/Museum of the City of New York/F2013.41.1280: 125; William Auerbach-Levy (1889-1964)/64.100.176/Museum of the City of New York: 81; Wurts Bros. (New York, N.Y.)/Museum of the City of New York/X2010.7.1.1588: 23; Wurts Bros./Museum of the City of New York/X2010.7.1.1586 : 46

National Archives, Office for Emergency Management: 194

Personal Collection of Stewart F. Lane: 14, 17, 19, 20, 87, 119, 128, 139, 147, 150, 151, 157, 162, 168, 172, 179, 185, 187, 188, 200

Photography by Jack Deutsch: Background Image on Cover, End Sheets, 6, 7, 8, 9, 190, 200, 204

Photography by Mia McDonald: 4, 5, 13, 174, 176, 180, 189, 200, 205

Playbill, Inc.: 22, 101, 106, 112, 124, 129, 133, 142, 149, 152, 155, 161, 166, 169, 170, 195, 202

Private Collection of Melanie Seinfeld: Cover, 14, 15, 31, 34, 35, 40, 43, 59, 67, 70, 82, 83, 84, 85, 91, 132, 177

Property of Vanessa Campos: 145

Public Domain: Cover, 18, 32, 40, 51,61, 64, 102

The New York Public Library for the Performing Arts: Photo by Friedman-Abeles ©The New York Public Library for the Performing Arts: Cover, 16, 92, 93, 100, 103; Photo by Kenn Duncan ©The New York Public Library for the Performing Arts: 110, 118; Photo by Martha Swope ©The New York Public Library for the Performing Arts: Cover, 79, 94, 108, 109, 120, 122, 126, 130, 131, 154; Photo by Vandamm ©The New York Public Library for the Performing Arts: 115; New York Public Library Digital Collections/PALACE THEATRE, BROADWAY & AMSTERDAM: 138; New York Public Library Digital Collections/Billy Rose Theatre Division: Cover, 49

IT HAPPENED AT

THE PALACE

A HISTORY OF NEW YORK'S ICONIC BROADWAY THEATER

STEWART F. LANE

FOREWORD BY JAMES L. NEDERLANDER

broad
book
press

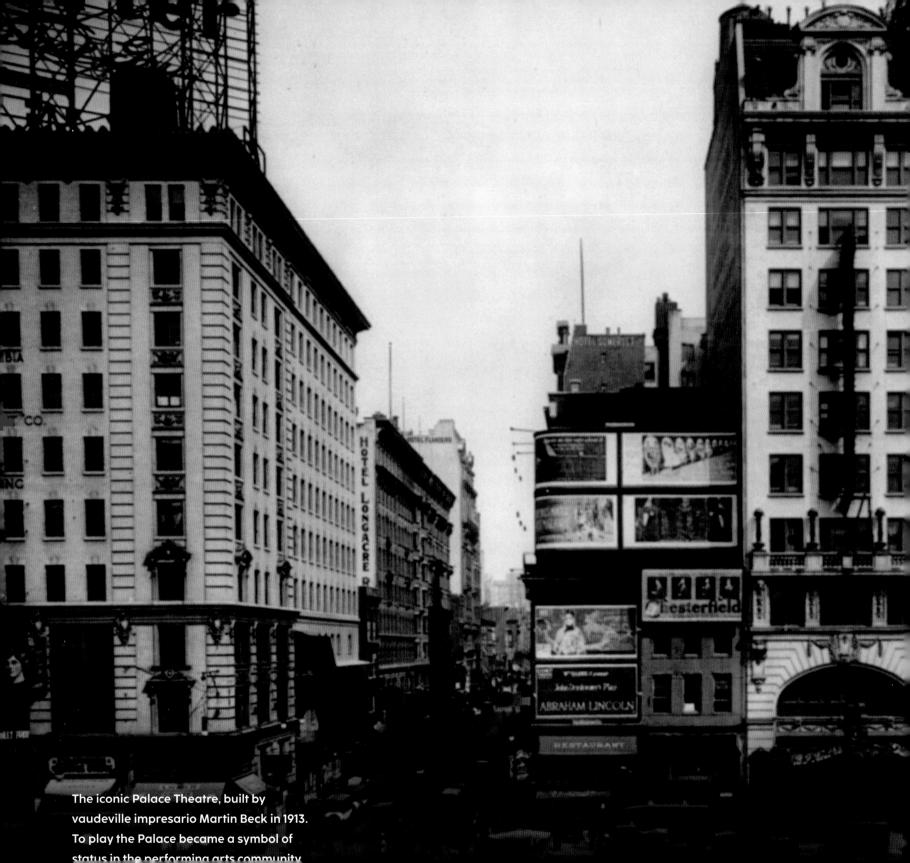

The iconic Palace Theatre, built by
vaudeville impresario Martin Beck in 1913.
To play the Palace became a symbol of
status in the performing arts community

CONTENTS

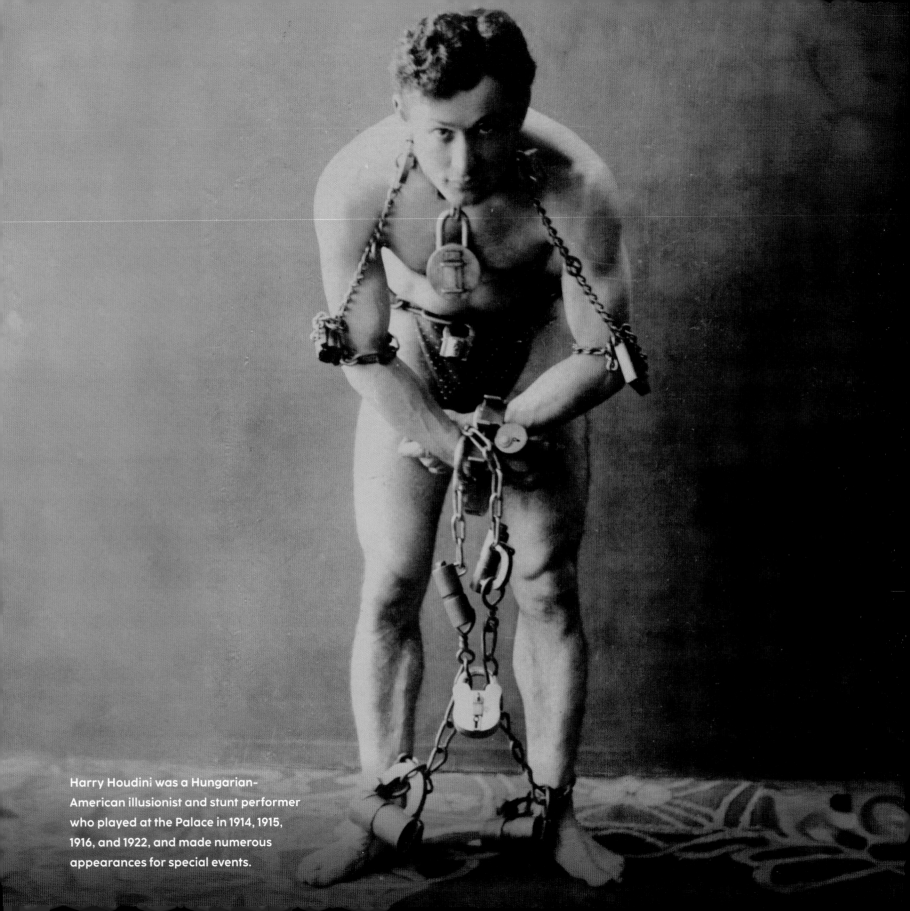

Harry Houdini was a Hungarian-
American illusionist and stunt performer
who played at the Palace in 1914, 1915,
1916, and 1922, and made numerous
appearances for special events.

FOREWORD

JAMES L. NEDERLANDER

James L. Nederlander, president of the Nederlander Organization, at the ribbon-cutting ceremony to reopen the Palace on May 6, 2024.

In the grand tapestry of Broadway, certain theatres stand as icons, their history woven with the stories of legends. The Palace Theatre is undeniably one of these revered stages. Since its opening in 1913, it has been a beacon, drawing the brightest stars of every era to its hallowed boards. From Vaudeville to musicals and dramas, "Playing the Palace" has been the dream of countless performers, a testament to the allure and prestige of this historic venue. As we embark on a journey through time, we trace the footsteps of the giants who graced the Palace stage, from the enchanting melodies of Judy Garland to the mesmerizing illusions of Harry Houdini.

Stewart Lane takes us behind the curtain to reveal the intricate history and evolution of the Palace Theatre. As a co-owner of this Broadway treasure, his passion for preserving its legacy shines through every page. His dedication to the arts, from producing groundbreaking shows to championing BroadwayHD, underscores his commitment to keeping the spirit of Broadway alive for generations to come.

The Palace Theatre is not merely a venue; it is a living testament to the resilience and artistry of the theater community. My father purchased the Palace Theatre in 1964, and he always said that when

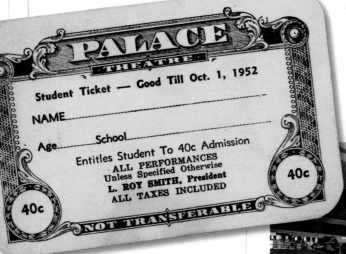

ABOVE: A voucher from 1952 entitled the recipient student entry to all performances at the Palace Theatre for only 40 cents.

RIGHT: Stewart Lane inspects the progress of the raising of the Palace. The theater's box will live 30 feet above ground level once the project is completed.

he entered the Palace, he felt what a magical place it was and that you could feel the presence of the artists who had performed before. I grew up at the Palace, wandering through the floors and various offices, most of which were vacant. I always had a friend in Julius, the elevator operator who worked for decades at the Palace Theatre and would always give a blessing to you each morning.

When faced with the need for renovation and restoration, Lane and I saw this as a unique opportunity to move beyond the norm of historic preservation and to reimagine the Palace Theatre for the next generation by allowing for mixed-use space on the ground floor. The meticulous efforts to raise this historic landmark 30 feet in the air, without so much as a crack in its ornate plasterwork, is a testament to the reverence with which the Palace is held and the profound desire to ensure its storied past continues for future generations.

Through Lane's eyes, we witness the rebirth of the Palace, its transformation into a modern marvel while honoring its rich heritage. From the new entrance on West 47th to the exquisite finishes inspired by its Beaux-Arts roots, every detail is a tribute to the past and a nod to the future.

As a Broadway producer and leader in the theater community, Lane invites us into the heart of Broadway, where dreams are realized, and legacies are forged. The Palace Theatre stands as a guardian of the arts, a place where the magic of live performance continues to captivate audiences from around the world. It is my honor to introduce this journey through the history of the Palace, a testament to the enduring power of theater and the visionaries who bring it to life.

—JAMES L. NEDERLANDER, President and CEO, The Nederlander Organization

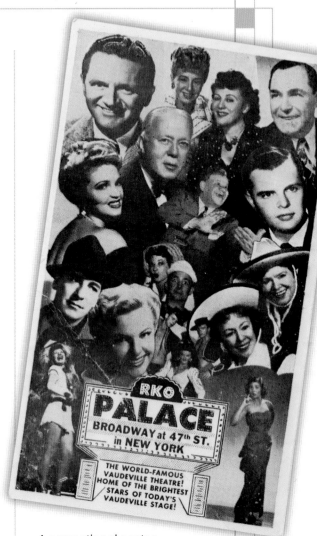

A promotional poster featuring the many vaudeville acts performing at the Palace Theatre.

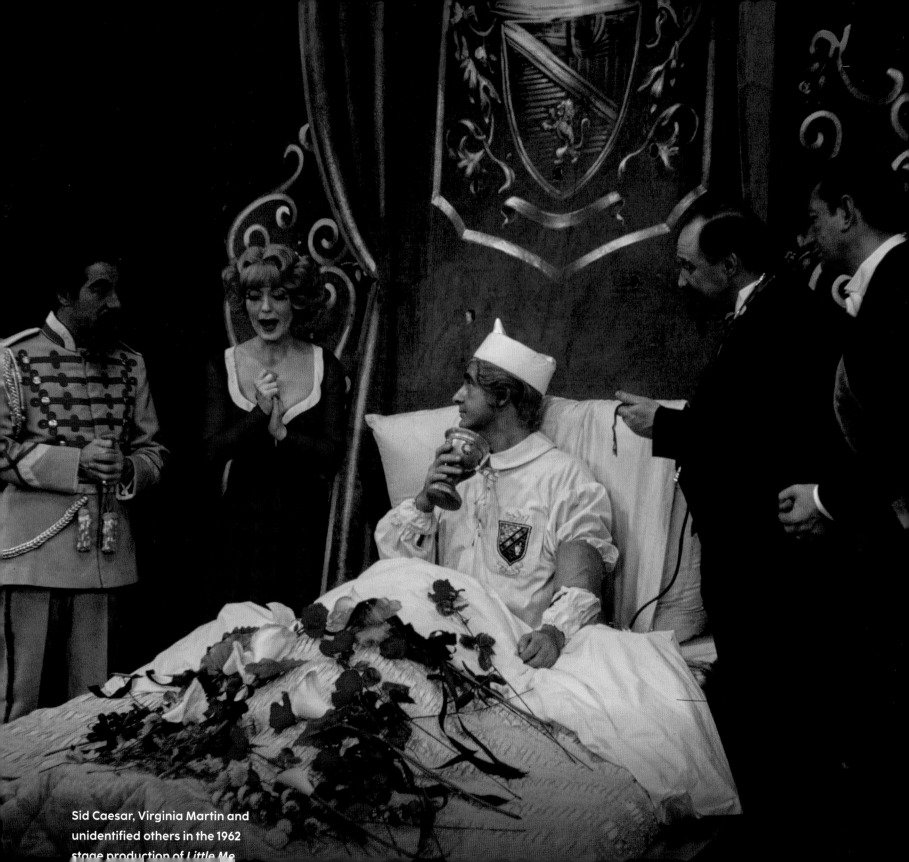

Sid Caesar, Virginia Martin and unidentified others in the 1962 stage production of *Little Me*.

AN UNFORGETTABLE EVENING

It was 1962, and I was 11 years old, when my best friend at the time, Ricky, asked me if I wanted to go with him and his family to the city to see his father perform in a play. Growing up in Great Neck on Long Island, I always considered a trip to Manhattan a special treat. The bright lights, the skyscrapers, and the busy sidewalks overflowing with a wide range of characters created a unique energy that was second to none. After getting the green light from my parents, I was ready to go on what would become a life-changing adventure.

Stewart Lane on the way to his first Broadway show, and the start of a lifelong adventure.

Sheet music of the song "Dimples" from the Broadway production of *Little Me* starring Sid Caesar.

On this afternoon, we were going to Broadway, the Lunt-Fontanne Theatre to be precise. I had never been to a Broadway show before, and as we approached the marquee, I saw the name of the show, *Little Me*, in bold, glimmering lights. Then, upon entering the theater, a ticket taker in a uniform took my ticket, tore it in half, and gave me what would be my first memento of the evening: a Broadway ticket stub. As we headed from the lobby into the actual theater auditorium, I was then handed a small magazine, a *Playbill*, which also had the name of the show on the cover, along with a photo of my friend's dad. Two souvenirs, and I had not even sat down!

Once settling into a comfortably cushioned seat, I looked around at the high ceiling, the décor on the walls, and the people seated around us. This was far more majestic than any local movie theater on Long Island.

Suddenly, as the lights dimmed and music filled the air, my buddy pointed to where it was coming from—a large, recessed area in front of the stage, which he informed me was the orchestra pit. And before I knew it, the curtain went up, and there was the stage aglow under the spotlights with a full set and cast members ready to launch into what I learned later was a show written by an up-and-coming playwright, Neil Simon.

It was an evening I would never forget. The show was very funny, mainly because my friend's father (and the star of the production) was none other than the inimitable Sid Caesar. From that day forward, I was hooked. Broadway was my destiny.

Fast forward 20 years, and after attending Boston University College of Fine Arts, where I graduated with a Bachelor of Fine Arts degree in Acting in 1973, I began an acting career in Off-Broadway productions and regional theater. In 1974, I earned my Actors' Equity card while in the classic musical *Oklahoma!* in Sullivan, Illinois. I continued acting for a few more years, later moving to California, where I joined AFTRA and the Screen Actors Guild. During my acting career, I enjoyed working with notable performers including 1950s movie legends Van Johnson, Peter Palmer, and Ed Herlihy.[1] However, it was only a matter of time before my love of theatre summoned me back to New York and Broadway where I stepped out of the footlights and into theater management and production.

1968 Stewart Lane in *The Crucible* – The Junior Players Great Neck, NY.

Not long after, I found myself working with theater impresario and producer James M. Nederlander who would become my mentor and, later, business partner. Learning from James was a marvelous experience. I soaked up as much of his wisdom and experience as I could and soon found myself in the role of assistant to the producer on the Broadway productions of *The Grand Tour* and Tom Conti's *Whose Life Is It Anyway?*

Then in 1980, a unique opportunity presented itself. I had the chance to co-own a theater—not just any theater, but the Palace Theatre on Broadway. As you'll read more about later in the book, New York City went through some unfavorable economic

"... Nederlander who would become my mentor ..."

times in the 1970s, and Broadway theaters struggled tremendously at the box office. There was a cultural transition of audiences and of the material while the city was going down the tubes financially. Times were difficult for all the Broadway theaters, including the long-standing Palace. The Palace was in trouble between paying insurance and real estate taxes, the mortgage coming due, and loans being almost impossible to get from the bank without income. After years of loving theatre, I thought it would be time to step in and save this renowned venue. For me, it was more of a desire to have a piece of New York and be in the world of theatre than anything else. This was an overwhelming desire, and both dreams came true when I became co-owner of the Palace.

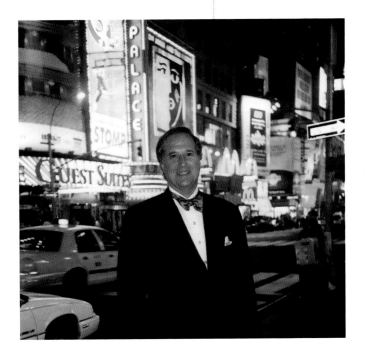

Stewart Lane in Times Square with the Palace and the old DoubleTree Suites in the background.

The sad truth was, at the time, nobody else would go near such an offer considering the bleak outlook for the city's economy, but this was New York City. It is a town that respects free enterprise and the pursuit of fortune—and not solely on Wall Street. Andrew Carnegie amassed much of his fortune in New York, as did the Vanderbilts, the Astors, J.P. Morgan, Flo Ziegfeld, as well as the Shuberts and the Nederlander family.

As for my belief that New York (and Broadway) would thrive again, I knew that this had long been a business town founded on capitalism. So, I became co-owner of the Palace Theatre with James M. Nederlander in 1980, understanding that I was taking a significant risk and knowing that the passion for and the power of theatre in New York City would never die.

Fast-forwarding once again, I opted to write this history of the Palace to jog the memories of those who have been to the landmark theater before the latest renovation and those who are seeing the Palace for the first time. One of the other reasons I wanted to own the Palace Theatre was because it came with such a glorious showbiz history. As a dedicated student of theatre history, I wanted to know more about the great history of the Palace Theatre; I wanted to share my findings with other theater aficionados.

IT HAPPENED AT THE PALACE

Numerous stories and many significant (and even magical!) theatre moments happened at the Palace. In the upcoming chapters, you'll read about everything from Martin Beck and his initial plans to build the grand theater in 1912 to lifting the entire structure in 2022 and moving it into its new Times Square home.

Vaudeville star Sophie Tucker.

Through the journey of the Palace, we'll recount some of the stars and their stories from two magical decades of vaudeville featuring song, dance, comedy, juggling, and dramatic readings featuring a bevy of legendary stage talent, including Ethel Barrymore, Sophie Tucker, Fanny Brice, Bob Hope, and Kate Smith.

As goes history, so goes theater—and we'll explore that, too. For example, just as the Roaring Twenties descended into the Great Depression of the 1930s, the Palace followed suit. It went from the excitement of star-studded live vaudeville performances to three darker decades as one of many New York movie houses, which occasionally sprung to life in the 1950s with classic performances by some of the greatest talents of the era.

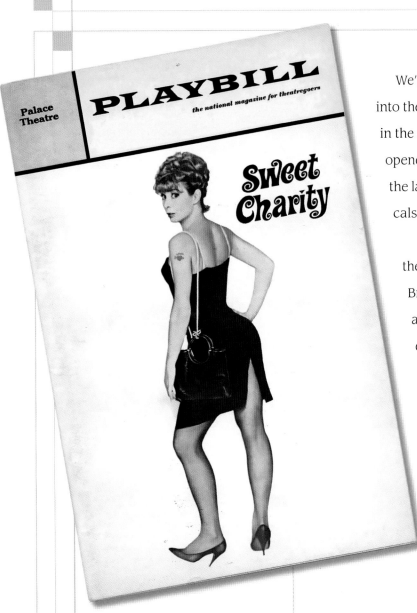

We'll glimpse at the brief return to vaudeville in the 1940s and then dive into the subsequent shift to bring live theatre back to the Palace, this time in the form of full-fledged Broadway musicals. From *Sweet Charity*, which opened in 1966, to *SpongeBob SquarePants*, which closed the Palace (for the latest renovations) in 2017, we'll look back at the many diverse musicals that graced the Palace stage for over fifty years.

Finally, we explore the latest renovation, the celebrated lifting of the theater, and the new setting for the Palace in which revivals of Broadway classics, adaptations from film, novels and T.V. programs, and original musicals will introduce a new generation to the Broadway experience.

Broadway's love affair with the glorious Palace has withstood wars, financial upheaval, changing tastes and attitudes, and even a pandemic. Amid it all, the Palace has stood tall (and now even taller!) on the Great White Way. It is my privilege and my honor to tell her story. This is my love letter to the grand dame of Broadway.

The grand staircase of the
original Palace Theatre.

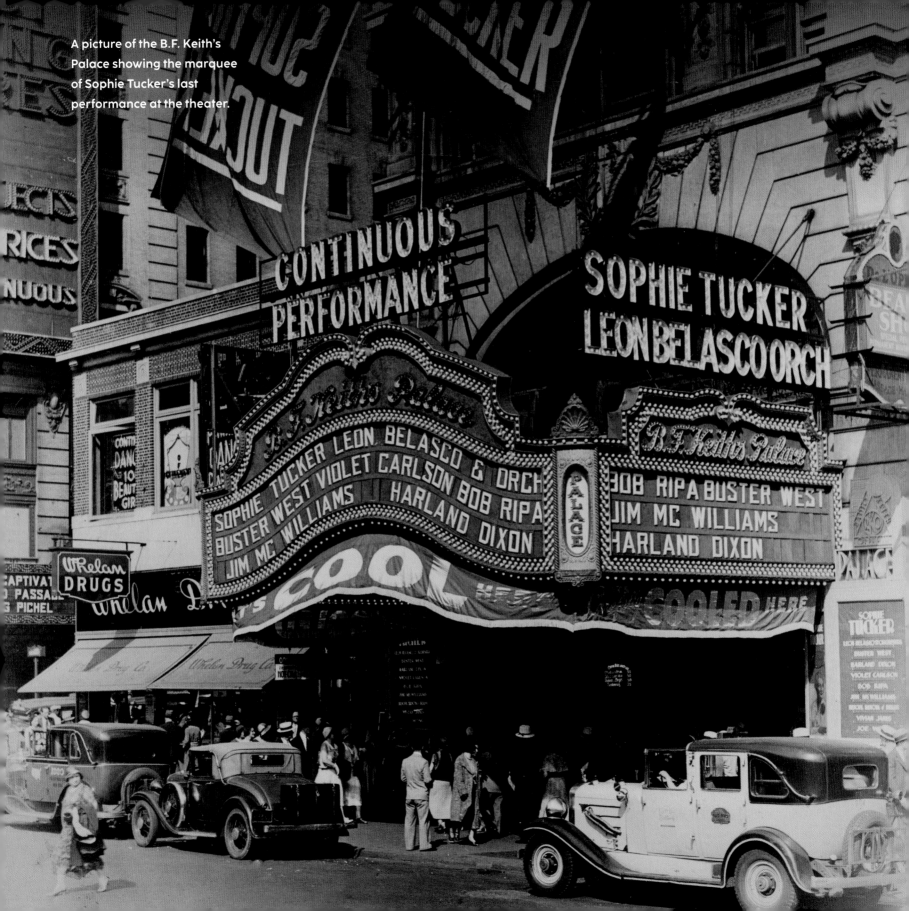

A picture of the B.F. Keith's Palace showing the marquee of Sophie Tucker's last performance at the theater.

CHAPTER 1

THE BIRTH OF THE PALACE

"*If one theater in New York's Broadway theater district were to be named the most famous, the privilege would fall virtually uncontested to the Palace, designed not as a legitimate stage theatre but as a vaudeville house.*" These words were written by Kelly Carroll of the Historic District Council of New York and included in the theater interior's designation report in 1987 when the Palace Theatre was being considered for landmark status. Those whose parents or grandparents recount stories of the glorious days of vaudeville at the Palace or have enjoyed many dazzling musical stage productions over the past few decades would agree with Kelly Carroll's assessment.

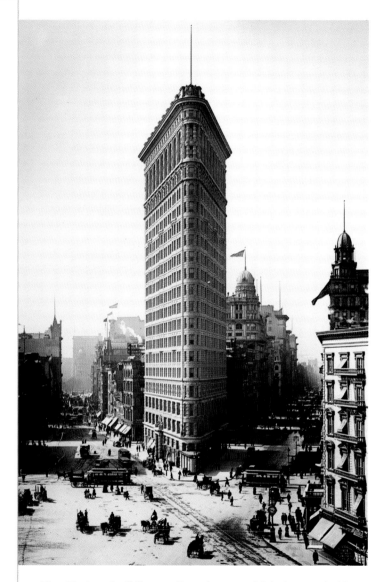

The Flatiron building on Broadway and 5th Avenue in New York City.

The early years of the twentieth century were considered by many to be a progressive era for New York City. It was a time in which many of the city's most famous buildings were completed, such as a massive new department store on 34th Street, forever known as Macy's of Herald Square. There was also an unusual triangular steel-framed structure resembling an early twentieth-century clothing iron known as the Flatiron Building, and the New York Stock Exchange building in lower Manhattan.

It was also the time in which the city's need for improved transportation was fulfilled as New York City took its train tracks underground in 1904 and soon expanded the subways throughout all five boroughs. Not only did subways quickly become the choice for commuters to and from the office, but it was also a convenient means of getting to entertainment venues around Manhattan which included a couple of new Broadway theaters, the Lyceum built by Broadway producer-manager David Frohman and the New Amsterdam, built by the production partnership of Marc Klaw and Abraham Erlanger. Both theaters opened shortly before the subways in 1903. The two stunning new venues, and most of Broadway's theaters at the time, presented theatrical productions from various sources. Along with productions of Shakespeare, including

Sarah Bernhardt in *Hamlet*, there was Frank Baum's *The Wizard of Oz*, George M. Cohan's *Little Johnny Jones*, and operettas such as Victor Herbert's *Babes in Toyland* and Franz Lehar's *The Merry Widow*. And then there was *Floradora*, a British musical comedy that shook up Broadway with over 500 performances, which was unheard of at the time. Part of the reason for the show's immense popularity was the *Floradora* girls, a sextet of beautiful young women in stunning gowns who became the talk of the town.

The early years of the century also brought the "elephant (or hippo) in the room," or in this case, on the island of Manhattan. It was called the Hippodrome, built in 1905 on Sixth Avenue between West 43rd and West 44th, and billed as the world's largest theater, with a stage 12 times larger than any Broadway theater. It could accommodate 1,000 performers and had a seating capacity for an audience of 5,300 attendees. While the Hippodrome presented occasional plays and some vaudeville, it was designed primarily for large-scale entertainment like circuses and various other spectacles including water diving shows utilizing a massive pool that could be raised and lowered from below the stages. It was also New York's venue of choice for the legendary escape artist and magician Harry Houdini. Where else could he make an elephant disappear? Yes, he did such a trick.

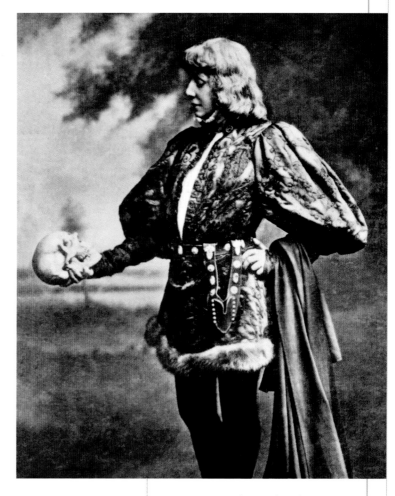

Actress Sarah Bernhardt was the first woman to play the title role of Hamlet. For the famous scene pictured, she used a real skull given to her by author Victor Hugo.

American silent film actress Gertrude Olmsted.

By the second decade of the twentieth century, New York City was abundant with entertainment options, including several hundred storefronts housing "little theaters" known as nickelodeons where you could watch a dozen brief motion pictures for as little as five cents. The silent movie era was in full swing, bringing inexpensive entertainment to the small screen for mass consumption before larger screens and talkies would provide serious competition for theatre, opera, and what emerged as the hottest form of entertainment at the time . . . vaudeville.

While Broadway theatre, not unlike opera, was still considered the choice of the "aristocracy," vaudeville and its bawdy cousin, burlesque, were providing entertainment options for a diverse socio-economic audience at a time in which immigrants, who could ill afford Broadway shows, were pouring into America, most often through Ellis Island which sits just seven miles outside of Manhattan.

It is no wonder that Hungarian immigrant Martin Beck, who came to the United States via Germany as a teenager in 1884, had a burning desire to build a vaudeville theater in the heart of New York City. Little did Beck know at the time that challenging wealthy, notable, powerful Broadway theater owners on their own turf would be a more significant challenge than he had ever considered.

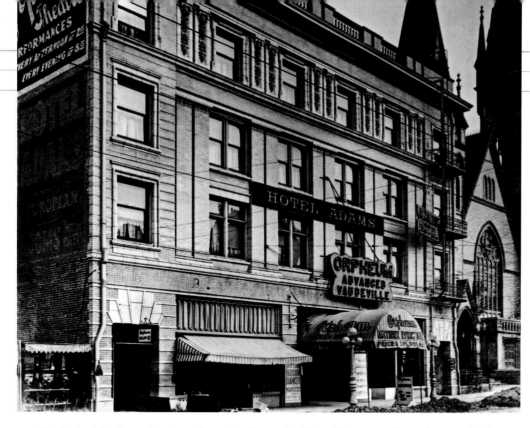

The Orpheum Theatre in San Francisco, where Martin Beck worked as a vaudeville booking agent and house manager.

Early in his days in America, Beck settled in Chicago, where he worked at a beer garden before joining a vaudeville troupe that headed to San Francisco, where he would get his first taste of vaudeville as a performer. He later moved behind the scenes, where he would become a booking agent and house manager of the original Orpheum Theatre in San Francisco. Beck built up the Orpheum name by helping to create a circuit, adding theaters along the West Coast before making his way across the country to New York City. On his cross-country journey back east, he stopped in various cities to take in the vaudeville experience while doing business with the local vaudeville houses, with which he had become familiar while in Chicago. Then it was on to New York City, where Beck began looking for the ideal location to build what he believed would be the grandest theater of them all (vaudeville or otherwise). His dream was a palatial theater simply called the Palace.

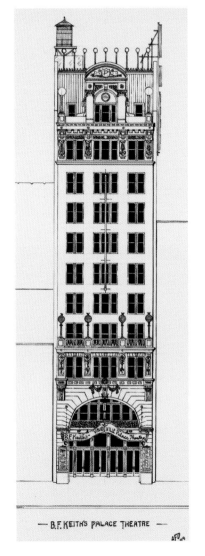

An original architectural rendering of the Palace exterior.

LET'S BUILD A THEATER

In 1911, Beck found a premier location at the corner of Broadway and 47th Street. This was the north end of Times Square, which was already bustling with businesses, theaters, eateries, and retailers. There were already several vaudeville theaters in the neighborhood, such as Oscar Hammerstein's highly popular Victoria, among others. Suffice it to say, Beck found a premium location complete with ample subway and taxi service and even trolleys. At this point, Beck was not leery of the competition, which would become fierce as the reality of his new theater drew near. In February 1912, plans were officially filed with the New York City Department of Buildings for a Broadway and 47th Street theater building. It was not yet entirely clear what type of entertainment would be presented in the new venue. While many presumed it would be vaudeville, many strongly opposed a new vaudeville theater within walking distance of its competitors. New York theater owners, bookers, and managers spearheaded such resistance.

Unfazed by the opposition, Beck purchased the property building and leased the land the first year, which would then escalate each year. The original lease included five twenty-year options and would expire in 105 years, concluding at the end of 2017.[2] It was signed by the Palace Theatre and Realty Company and by H. Earle Jr. of Philadelphia, a lawyer and financier known as a "doctor" to ailing corporations.

The next step for Beck was getting his theater built. For this, he called on the architectural team of Charles Kirchhoff Jr. and Thomas Leslie Rose, who had been architectural partners for 16 years before meeting Beck. While the team had no previous experience designing theaters in New York City, they had esteemed credentials in

Milwaukee, designing many of the city's most iconic buildings, including the original Empire Building, The Palm Garden Schlitz Hotel, notable businessman and philanthropist J.E. Uihlein's home on Lake Shore Drive, and Pawling & Harnischfeger's crane manufacturing plant, as well as many theaters in the city. One such theater, the Alhambra, was designed by Kirchhoff just before his collaboration with Rose. The Alhambra was quite elaborate and sported a large stage under a proscenium arch. It's likely that during his cross-country travels, Beck saw this theater, among other works of Kirchhoff and Rose.

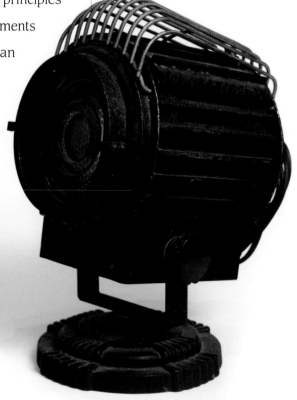

A vintage theater spotlight from the early days of the Palace helped shine a light on the many talented acts that graced the stage.

The Palace would be built in a Beaux-Arts style, which drew upon the principles of French neoclassicism while incorporating Renaissance and Baroque elements and modern materials such as iron and glass. Classical Greek and Roman decorative elements, including columns, pediments, and balustrades, were also included to create a bold architectural design.

The initial property Beck purchased included five buildings. The building in which the Palace would be built would be a new high-rise L-shaped structure which would also house the offices of Palace executives and other staffers.

As for the exterior, the Palace was encapsulated within a larger building from the beginning, with multiple signs and billboards covering the façade. This was, and still is, the case with most buildings in Times Square. Therefore, Manhattan theater owners do not spend great sums of money on the exterior aesthetics of the building but instead budget more funds for the interior. In the case of the Palace, the budget included

artistic designs, magnificent chandeliers, comfortable dressing rooms, and of course, materials to ensure the safety of the overall building. Initially, there was no extended marquee, just lit signage, which was typical of many theaters in large, congested cities like New York. Not unlike Russian stacking dolls, inside the larger building, was a theater, and inside the theater was a plush interior with a stage on which productions came to life. Nonetheless, a marquee was added several years later.

THE COMPETITION HEIGHTENS

Despite having spent a significant amount of money to build it, Beck took the growing conflict surrounding his new theater and forthcoming grand opening in stride. Although the theater was being constructed from 1912 well into 1913, those who held high positions of power in the world of vaudeville, including theater owners, talent bookers, and managers, continued making it clear that they were not going to welcome Beck or his new theater with open arms. Prior to Beck's arrival, these impresarios monopolized the industry. They had already drawn their own proverbial lines in the sand, explicitly laying out the ground rules as to who could book which specific acts and in which territories within Manhattan they could perform. It was a turf war not unlike that of *West Side Story* (which would play the Palace several decades later), only without singing, dancing, or actual fighting.

Two of the key players at this time were B.F. Keith and E.F. Albee. Both men had previously worked for the circus, and later partnered to establish venues for early motion pictures before their vaudeville ventures, which led to the powerful Keith-Albee Circuit.

E.F. Albee was an American vaudeville impresario who toured with P.T. Barnum as a roustabout and later partnered with Benjamin Keith to operate the Bijou Theatre in Boston. Keith and Albee were the first to introduce moving pictures in the United States.

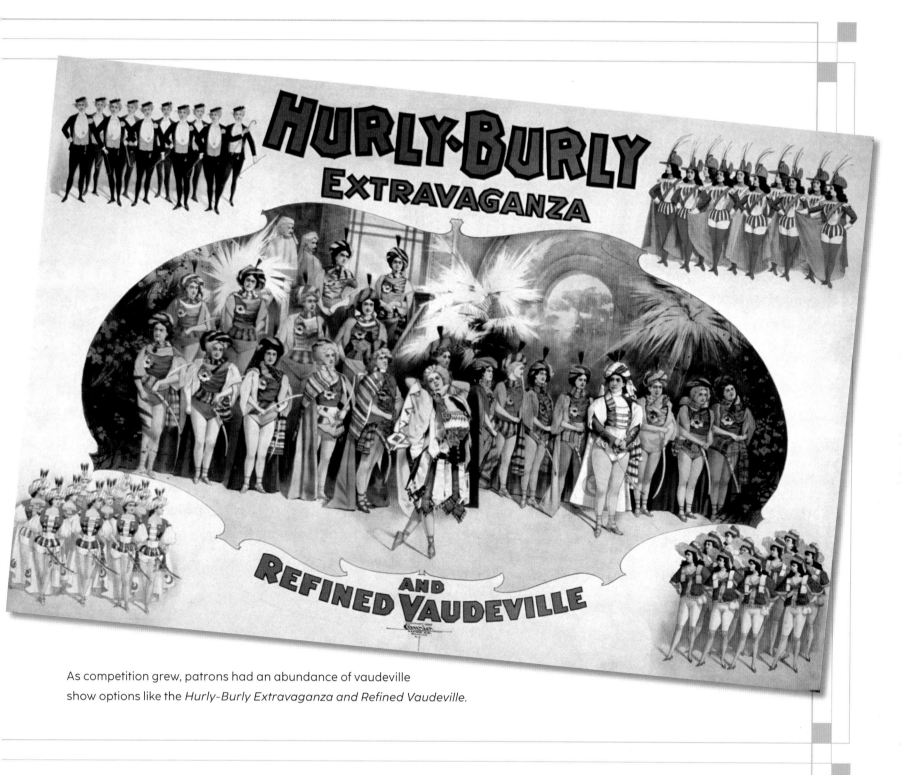

As competition grew, patrons had an abundance of vaudeville
show options like the *Hurly-Burly Extravaganza and Refined Vaudeville.*

A program showing the matinee and evening shows for the week of January 25, 1915, at B.F. Keith's Palace Theatre.

"Rumors flew that the Palace would resemble an English music hall"

They would do whatever they could to infringe upon the success of the Palace. To make matters worse for Beck, the powers in the Orpheum Circuit, which Beck had built up over the years, considered his Palace Theatre endeavor a separate business from the Orpheum Circuit and would not be supportive of his theater.

During this pre-Palace period, opposition also came from opera impresario-turned-vaudeville manager Oscar Hammerstein Sr. and William Morris, booking agent and founder of the talent agency that still bears his name. Morris had control over various circuits, which meant a host of stipulations regarding who could book acts and where they could be booked.

DESPITE THE OPPOSITION, THE PALACE IS COMPLETED

By late 1912, the Palace on the north end of Times Square was completed, alongside an adjoining high-rise office wing facing Broadway, also designed by Kirchhoff & Rose. While awaiting the theater's official grand opening in March of 1913, little information was divulged to the media regarding the opening program or subsequent events for the Palace. Rumors flew that the Palace would resemble an English music hall, with events such as ballets rather than strict

vaudeville being performed. Little did anyone know the epic stories that would emerge from the magnificent new theater for years to come.

Those performers the theater would employ, many of whom would be working in the adjacent wing of the building which housed the offices, were among the few who got a sneak peek inside the stunning new auditorium, which sported an ivory-and-bronze color scheme with red seating and included two large balconies with cascading tiers of private boxes. An extensive stage designed with the larger vaudeville acts in mind sat beneath a spanning proscenium arch, which formed a stylized sunburst on either side. In front of the stage was the orchestra pit.

High-relief ornamental plasterwork of extravagant neoclassic design accentuated the interior design, and roomy, cushioned seating provided a most relaxing, comfortable experience for attendees. Circular light fixtures throughout the interior were selected to be stylistically compatible with the overall theme of the venue while not distracting performers or audience members. Inside the 40-foot-wide entrance, theatergoers would find outer and inner lobbies that led to a foyer and into the auditorium. The lobbies were accessed by two sets of stained-glass, bronze-framed screen doors. There were stairs to the upper floors in the inner lobby.

Often housing more than one show daily, a large lobby was important. In this case, the spacious lobbies were designed in two styles of marble. In addition, the Palace offered perfect sightlines and excellent acoustics to provide audiences with a superior theatrical experience. A sign on the exterior of the building was lit shortly before opening night to let it be known that despite the fervor, the Palace was ready to present the finest in vaudeville.

Early promotional material for the Palace Theatre printed in 1913.

Entering the New York City entertainment scene in 1913 was, like today, quite challenging, although far less costly. Nonetheless, those making the most noise about the opening of the Palace *actually did have* a lot of clout—the Keith Circuit, run by B.F. Keith had a tight grip on the vaudeville acts, highlighted by the Victoria Theatre, complete with the glamorous Paradise roof garden for outdoor entertainment and parties at the corner of Broadway and 42nd Street. The nearby Eltinge Theatre, also on 42nd Street, was another of the many vaudeville venues dotting the island of Manhattan in the early 1900s, all of which were doing reasonably well as the Palace prepared to join the fray. Vaudeville was where the money was during the first two and a half decades of the century. *Variety* had reported in 1907 that the burgeoning form of entertainment for the masses had blossomed into a $30 million annual business. It is estimated that vaudeville venues had grown from under 100 theaters at the turn of the century to over 400 by 1913. With 48 vaudeville emporiums, New York City was the undisputed center of the latest entertainment craze.[3]

OPENING NIGHT BROADWAY COMPETITION

At the time of the Palace's opening in 1913, there were a number of popular variety shows playing on Broadway, as well as musicals and straight plays from which to choose. One of the popular shows at the time was *The Sunshine Girl* at the Knickerbocker

Competition on Broadway heated up with the addition of theaters like the Winter Garden, Knickerbocker, and many more.

Theatre on 38th Street, known for introducing the first moving electrical sign in a theater. A musical farce set in France, *The Honeymoon Express*, was early in its run at the Winter Garden (formerly a horse stable), which had opened just two years earlier. The Shuberts had *Girl on Film*, a three-act musical running on 46th Street at the Gaiety. Meanwhile, the latest iteration of the always popular *Ziegfeld Follies* was just heading into rehearsals for opening night at the New Amsterdam on 42nd Street, while the latest rendition of a popular competitive revue, *The Passing Show*, was also gearing up for its 1913 version, which would debut in the summer. Then there was the massive Hippodrome, also home to a revue simply called *America*. Between the established vaudeville houses, led by Willie Hammerstein's Victoria Theatre, the storefront nickelodeon film houses, and the revues and musicals on Broadway stages, it was clear that the Palace was going to have plenty of rivals when it came to selling tickets in a busy city like New York. The hope was that having nightly shows featuring a diverse lineup of top-notch performers flanked by the lavish décor of the majestic theater would draw crowds to the Palace. Beck had achieved his dream of opening the glorious venue, but it was now up to the public, the performers, and the critics to determine its fate.

PRICING IN 1913

Prior to the grand opening, the Palace prepared to offer a two-a-day format (referring to matinee and evening performances). The price for all shows would be $2 per person. As a point of reference, a gallon of gas costs 22 cents, and a quart of milk costs nine cents.

As for going to the Palace Theatre around that same time:

- Your ride to the restaurant for a pre-show dinner and later back home from the theater in a cab (horse-drawn) from the Hansom Cab Company would cost roughly $1.50.
- Dinner for two at Allaire's Scheffel Hall in New York City consisting of oysters, bisque of lobster, baked bluefish, tenderloin of beef with mushroom sauce & green peas, baked apple, and demitasse would set you back another $1.50.
- A cocktail at intermission would cost you 25 to 40 cents.

Pricing comes from various online sources, including Restaurant-ing through history, and the Morris County Library website: Historic Prices in 1911.

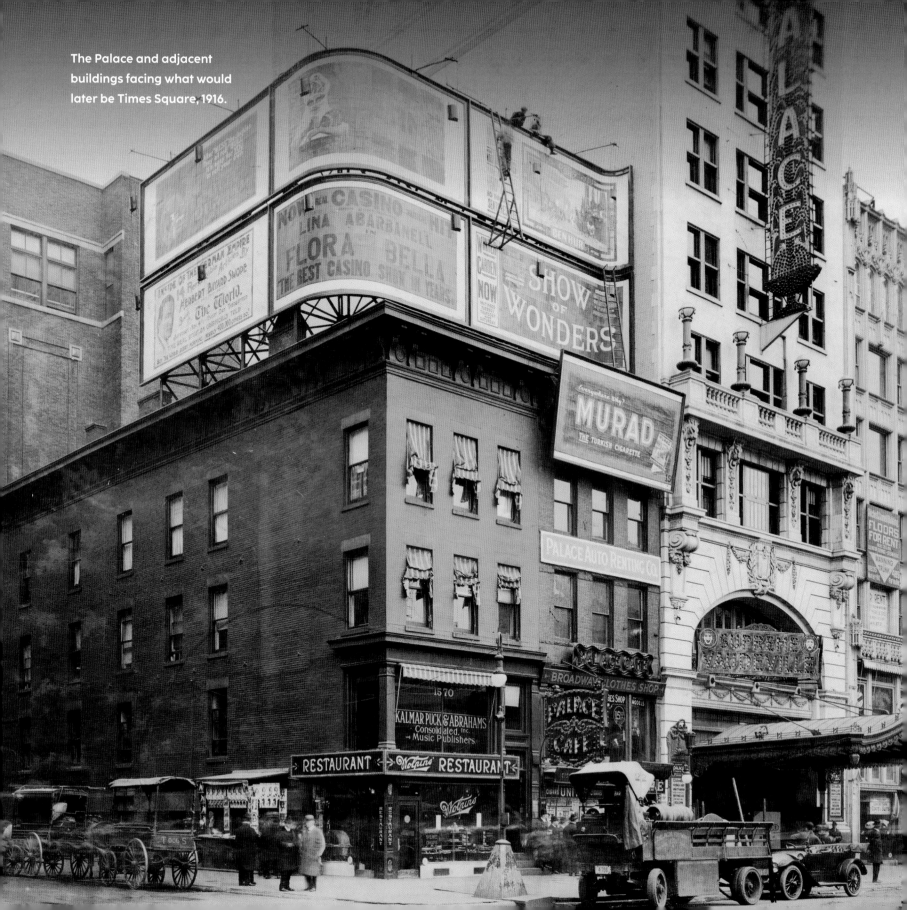

The Palace and adjacent buildings facing what would later be Times Square, 1916.

CHAPTER 2

THE VALHALLA OF VAUDEVILLE

It was entertainment for the masses, featuring a mix of talent from all corners of the country . . . and abroad. It was a potpourri of crowd-pleasing performers with one goal in mind—to wow the audience. Vaudeville was America's expanded version of what the French called Vaux-de-Vire, which refers to light, often comic, theatre featuring pantomime, dialogue, and song and dance.

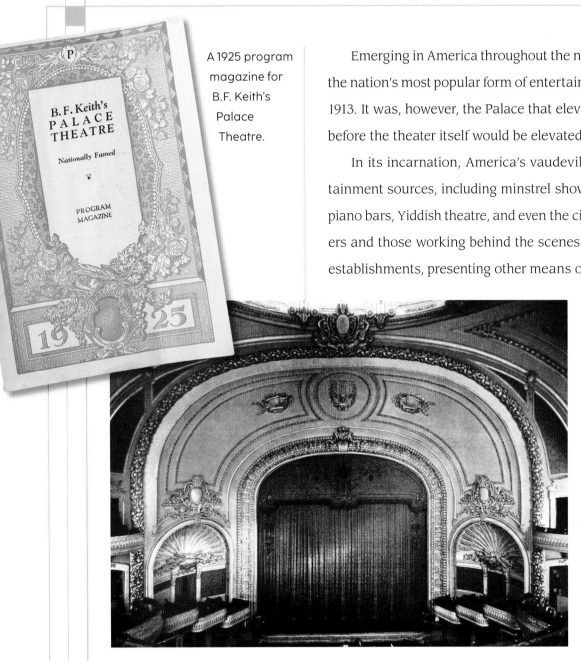

A 1925 program magazine for B.F. Keith's Palace Theatre.

Emerging in America throughout the nineteenth century, vaudeville was already the nation's most popular form of entertainment when the Palace Theatre opened in 1913. It was, however, the Palace that elevated vaudeville to new heights, a century before the theater itself would be elevated to new heights.

In its incarnation, America's vaudeville borrowed from a wide array of entertainment sources, including minstrel shows, music halls, saloons, dime museums, piano bars, Yiddish theatre, and even the circus, to name a few.[4] Most of the performers and those working behind the scenes also started out working in one or more establishments, presenting other means of amusement.

The Palace, however, was built with vaudeville in mind, featuring a large stage designed to give performers many options, especially for big productions such as large dance troupes, orchestras, acrobats, and scenes from legitimate stage productions (even some from Broadway) complete with musical accompaniment and scenery. The Palace was also constructed with the patrons in mind, boasting ample legroom and extraordinary sightlines so nobody navigated their way around pillars or other inconveniences while watching

performances, typically consisting of eight to a dozen diverse acts twice a day. The lobby welcomed attendees to a world of opulence and show business royalty. This was a palace, and those who played the grand stage were vaudeville royalty.

It should be noted that the most discerning factor when it came to getting on the Palace stage, whether as a comic, singer, dancer, actor, or novelty act, was talent—nothing more, nothing less. Regarding diversity, vaudeville was the great equalizer. Ethnicity and gender took a backseat to talent, at least at the Palace. Likewise, the seats were filled with a crowd ranging from businessmen to families to tourists. And, at a time when immigrants were flocking to New York's nearby Ellis Island in droves, vaudeville offered them an opportunity to laugh at themselves as many ethnic characters were portrayed on the Palace stage. While certainly not devoid of the stereotyping of the times, vaudeville was part of a pre-PC era, for better or worse, and served as an ideal form of entertainment for the melting pot that was America.

A DISAPPOINTING OPENING NIGHT (TO SAY THE LEAST)

The Palace Theatre had its grand opening on March 24, 1913, a rainy Monday night . . . and things went downhill quickly. It was not a packed house, and the opening night lineup did not dazzle as much as the magnificent setting. As is often the case in such a disaster, everyone associated with the venue looked to one another to find someone to blame. Headliner Ed Wynn was in the initial stages of what later blossomed into a heralded career, including appearances in the *Ziegfeld Follies of 1914* and the Broadway revue *The Perfect Fool* in 1921. Yet, for the grand opening of the

While Ed Wynn's performance at the opening night of the Palace was not well received, he went on to a storied career, including a memorable appearance alongside Dick van Dyke in *Mary Poppins*.

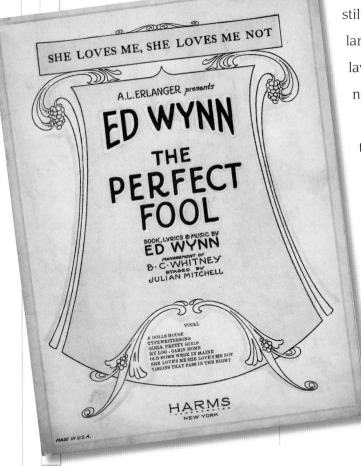

Sheet music for *The Perfect Fool*, a 1921 Ed Wynn musical.

Palace, Wynn was probably not the right choice of headliner. According to *Variety* magazine, the "go to source" for entertainment at the time, it would not be his finest hour. *Variety* mocked the opening bill and the "high" ticket prices, printing a headline that began with "Palace $2 Vaudeville a Joke." *Variety* also pointed out that while the Victoria (the soon-to-be arch-rival of the Palace) had played to capacity two days in a row, the Palace had to give out free coupons to half the guests and still struggled to fill the balcony seats. *Variety's* unkind review, among similar assessments in other publications, had the vaudeville elite predicting the lavish new venue would not last a year. Some were even making bets on the new theater's impending demise.

Despite the poor reviews, Beck still believed in the future success of the Palace. Unfortunately, so did his adversaries. Shortly after the Palace opened, E.F. Albee, head of the Keith Circuit of Vaudeville theaters, informed vaudeville's top entertainers that any acts that played the Palace would not be allowed to play the Keith Circuit. This was a powerful threat and one that Albee was prepared to keep. At the time, many of the best-known performers who wanted very much to play in the new venue also knew that they could ill afford to lose the well-paying stage opportunities at the Keith venues. It didn't help Beck that Keith had also aligned with Hammerstein, making a deal in which Keith acts could play Hammerstein's theaters instead of the Palace. Ultimately, the conflict came to a head with Albee and Hammerstein poised to block many of vaudeville's best performers from appearing on stage at the Palace.

Beck had no choice but to close a one-sided deal with Albee that would take 75 percent of control of the theater away from him, meaning most of the commissions from performers would go into Albee's pockets. It was still Beck's dream theater, but Albee would also oversee all bookings, including those recommended by Beck.

Apparently, Beck recognized or simply acquiesced to the reality that 25 percent of something with the significant potential earnings of the Palace was better than nothing. With that in mind, he decided to make his investment pay off with a scheme to bring a "non-vaudeville" celebrity with great fan appeal to the Palace stage. Where would such a star come from? He or she would come from motion pictures or "silent movies," as we refer to them today. The silent film industry was already booming, and if Beck could bring a movie star to the grand stage of the Palace, it would make the kind of headline news that even *Variety* could not ignore.

Along with ongoing negative reviews, the Palace struggled financially right out of the gate. The cost of building the theater had been greater than anticipated, resulting in ticket prices that were higher than the competitive vaudeville venues in the city. The theater also received several lukewarm, sometimes blatantly cruel, reviews from *Variety*.

While Beck prepared for a pilgrimage to Paris to find the film star he had in his sights, Albee booked the first theatrical production into the Palace. It was a play by Richard Harding David

A program from 1903 included a personal note from the owner highlighting the Four Marx Brothers' "On the Balcony" show as 'at their best.'

"Palace $2 Vaudeville a Joke."
—*Variety*

Ethel Barrymore in one of the costumes from *Captain Jinks of the Horse Marines*, 1901.

called *Miss Civilization*, starring the first lady of Broadway, Ethel Barrymore.[5] Although the theatrical production took a slight deviation from vaudeville, it brought many fans of Barrymore to the Palace to see the esteemed star. Ethel was also part of the dynastic Barrymore family, the daughter of actors Maurice and Georgiana Drew Barrymore and granddaughter of actress and theater manager Louise Lane Drew, who had appeared several times on stage alongside actor Junius Brutus Booth, whose son was John Wilkes Booth (yes, *that* John Wilkes Booth).[6]

While the Palace was generating attention in April of 1913 with *Miss Civilization*, Beck was on route to Paris with a single objective in mind . . . to sit down with renowned actress Sarah Bernhardt. He wanted to convince her that her adoring fans in America would turn out in droves to see her (he hoped)

and that she would get more work in silent films (he also hoped), which was rather likely since she had already appeared in several popular motion pictures. Clearly, Bernhardt was a higher caliber performer than most of the acts on the vaudeville circuit at the time, so it took some convincing on Beck's part. Yet he knew that Bernhardt would never say no to the adoration she would receive from a New York City engagement. Fortunately for Beck and the Palace, her faithful followers were enthusiastic about seeing the 68-year-old star of stage and screen. Bernhardt did not disappoint and ultimately played a significant role in putting the Palace on the proverbial map of New York's elite venues. Of course, this was a costly move on the part of Beck. Besides travel expenses, it was reported that Bernhardt received $500 after each performance, in gold, for her Palace engagement.

Together, the performances of Barrymore and Bernhardt would pay off handsomely by drawing nightly audiences to the new venue, many of whom would soon become regulars.

SUCCESS AT LAST

By the end of the first year of operations, things were looking bright for the future of the Palace. This was due in part to E.F. Albee's decision to bring in a Broadway star and Martin Beck's resolution to import a French superstar. However, it was also due to the closure of the successful Victoria Theatre following the unfortunate death of owner Willie Hammerstein.

Promotional artwork of Sarah Bernhardt.

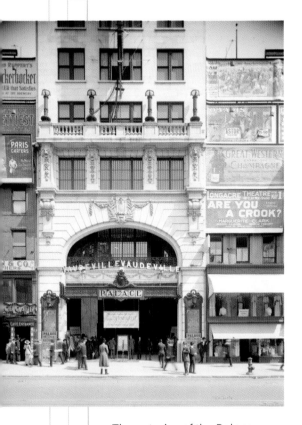

The exterior of the Palace during the heyday of vaudeville.

Not long after that, the Palace would soon emerge as the "Valhalla of Broadway," as it was dubbed in 1914. In fact, in December 1914, *Variety* even characterized the Palace as "the greatest vaudeville theater in America, if not the world." Despite not having full ownership of the Palace, these were the words Beck longed to hear. His dream had come true.

RUMBLINGS & TUMBLINGS

Although vaudeville was the belle of Broadway, the Victoria Theatre would be among the first wave of vaudeville houses to succumb to rumblings that big screen motion pictures were heading for the vaudeville houses. In 1915, the Victoria officially fell from grace as a vaudeville house by being transformed into the Rialto Theatre, a silent movie palace.

Other vaudeville impresarios, however, remained firmly behind their nightly bookings to sell tickets. By the 1920s, audiences were still ravenous for the nation's entertainment craze, with devoted vaudeville enthusiasts returning regularly to find seats in the packed houses. Some even jeopardized their jobs to attend afternoon shows. Meanwhile, vaudevillians throughout America wanted, more than anything, to have the opportunity to play the Palace. Those lucky enough to make the grade marveled at the sheer size and elegance of the theater as they stood below the *expansive* proscenium arch that stretched across the stage, forming a stylized sunburst above them on either side.

It wasn't long before playing the Palace became the dream of every vaudevillian. One vaudeville performer, Jack Haley, painted the picture of the "chosen" vaudevillian

as he or she embarked on a Palace engagement. *"The walk through the iron gate on 47th Street through the courtyard to the stage door was the cum laude walk to a show business diploma. A feeling of ecstasy came with the knowledge that this was the Palace, the epitome of the more than 15,000 vaudeville theaters in America, and the realization that you have been selected to play it. Of all the thousands upon thousands of vaudeville performers in the business, you are there. This was a dream fulfilled; this was the pinnacle of success."*[7]

THE GREAT VAUDEVILLIANS

The Palace later became known as "the one that started them all," referring to the numerous stars who launched legendary careers at the venue, leading to countless stage bookings, Broadway engagements, radio, film, and for some—much later—television.

During the twenty years that the Palace was the preeminent home to vaudeville, a veritable Who's Who of celebrity entertainers graced the giant stage, many from the ranks of vaudeville and others from legitimate theatre success in the United States and abroad.

A Method to the Madness

The Palace typically featured nine performers on the bill, but as many baseball managers will attest, putting the lineup together was not always a painless process. And yet, there was a methodology to the madness. For example, the opening act would usually be a "silent act" such as acrobats, jugglers, or animal acts so patrons taking their

Promotional posters for vaudeville acts often featured outrageous feats of human strength.

SWALLOWING SIXTEEN SWORDS AT ONE TIME.

SALTINESS ON STAGE

It sufficed to say that with a wealth of performers came a wealth of verbiage, often in various accents. But accents were welcome only as long as the audience could interpret the performers' words. What was not welcome at the Palace, among other vaudeville theaters in major markets, was profanity (which at the time included words such as "hell" and "damn") or any material that was sacrilegious or "suggestive," even in song lyrics. Theater managers in many establishments would send out blue envelopes letting performers know what they needed to change or omit from their acts. Hence the term "blue material." At the Palace, Albee was extremely strict about enforcing family-friendly performances and quickly canceled an act that did not adhere to his rules.

Albee listened closely to what was included in the material presented by his performers, especially the comics. However, in time, while specific words and most references to religion remained off-limits, greater leeway was given to performers who reached headliner status. After all, the songs of Eva Tanguay and Sophie Tucker, among others, were suggestive from the titles alone, such as Tanguay's "It's All Been Done Before but Not the Way I Do It," and "Go As Far As You Like," or Tucker's "Last of the Red Hot Mammas" (which was also her nickname). Clearly, in some cases, Albee had to look the other way since rules were made to be broken or at least occasionally bent.

seats would not detract from others hearing the performance on stage. The next two spots usually went to singers, dance teams, or comics, typically followed by a short one-act play, often featuring Broadway talent. A novelty act would bridge the gap between the theatrical performance and a known crowd-pleaser who would then take the show to intermission.

Large-scale acts, needing plenty of time to set up, would follow intermission, which could be anything from flying acrobats to a full orchestra. A variety act would often bridge the gap between the large-scale act and the headliner who would follow. This was usually a notable name that most of the audience came to see. And finally, after the headliner left to (hopefully) a standing ovation, there was a "mop up" act that was annoying enough to encourage people to leave the theater. Many such acts remained unknown but had their moment on the stage in infamy. Nonetheless, they could then puff out their chests with pride and boldly proclaim that they played the Palace.

As one might rightfully assume, there were many stories from the two glorious decades of vaudeville at the Palace. Some are well documented while others, like the many sightings of ghosts throughout the theater over the years, may be the result of bold imaginations or at least exaggeration.

Sophie Tucker was among the early Palace headliners. She brought her own risqué brand of humorous banter and songs to the Palace in 1914 and later returned in 1916 to introduce a new dance called the "shimmy." Tucker proceeded to shimmy (aka gyrate) her way into the hearts of her audience, particularly the males in the crowd. She would later go on to Broadway in the 1938 musical *Leave It To Me!*. Some 25 years later, after a celebrated career in radio and film, the Broadway show *Sophie* played for a limited run, paying tribute to the many talents of Sophie Tucker.

At the Palace, a well-documented battle between Tucker and singer, songwriter, and comedian Nora Bayes would reach a boiling point. Bayes, born in Chicago in 1880, started her rise to fame at the Chicago Opera House in 1899. Then, after a few years of honing her singing and comedic skills in Paris, she made a name for herself at Brooklyn's Orpheum Theatre in 1902. By the time the Palace opened, Bayes had already staked her claim to stardom, playing all the major New York City vaudeville houses, as well as being one of the featured headliners in Flo Ziegfeld's famous follies.

Described as a complex mixture of training, talent, and temperament, Bayes was among vaudeville's most notable divas. By 1910, she was among the best-loved performers of

Sophie Tucker poses glamorously for the camera in this promotional image.

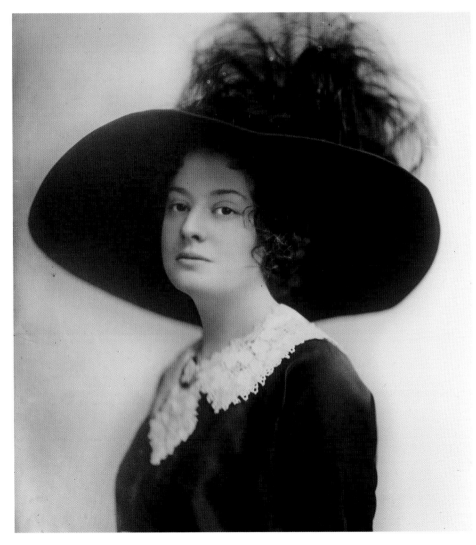

Nora Bayes was an American singer and vaudeville performer with over 160 recordings. She is credited with co-writing the song "Shine On, Harvest Moon" and performed during the First World War.

the era and one of the highest-paid stars, often touring the vaudeville circuit with her talented first husband, singer and songwriter Jack Norworth, best known for writing the baseball anthem "Take Me Out to the Ballgame" as well as "Shine on, Harvest Moon," which he co-wrote with Bayes.

Yet, while Bayes won over audiences, she did not always win over her fellow performers. One such performer was Tucker, who campaigned diligently to get into one of Flo Ziegfeld's fabulous follies. After numerous efforts, Tucker finally got Ziegfeld's attention and was given the opportunity to close the *Ziegfeld Follies* on Broadway with a final number. Unlike vaudeville, where the final act was supposed to disperse the crowd, this was still Broadway, and Tucker was going to offer up a true Broadway finale in hopes of bringing the audience to their feet cheering.

As a prelude to her Broadway debut, Tucker was whisked down to Atlantic City for a preview performance before Broadway's elite, which, at the time, included her friend Irving Berlin. Tucker was reportedly so nervous that she had to be "shoved onto the stage." But her fear disappeared once the music began to play, leading to a magical night ending with multiple standing ovations and several encores.

Once back in the dressing room, as Tucker described the scene, "Nora Bayes was in a lather. She was outside her dressing room door screaming at Mr. Ziegfeld and pointing like a lunatic in my direction. My goose wasn't just cooked; it was burnt to a crisp."

Bayes was furious that someone else was taking the spotlight away from her. But Ziegfeld maintained firmly that he wanted Tucker to be a major part of the show. This caused a rift between Ziegfeld and Bayes, who stormed out on him. From this encounter, Bayes learned a valuable lesson: you don't walk out on Flo Ziegfeld, who proceeded to win a breach of contract suit against her. Bayes became *persona non grata* at several New York venues for the next few months before ironically returning to the stage in a Broadway musical show called *Miss Innocence*, taking over a role played by Ziegfeld's ex-wife Anna Held.

Over the ensuing years there was no love lost between Bayes and Tucker. Fueling the fire was that Bayes' career was cooling while Tucker's star kept rising. They would rarely

Florenz Ziegfield Jr. was an American Broadway impresario notable for the *Ziegfeld Follies*, producer of the musical *Show Boat*, and a member of the American Theater Hall of Fame.

Sheet music for "I'm Learning Something Every Day," featuring Anna Held, Flo Ziegfeld's ex-wife, 1909.

appear on the same bill, but when they did, Bayes would supposedly find ways to bump Tucker down in the order. Bayes also took opportunities on stage to toss in digs at Tucker, who, several years later, decided it was time to get even.

A benefit came up at the Palace in 1928 for the National Variety Arts. Eddie Darling, the highly respected booker of the Palace at the time, asked Tucker to come and close the show. Tucker agreed and had every intention of doing the show; however, she "leaked" to the press that she couldn't make it that night, which would leave Bayes as the headliner, something she cherished.

The night of the show, while on stage at her own nightclub, Tucker set it up so that Eddie Cantor, who was performing that evening, would run on stage and announce that the National Variety Arts needed her immediately. She played up the mock predicament in front of the audience, asking how she could just leave her club while the crowd cheered at such an obvious set-up. Finally, she told the audience she'd be back very shortly, at which point she dashed out the door to a waiting car that took her to the stage door of the Palace, where Eddie Darling met her. Together, they headed toward the stage just as the emcee announced the headliner for the evening, Nora Bayes. As Bayes began her act, Tucker and Darling ensured she could see them watching closely from the wings. Bayes was not amused, and after her last song, but before her curtain call, she left the stage to scream at Eddie, something to the effect

that, "If that blimp goes on after me, I'll never play this dump again," to which Eddie motioned for her to get back on stage where she took what would be her final bow at the Palace. As the story goes, as Bayes exited the stage, Tucker went on stage, and Eddie Darling ushered Nora Bayes out of the Palace forever.[8]

While the Palace was built with vaudeville in mind, it was assumed, in error, that there would be only one star or headline performer on any bill. Thus, there was only one lavish star dressing room. This would become a potential issue when two or more major stars were booked for the same show, such as the night Fanny Brice and Eva Tanquay were on the same bill.

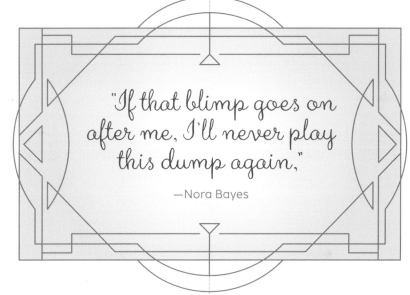

"If that blimp goes on after me, I'll never play this dump again,"

—Nora Bayes

Brice is remembered today mainly from the movies *Funny Girl* and *Funny Lady*, based on her life story. She was indeed the unsurpassed funny woman of her generation, and some critics will argue of "any generation." While the biofilms illustrate that there were many serious moments in the life of Brice, the public saw her as just plain funny, on stage and off. "Anything for a laugh," she would quip. From her years in burlesque, vaudeville, and the *Ziegfeld Follies* to her days on the radio featuring her Baby Snooks character, Brice wowed audiences with her own brand of comedy through song, dance, and characters. Brice, already a Ziegfeld star on Broadway, was often a featured Palace headliner starting with her debut performance in 1914.

A stamp featuring vaudeville star Fanny Brice.

While Canadian-born singer Eva Tanquay remains a far less familiar name than Fanny Brice, in the early days of vaudeville she was a major force, billing herself later as "the girl who made vaudeville famous." From her wild reddish hair to her frenzied behavior to her "attention-grabbing" wardrobe (which included a $40 dress made from 4,000 pennies) Tanquay was called everything from eccentric to cyclonic as she sang her way onto the vaudeville stages and into the *Ziegfeld Follies* with suggestive comedic songs such as those mentioned earlier as well as "I Want Someone to Go Wild with Me."

Her biggest hit song was "I Don't Care." However, she did care very much about her career and soaring popularity. She would create her own headlines through her unorthodox behavior while traveling the vaudeville circuit to ensure she was getting her fair share of publicity and more. For example, in 1907, Tanquay spent nearly a week in a Brooklyn hotel with a notable entertainment journalist whose wife hired a private eye to act as a bellhop and found them. The tryst must not have had much of an effect on Tanquay's star power, as she ascended the ranks to become one of the most profitable stars in vaudeville, even headlining at the Palace.[10]

Booking both Brice and Tanquay on the same bill was a daring feat that left Eddie Darling with quite a dilemma regarding who would inhabit the sole star-dressing room. But Darling had a plan. As described by Marion Spitzer in her 1969 book *The*

"FIRE!"

The (unwritten) rule is that you are not supposed to yell "fire" in a crowded theater unless there actually is a fire. As it turned out, there was one such occasion at the Palace in its final years of vaudeville. An electrical fire sent sparks flying, flames rising, and audience members scurrying to the exits.[9] Fortunately, there were no serious injuries, not even to Sophie Tucker, who was on stage then, or comic Bill Robinson, who was waiting in the wings. There were some props, curtains, and scenery damage, but the Palace did not shut down for any upcoming shows. Since Tucker was on stage at the time of the fire, newspapers had a field day with their headlines touting her "scorching" performance at the Palace.

Palace, "a resourceful Mr. Darling, according to one of the hardiest of Palace legends, solved it. The story goes that Darling had a ladder placed against the dressing room wall, a canvas spread on the floor, and a bucket or two of paint on the canvas. Then he would explain, apologetically, that he'd been having the room redecorated and the painters were so slow that the room couldn't be used. Thus spared the need for hand-to-hand combat to possess the star room, both gals would settle for dressing rooms upstairs." It was a daring plan, but it worked, and peace was maintained at the Palace.

There are also numerous stories of stars whose careers were just formulating when they played the Palace on their way to fame and fortune. For example, Judy Garland would take baby steps toward her legendary career while performing with her two older siblings as the Gumm Sisters at the Palace long before she strolled down the yellow brick road in 1939 or returned to the Palace for her legendary performances in the 1950s. The multi-talented Jimmy Durante took slightly larger steps toward his brilliant career by performing as part of the comedy trio Clayton, Jackson, and Durante.

At the Palace, a long-time struggling vaudevillian would finally get his chance to engage and delight audiences with his wisecracks and quips as a new headliner in 1931. Bob Hope finally hit the big time and packed the house in the later years of vaudeville, where he headlined a billing with comic genius Beatrice Lillie and the incomparable Noble Sissle and his band.

Like many performers at the time, Hope worked long and hard before achieving headliner status at the Palace, starting out as part of a dance team before moving to comedy with his "Keep Smiling" tour of vaudeville venues around the nation.

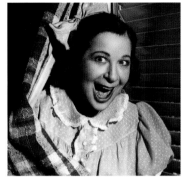

TOP: Fanny Brice, the inspiration for the musical *Funny Girl.*

BOTTOM: Eva Tanguay, star of *The I Don't Care Girl*, 1919.

In the early 1920s, Bob Hope (right) dreamed that he and his Cleveland girlfriend, Mildred Rosequist, would achieve the success of the dancing sensations of the 1910s, Vernon and Irene Castle (below).

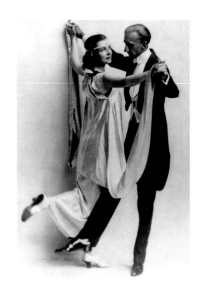

A review of Hope's first vaudeville performance at the Palace was a bit tepid yet encouraging, stating, "He is a nice performer of the flip comedy type, and he has his own style. These natural resources should serve him well later on."[11] Indeed, his "natural resources," charming persona, and precise comic timing did just that, as he took his star-studded USO shows worldwide to provide much-needed entertainment to U.S. troops from Berlin to Saigon for over 50 years. Hope became synonymous with his USO legacy, tours, radio programs, films, and countless television appearances securing him as one of the most celebrated entertainers of the twentieth century.

While Hope was just reaching headliner status when he made the Palace roster, others quietly emerged while honing their skills at the theater. Back in the first year of the Palace, a young man in baggy pants and a shabby top hat, donning a big red nose, made his way into the Palace as a silent juggler, quite an outstanding one at that. His name was William Claude Dukenfield, better known as W.C. Fields, and his aptitude for juggling surpassed anyone else at the time as he incorporated a variety of items, such as canes and hats, into his act. This led to marvelous reviews and countless stage performances in which he worked more comedy into his act. After appearing in several renditions of *Ziegfeld Follies*, Fields became a silent movie star and later moved into the talkies.

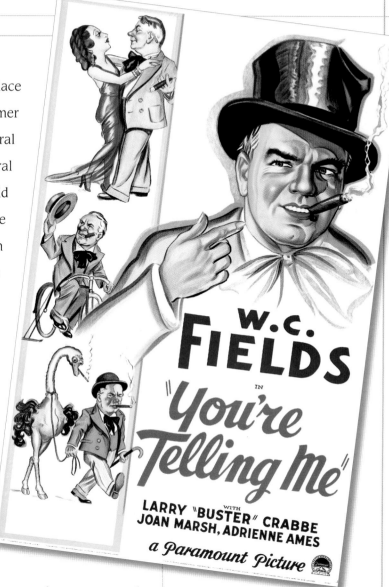

Movie poster for *You're Telling Me!* (1934) with W.C. Fields, Buster Crabbe, Joan Marsh, and Adrienne Ames.

By then, audiences became aware that the silent comic juggler could speak. Fields quickly became widely known for his pinpoint comic timing and acting in over 40 films, as well as his heavy drinking and being one of the most cantankerous performers to ever set foot on the stage or grace the film studios. And yet, the lovable Fields started at the Palace.

THE PALACE BEACH

While one does not typically acquaint a beach with Manhattan, there was a beach outside the Palace Theatre. While there was no actual sand and no ocean in the vicinity of Times Square, the beach was a parcel of land in front of the Palace where vaudeville wannabes and industry professionals would hang out in hopes of the unlikely opportunity to go on the grand stage. Fans would also congregate at the "beach" in hopes of meeting their vaudeville idols. The crowd at the Palace beach was usually a good barometer of how business was going. Lots of people on the beach meant the house was probably packed, while a smaller gathering meant it might have been a quiet afternoon or evening.

MODERNIZING THE THEATER

During the vaudeville years, the Palace made some upgrades. For one, projectors were installed in 1915, which could be used to show short movies by novelty performers to add to their repertoire or simply be used to fill time between performers. Like animal acts, these brief movies were billed as "dumb" acts. In 1920, another new feature of the Palace, a Wurlitzer pipe organ, was installed. When the occasional silent movie would be part of the evening's entertainment, an organist would play in conjunction with the film, as was the case with the growth of silent film theaters.

VAUDEVILLE'S SWAN SONG AT THE PALACE

When the Palace Theatre opened in 1913, vaudeville was riding high. It was considered more family-friendly than burlesque and provided a wider variety of performers while also reaching

a broader audience than opera, operettas, or any type of stage entertainment at the time. Vaudeville was widely considered the unrivaled performance art form of the first two decades of the twentieth century.

Vaudeville, throughout the Roaring 20s was, as they said in the jazz age, "the cat's meow," with what became the Keith–Albee-Orpheum circuit ruling the business. In fact, the circuit grew rapidly with more than 700 theaters, having a combined seating capacity of roughly 1.5 million through-out the United States and Canada. Fortunately, the supply of talented vaudevillians sustained, with the top regulars performing nightly, traveling from theater to theater. Headliners commanded higher fees, but bookers could negotiate just enough to make both sides happy. And yet, besides the frenzy of vaudeville, popular dance clubs, Broadway revues, and the fabulous follies were running amuck in the Roaring 20s as the nation rejoiced after declaring victory in World War One in late 1918.

Prohibition was also part of the 1920s, and it provided a boost for much of the entertainment industry. Without saloons, audiences needed another place to spend their time and money. Of course, in most cities, speakeasies also became popular haunting grounds for those embracing partying before and after taking in a vaude-ville performance. Some entrepreneurial vaudevillians opened their own speakeasies, while other acts made some side money (or bartered for booze) by performing at the speakeasies.

Theatrical cold cream, a high-grade cream with a smooth texture, was often used as base for stage makeup in the early days of the theatre.

AN UNFORGETTABLE BOOKING

On February 2, 1920, the Palace Theatre introduced a unique guest who was not a singer, dancer, comic, actress, or performer in any capacity. Yet she was an iconic individual who is forever remembered for her courage and sheer will to overcome her significant handicaps.

Accompanied by her extraordinary teacher and lifelong companion, Ann Sullivan, Helen Keller took the Palace stage for the first night of a weeklong booking. Sullivan spoke first about the remarkable journey they shared and the incredible accomplishments of Helen Keller, who, while deaf and blind, would defy all the odds and go on to graduate from Harvard University, write several books, and become an activist, speaking about various issues of the era including women's suffrage, which would later that year result in ratification of the 19th amendment to the U.S. Constitution, finally and formally giving women the right to vote.

Not only was she the first deaf and blind person to take the stage at the Palace, but she was asked to return for a second week. Her strength and insights forever touched those who were there to hear her speak about the world at large. During her booking, headliner Sophie Tucker was so enthralled that she befriended Keller and taught her how to apply her own makeup before going on stage. Tucker also taught her about jazz at Miss Keller's request.

And, yes, it happened at the Palace.

Helen Keller, circa 1920, was one of the most unique notables to appear at the Palace.

No one in those early years of the Palace in 1913 would have fathomed that two decades later, vaudeville would be akin to that old pair of dance shoes worn on many stages but now gathering dust in the back of many a vaudevillian's closet.

So, what happened? Why such a rapid demise for vaudeville? In the mid to late 1920s, film technology started speaking to its audience. The first motion pictures with sound arrived in 1926, using synchronized sound effects to enhance otherwise silent films. But before the newly founded "film fad" could fade, the talkies followed with a "sound movie" explosion. *The Jazz Singer*, starring Al Jolson, had its screen debut in 1927 and was considered the first talkie, although technically it was part talkie and part silent film with subtitles. By 1928, many more part-talkies would follow. Then, in 1928, *Lights of New York*, a film from Warner Brothers, would become the first all-talkie. Aware of the impending impact of films, the Palace would later make what would turn out to be a fortuitous move by installing a new sound system in 1929. And yet, E.F. Albee, who ran the Palace in the vaudeville days, never "appeared" to take the movie crazy seriously.

But it was more than just the films alone that intrigued audiences. From the small theaters known as nickelodeons in the early 1900s emerged grand film "palaces" in many major cities, including New York, which was already home to several spectacular new movie venues such as the Rivoli and the Capital. Also in New York City was the lavish Roxy Theatre, which featured the lovely Roxyettes—a precursor to the Radio City Rockettes, still high-kicking a century later. Then there was the Paramount, which was to motion pictures what the Palace was to vaudeville, only much larger, seating 3,664 patrons and located just four blocks south of the Palace. The artsy new

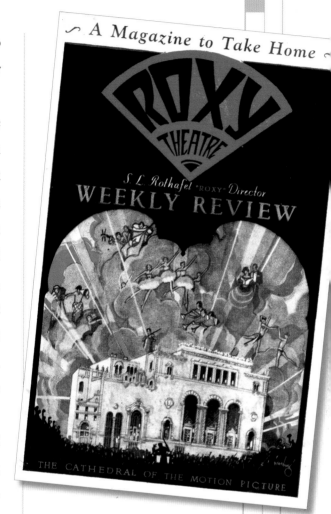

Promotional material for the neighboring Roxy Theatre.

Gracie Allen and George Burns in a publicity portrait, 1935.

Paramount sported spectacular murals throughout the building, which drew advance media attention to the new venue. For the grand opening, among many notables on hand was Thomas Edison, and why not? He was one of the inventors in the motion picture!

Suddenly, film was all the rage, and to make things worse for vaudeville theaters, the cost of running a theater dropped significantly without having to pay for a host of performers day and night. This made it easier to charge less for tickets. Nonetheless, many of the successful new film houses also began sporting live entertainment.

Vaudeville at the Palace kept going despite the rising attention from motion pictures and the growing popularity of radio programs, some of which featured vaudeville entertainers. Many headliners remained faithful to the Palace, including the notable legendary comic and violinist Jack Benny, comedian George Jessel, Fanny Brice, Sophie Tucker and the incomparable husband and wife comedy team of George Burns and Gracie Allen. Yet, despite the best efforts of Albee and everyone involved in running the Palace, finances were falling. Empty seats, once a rarity in the esteemed venue, began cropping up more frequently. While vaudeville still had its loyal following, movies became the talk of the town, not just in

New York but in towns and cities all over the country.

By the late 1920s, RKO (Radio-Keith-Orpheum) had emerged as one of the country's most significant film and production companies. While Keith posthumously remained part of the esteemed RKO name along with Orpheum, which was the name of the circuit that began in 1886, the one conspicuous name missing from the famous title was that of E.F. Albee, who presided over the Palace for many years and played a major role in the Keith-Albee vaudeville theater dynasty. Ironically, just as Albee "bumped" Martin Beck out of full control of his own theater, this time, Albee was on the other end of such a "bump." Joseph Kennedy, the patriarch of the Kennedy family, offered Albee a deal for a stake in the business. Albee, already a rich man and a tough-as-nails theater manager, was not the esteemed businessman he thought he was. In the deal, Albee unknowingly gave all his holdings in the Palace to Kennedy who ran the Film Booking Offices (FBO) of America. Kennedy, however, never had any real interest in the theater business, so it didn't take long for him to sell his newly acquired stake in the theater over to David Sarnoff, who headed RCA which later merged with FBO to form RKO.

Under RKO ownership, the theater continued as a vaudeville house for the next few years. However, as the cost of booking headline entertainers increased, Palace box office grosses declined. Once the Great Depression hit in 1929, the Palace could only afford to remain a vaudeville theater for a few more years. Vaudevillians and those who still loved the magic of the hodgepodge that made up this exhilarating, unbridled art form knew the curtain would come crashing down soon. In this case, instead of a curtain, it was a movie screen that stifled the of Vaudeville.

Joseph P. Kennedy, patriarch of the Kennedy family and financier, became the chief executive of Film Booking Offices. He would later go on to become the first chairman of the Securities and Exchange Commissions.

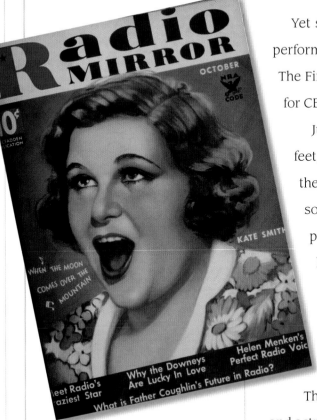

Radio Mirror magazine featuring artwork of Kate Smith.

Yet stage shows at the Palace did not go down without a fight. One notable performer who kept the Palace afloat in 1931 was Kate Smith, already known as The First Lady of Radio from her NBC series, *Kate Smith Sings*, and her new show for CBS, the *Swanee Music Series*, which began in 1931.

Just as Beck reached out to Sarah Bernhardt to help get the Palace on its feet, Palace management reached out to Smith, imploring her to please throw them a lifeline to continue. Far from a typical "vaudeville act," the 24-year-old songstress was glad to do her part for the cause. Smith proceeded to shatter previous box-office records with a ten-week run. Her fans were thrilled to see her perform, and fans of the Palace and vaudeville were grateful.

While Smith's run at the Palace was great while it lasted, it wasn't enough to stem the tide of change. Although Smith went on to a legendary career spanning 50 years, her presence was not enough to save vaudeville at the Palace.

The massive stage at the Palace, once home to everything from legendary actors and actresses to jugglers to the escape mastery of Harry Houdini, was now obscured by a giant film screen. Vaudeville had come to an end, but the Palace was still standing strong after two fabled decades. And yet, despite the initial horrid reviews from *Variety*, the fire of 1931, and the countless shenanigans of so many vaudevillians over the years, not to mention a wide variety of animal acts, the Palace somehow remained elegant and pristine.

By the start of 1932, the question was: What would happen to the Palace? Could it survive as just another movie house amongst so much competition? Would it continue

A WHO'S WHO OF STARS

Among the many vaudevillians that became film stars were:

George Burns: The straight man for many years with his partner on stage and in marriage, Gracie Allen, Burns would appear in over 40 films. Together with Gracie, he made several comedies in the 1930s and '40s. Burns would also appear in several hit movies including Neil Simon's 1975 comedy *The Sunshine Boys* and the 1977 hit *Oh God!* where Burns excelled in the always-challenging role of playing God.

Bob Hope: His first feature film, *The Big Broadcast of 1938*, led to over 50 funny films over the next four decades. Hope had a successful run of hit films while teaming up with singer and actor Bing Crosby in the 1940s and 50s with *Road to Singapore, Road to Zanzibar, Road to Morocco, Road to Utopia, Road to Rio,* and *Road to Bali.* He also shared the screen with many notable leading ladies of the era including Betty Grable, Dorothy Lamour, and Jane Russell.

The Marx Brothers: Managed by their mom Minnie Marx, Chico, Harpo, Groucho and Zeppo, four of the five brothers, went from vaudeville to films starting in 1929 with the release of *Cocoanuts.* While best known for their visual comedic antics and Groucho's classic quips, they were also talented musicians and writers. Among the other popular Marx Brothers comedies are *Duck Soup, A Night in Casablanca, Room Service,* and *A Day at the Races.*

Bill Robinson: A prominent tap dancer and vaudeville performer, Robinson co-starred alongside child-star Shirley Temple in *The Little Colonel,* the first of five widely popular pictures they made together, starting in 1935. Robinson later moved on to a few feature films including an all-black wartime version of *Stormy Weather* in 1943.

Vintage poster of the Marx Brothers in *Cocoanuts*.

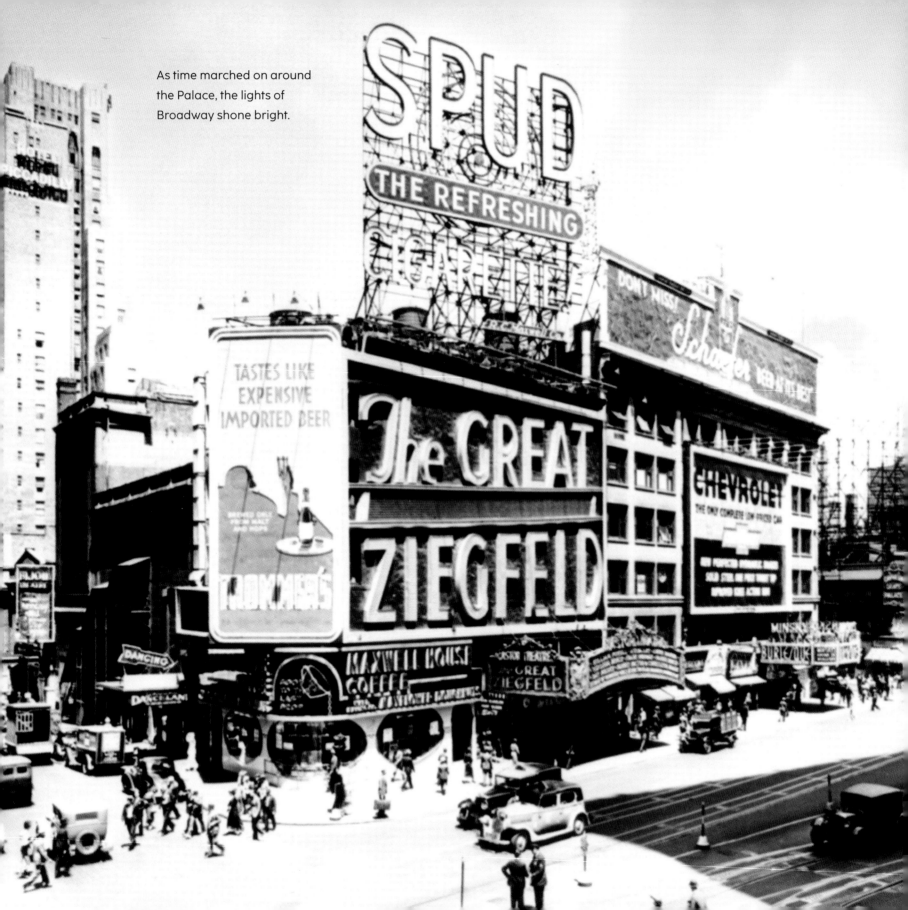

As time marched on around the Palace, the lights of Broadway shone bright.

to present any vaudeville performances? For a while, starting in late 1932, the Palace did a bit of both like many of the city's movie houses. This meant a few vaudeville acts followed by a film. For three years, this on-again-off-again hybrid program continued with two, then four, even five daily shows.

In some cases, you could see a performer on stage and then see them on the screen shortly thereafter. Many performers had already made a mark in film while still in vaudeville. Others made the move later in their careers.

The Palace closed as a vaudeville house officially in 1935 and switched to a film-only format. Whether it was 100 percent true or not, *The New York Times* had already dubbed it as the last of the full-time vaudeville venues. It was certainly the most celebrated.

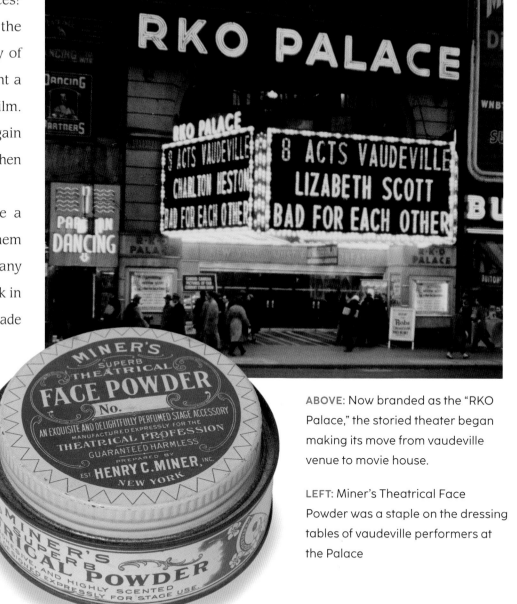

ABOVE: Now branded as the "RKO Palace," the storied theater began making its move from vaudeville venue to movie house.

LEFT: Miner's Theatrical Face Powder was a staple on the dressing tables of vaudeville performers at the Palace

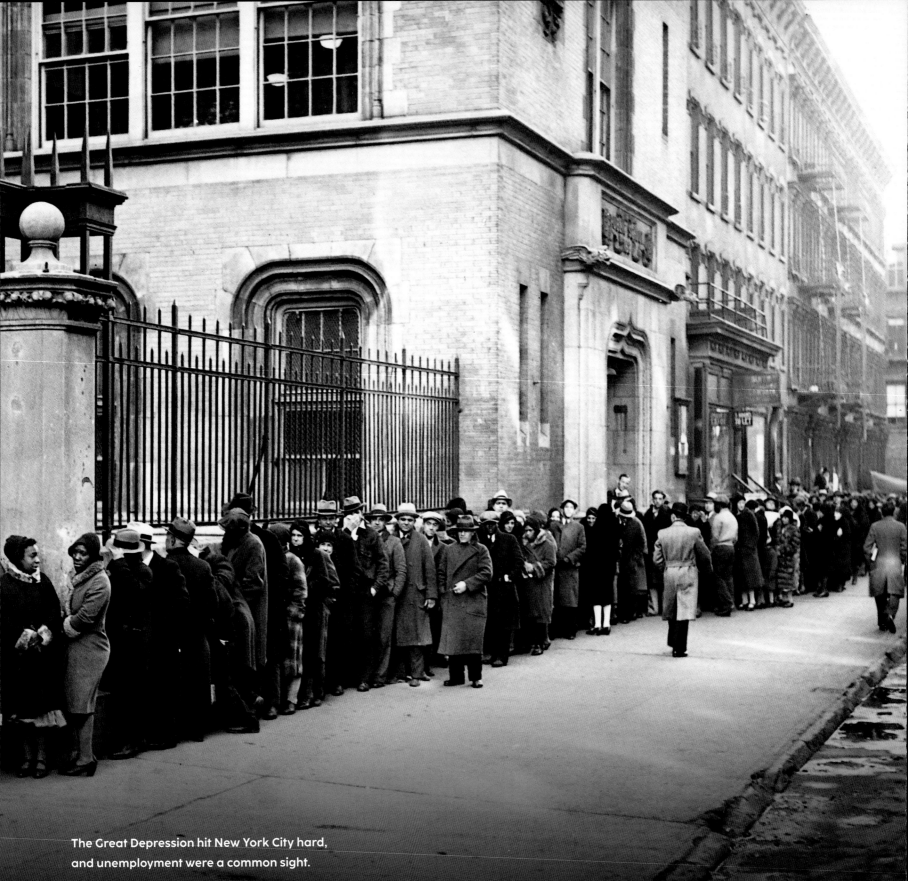

The Great Depression hit New York City hard,
and unemployment were a common sight.

CHAPTER 3

THE MOVIE YEARS

America suffered in the early 1930s as the Great Depression quickly descended upon a nation just stepping out of the roaring twenties. Sadly, bread lines were longer than ticket lines at the Palace Theatre and other vaudeville houses. It was an era of unprecedented economic hardship for the country, with soaring unemployment rates and widespread poverty. New York City, the heart of the nation's economy, was, like many cities, in a state of distress.

Hoping to bring some song and dance to otherwise downtrodden people, movies provided some comfort. In fact, it was estimated that over 60 million people a week throughout the country were going to the movies. Motion pictures provided a couple of hours of relief from the anguish and uncertainty that Americans were experiencing as they sought out work wherever they could find it.

ABOVE: A classic hat, similar to one worn by Fred Astaire in *Top Hat*, is on display at the newly renovated Palace.

RIGHT: Charlie Chaplin in *Modern Times*, 1936.

At the same time, many of Hollywood's future icons were making what have become timeless film classics, from comedies such as the Marx Brothers' *Duck Soup* and Charlie Chaplin's *Modern Times*, the Katharine Hepburn—Cary Grant film *Bringing Up Baby* and the introduction of *King Kong*. And of course, the first full decade of talking films would come to a dramatic conclusion in 1939 with two iconic films, *Gone with the Wind* and *The Wizard of Oz*.

By the latter years of the decade, the economy was finally turning around thanks, in part, to the "New Deal" programs instituted under Franklin D. Roosevelt throughout the 1930s. As for the Palace and other movie theaters, despite the penchant of audiences to escape to a picture show, turning a profit was another matter. Like most competitive movie houses, the Palace saw mediocre results.

For 14 long years (1935-1949), through wartime and beyond, the Palace would be almost exclusively a movie house. The spectacular stage that saw so many marvelous performers, from Sarah Bernhardt and Fannie Brice to Bob Hope and Kate Smith, was now obscured by a film screen. Suffice to say many audience members who had sat in the cushioned Palace seats basking in the joy and even drama of vaudeville, as well as those who had the esteemed honor of performing on that grand stage, collectively believed that the role of the Palace as a movie house was a colossal waste of what the theater had been built to offer. The many dressing rooms in which a legacy of talent once sat staring into makeup mirrors to get the perfect look were now vacant, and that magical aura of watching live entertainment was gone. The first movie to play the Palace was *Top Hat*, starring the incomparable Fred Astaire and Ginger Rogers in one of ten films they made together. Fred Astaire had

Top Hat, the 1935 musical featuring Fred Astaire and Ginger Rogers.

Promotional poster for the 1941 hit *Citizen Kane*.

previously performed on the Palace stage with his sister and dance partner (at the time), Adele, in 1917.

One of the rare nights that the Palace returned to the limelight was on May 1, 1941, when crowds returned to the beach outside the theater to catch a glimpse of the 23-year-old actor, producer, screenwriter and director Orson Welles. On this night, all eyes were on the Palace for the premiere of Welles' cinematic masterpiece, *Citizen Kane*.

Before the debut of *Citizen Kane*, Welles had unwittingly catapulted himself to national fame three years earlier in what was one of radio's most seminal moments, his adaptation of H.G. Wells' novel *The War of the Worlds*. It was on a Sunday evening, October 30, 1938, prime time for radio enthusiasts, and the night before Halloween, that Welles, along with his Mercury Players acting troupe,[12] brought an inspired and updated version of the sci-fi novel to life as never before with precise sound effects and vivid descriptions of creatures from mars landing in New Jersey while meteors plowed into peaceful communities and alien creatures obliterated thousands of national guardsmen.

The broadcast, which opened as "a special report," resulted in thousands of locals in the areas near the so-called citing of these horrific events, taking to the streets, armed and fleeing their homes for their own safety. When news of the growing unrest in the streets reached the broadcasting studio, an actual

non-alien (human) announcer had to chime in and remind the listeners that none of this was real but was only a staged reading of the sci-fi novel.

The War of the Worlds radio broadcast immortalized Welles and helped him land a contract to make his film, *Citizen Kane*, and have free reign over the filmmaking. This honor was rarely bestowed upon such a young talent, especially one who was making his first film. It didn't hurt that Welles had previously produced, performed in and directed a number of Broadway shows, beginning with *Romeo and Juliet* in 1934 and continuing with *MacBeth*, *Dr. Faustus*, *Heartbreak House*, and other, mostly dramatic, productions. Of course, Welles played a prominent role in selecting many of the leading players that he wanted as featured characters in his debut film. This included Joseph Cotton, who was part of Welles' Mercury Players and would later appear in the Broadway version of *The Philadelphia Story* along with Katharine Hepburn before amassing over 130 film and television credits.

Orson Welles' 1938 radio broadcast of "War of the Worlds" convinced listeners that the world was under attack.

Also in *Citizen Kane* was Agnes Moorhead, who later became known as Endora in the hit television sitcom *Bewitched*, and actress Dorothy Comingore, who was also seen the same year in the film *Strawberry Blonde* with James Cagney and Olivia de Havilland. On this night, however, Welles was simply being Orson Welles, large in stature, in character, and in personality.

So once again, the Palace welcomed a rising talent, only this time he would be part of the audience, including members of the cast and crew, friends, and the most esteemed film critics of the era. It was unusual for the Palace to host the world premiere of a feature film since The Music Hall at Radio City and other theaters owned by the major movie studios typically served as home to such theatrical events.

But it was perfect timing for the Palace to host such a grand event, as the theater had been recently dressed up with a series of renovations since the city was hosting the 1939 World's Fair. RKO took the opportunity to erect a brand-new marquee and make alterations within the theater itself. The outer and inner lobbies would now sport new walls, one in black and white granite and the other in black marble. New doors were also installed between the lobbies. Having been built as a vaudeville venue, there were also adjustments that needed to be made for a full-time movie theater. For example, some of the boxes nearest to the stage were removed – they had played a role in vaudeville with comedic acts using the boxes to plant "stooges" in the audience to play along with the comedy routine. Now, the boxes were simply interfering with the sightlines for moviegoers.

The grand premiere of *Citizen Kane* brought back the energy and exuberance that was once the familiar ambiance of the celebrated venue, with celebrities once again

"... *Orson Welles who nearly scared the country half to death . . .*"

making their way into the majestic theater. Many of the evening's guests looked around to see what changes had been made since they last played the Palace while other non-vaudevillians were taking in the grandeur of the auditorium for the very first time. Still others congregated on "the beach," where reporters and camera crews were busily trying to get close to the evening's celebrities for photos and comments.

As for the film, it garnered overwhelmingly outstanding reviews. *Variety* wrote: *"Orson Welles who nearly scared the country half to death with his memorable broadcast of a blitz by invaders from Mars,*

has uncovered for press review his initial production . . . Welles has found the screen as effective for his unique showmanship as radio and the theatre."

The Nation wrote: "It must be stated here that no amount of advance publicity or ballyhoo could ruin the effect of this remarkable picture. It is probably the most original, exciting, and entertaining picture that has yet been produced in this country."

Critical acclaim for *Citizen Kane* would reign supreme for decades to come despite failing to recoup its cost at the box office. This may have been due, in part, to newspaper magnate William Randolph Hearst, who was viciously profiled in the film. Hearst tried unsuccessfully to have the film shut down. And yet, the film received best picture honors at the 1942 Oscars. In fact, *Citizen Kane* was rereleased in the mid-1950s to critical acclaim once again. And it all began at the Palace Theatre.

While the theater was now showing films, many young talents still wished they could have played the Palace or would have a chance to do so in the future. It was such an inspiring goal that screenwriters Richard Sherman, Fred F. Finklehoffe, and Sid Silvers wrote the screenplay for a film called *For Me and My Gal*. Based on a story by Howard Emmett Rogers about the vaudeville team of Harry Palmer and Jo Hayden, the story depicted a couple of talented young performers who wanted nothing more than to play the Palace Theatre and get married shortly thereafter. The

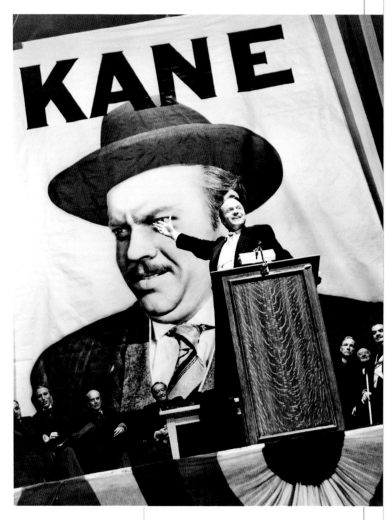

The world premiere of Orson Welles' film *Citizen Kane* at the RKO Palace, 1941.

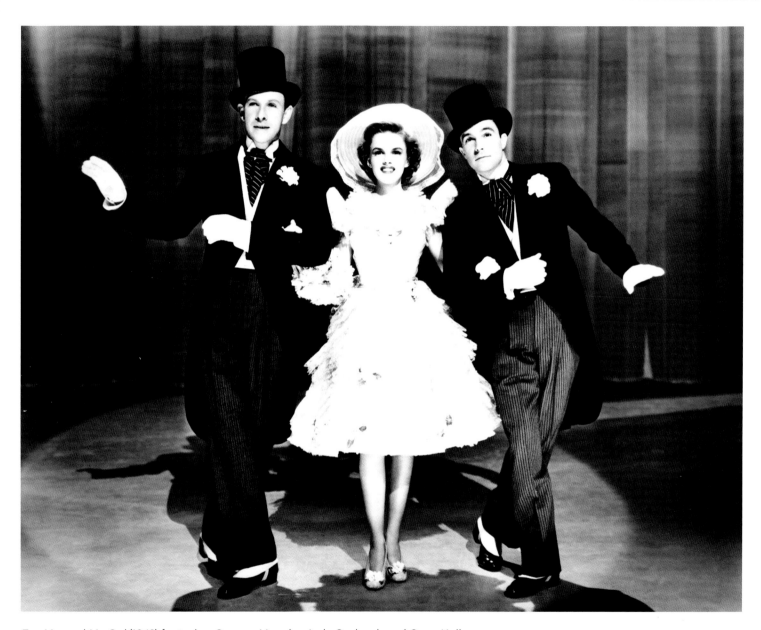

For Me and My Gal (1942) featuring George Murphy, Judy Garland, and Gene Kelly.

1942 MGM film was directed by Busby Berkeley,[13] featuring 19-year-old Judy Garland as Jo Hayden and Gene Kelly, who was 29, as Harry Palmer. Garland's acting coach, Stella Adler,[14] who served as an advisor on the film, recommended Kelly for the lead role opposite Garland despite the ten-year age difference. As the story unfolds, the young showbiz couple finally secure a coveted booking at the Palace that will make their dreams come true. Unfortunately, shortly before their long-awaited theatrical engagement, Harry is drafted during World War One. Not wanting to miss their big opportunity, Harry injures himself so he cannot serve in the military. Jo is mortified that he would do such a thing, having lost her brother in the War (Hayden had actually lost a close friend). The couple decides to go their separate ways, and Harry is relegated to perform for the troops.

As fate, or movie magic, might have it, Harry and his partner become aware of an imminent enemy attack on a convoy of ambulances. In a heroic act, Harry demolishes the enemy's machine-gun position. In doing so, he is injured but survives the war and is commended for his bravery in the face of danger.

When the war ends, Harry attends a victory performance at the Palace, where Jo is now performing. She sees him in the audience, and they reunite onstage to sing the first song they had ever sung together, "For Me and My Gal."

The film was widely acclaimed, and MGM made over two million dollars while costing roughly $800,000 to produce. And while the film did not bring Judy Garland to the actual Palace Theatre (it was filmed in Hollywood), Judy Garland got to play the Palace several times.

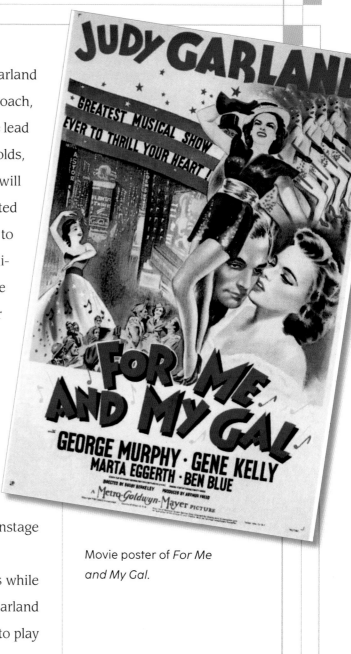

Movie poster of *For Me and My Gal*.

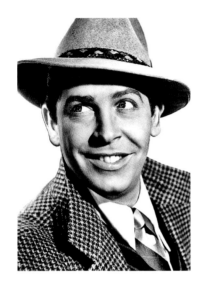

Comedian Milton Berle, who appeared at the Palace, would go on to be a pioneer of television.

VAUDEVILLE IS BACK!

Prayers were finally answered for vaudeville's diehard fans and forever-wanna-be Palace performers, who still spent afternoons camped out along "the beach" in front of the Palace. Following a hiatus of 14 years, 1949 would mark the return of vaudeville to the Palace stage. The hopes, wishes, and prayers were answered by Sol Schwartz, who had worked his way up the ladder within the RKO Studio. As if he needed a premise to draw the attention of the many remaining diehard vaudeville aficionados, Schwartz billed the occasion as the 36th anniversary of the Palace, which was technically correct. Once again, the Palace underwent some changes, such as upgrading the acoustics, re-doing the ticket offices, and cleaning the many dressing rooms that had been dormant for 14 years.

Not wanting to walk the proverbial "high wire" without a safety net, Schwartz arranged to follow the eight vaudeville acts with a feature film, which in this case starred Randolph Scott and Jane Wyatt in the western *Canadian Pacific.* But it was the vaudevillians that audiences came to see—living, breathing people once again on the Palace stage. The emcee for the evening was vaudeville comic Milton Berle, aka "Uncle Miltie,"[15] who was the most notable "star" to take the stage on that special night. But before Berle could even open his mouth, he had to wait as the crowd was already standing up and cheering for the Palace from the moment the house lights were dimmed. In fact, they were quite exuberant throughout the entire bill, cheering loudly for everyone who set foot on the stage. This special re-opening of vaudeville at the Palace was a kickoff for two solid years of ongoing vaudeville programs (followed by films). Since most of the notable headliners of the 1920s had moved on to other

endeavors, the bill pulled talent from stage, screen, and radio to book the second coming of vaudeville at the Palace. Dorothy Loudon and Kaye Ballard were among the names that appeared in Broadway's vaudeville revival. Both would later rise to stardom. An actress and singer, Loudon would go on to win a Tony Award for Best Performance by a Leading Actress in a Musical for her role as Miss Hannigan in the original version of *Annie*. Ballard spent most of her numerous years in show business as a comic actress of stage, film, and television. She was known for her role as the incomparable Rosalie in the David Merrick production of *Carnival* on Broadway and remembered fondly as the co-star of the hit TV sitcom *The Mother-in-Laws*.

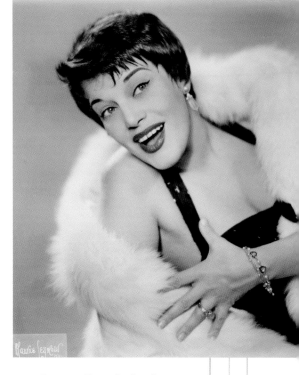

TOP: Actress Kaye Ballard appeared in Broadway's vaudeville revival.

LEFT: Actress Dorothy Loudon as Miss Hannigan in a scene from the Broadway production of the musical *Annie.*

The return of vaudeville at the Palace inspired theater owners in other parts of the country to follow suit. Unfortunately, what was once the height of entertainment was now a returning fad, but it lasted just two years. By 1951, the Palace once again bid farewell to the variety shows that were vaudeville. It was the end of a bygone era once again. Not unlike motion pictures, which led (in part) to the demise of vaudeville in the early 1930s, a new culprit stood in the way of any hope vaudeville had of making a comeback, and that was television. It was hard to compete against a medium that could bring the best performers of the era into people's living rooms free of charge. Singers, comics, dancers, and a wide range of variety acts made the rounds, appearing on programs like "The Andy Williams Show," "The Colgate Comedy Hour," "The Dinah Shore Show," "The Eddie Fisher Show," "The George Gobel Show," "The Jackie

The TV presenter Ed Sullivan at the backstage with American singer Elvis Presley before "The Ed Sullivan Show" in 1956.

Gleason Show," "The Red Skelton Show," "The Tonight Show" with Steve Allen and later with Jack Paar (prior to Johnny Carson, Jay Leno, and Jimmy Fallon) and, of course, "The Ed Sullivan Show." To ask people to leave the comfort of their homes to spend money to see performers live on stage required an act that possessed extraordinary talent, charisma, magnetism, and the stamina to sustain at a top level for at least one, if not close to two hours. Such magnetism was hard to find.

"JUDY AT THE PALACE"

In the fall of 1951, one of the most significant Palace events ever would capture the attention of the city. It was the first ever appearance of the legendary Judy Garland on the actual Palace stage to begin what was billed as two-show-a-day booking for four weeks.

Garland, whose career began unofficially when she sang "Jingle Bells" onstage at the age of two, had already made several films before the role that made her a household name, Dorothy in *The Wizard of Oz*, which she played at the age of 17. Her screen career would include a number of other notable films, including Busby Berkley's *Babes in Arms*, *Strike up the Band*, *For Me and My Girl*, *Girl Crazy*, *Meet Me in St. Louis*, and the 1954 version of *A Star Is Born*.

Original art of Judy Garland at the Palace, hand drawn by noted artist and caricaturist William Auerbach-Levy, Guggenheim Fellow and author of several books on the art of caricature. He often used famous figures as his subjects.

ANOTHER STAR IS BORN

Along with legendary Vaudevillians and Tony Award-winning hit musicals, the Palace was also known for its star-making. One such Palace-born star was Dick Shawn, who was asked to be an opener for singer, actress Betty Hutton best known for her film roles in *Annie Get Your Gun*, *The Greatest Show on Earth*, and on Broadway in *Panama Hattie*. In 1952 and again in 1953, Hutton brought her variety stage extravaganza, *Betty Hutton, and her All-Star International Show* to the Palace, where she introduced the young comic.

Shawn not only received a rousing response from the audience but also happened to impress one VIP in the audience, Marlene Dietrich,[16] who asked him to open for her in Las Vegas. This was one of the first stepping stones in a career that would include numerous nightclub engagements, TV appearances including *The Ed Sullivan Show*, films such as *It's a Mad, Mad, Mad, Mad World* and *The Producers* as well as Broadway roles in Neil Simon's *Come Blow Your Horn*, and the classic Burt Shevelove-Larry Gelbart comedy *A Funny thing Happened on the Way to The Forum*.

At this point, Garland's career had begun to shift from feature films to headliner performances, where she would bring the house down wherever she appeared. For this billing, Garland's manager and future husband, Sidney Luft, would serve as production supervisor. The first half of the performance consisted of a host of vaudeville acts that could now claim playing to a packed house at the Palace Theatre and as openers for Judy Garland.

PALACE TWO-A-DAY

RKO PALACE THEATRE

An original program from Judy Garland's 1951 residency, the *Palace Two-A-Day*.

Then, after the intermission, the lights were dimmed, and the red velvet curtains parted as Judy took the stage to thunderous applause from the packed house. Once the crowd finally settled into their seats, Garland opened with "Call the Papers" and "On the Town" before proceeding into a set that included "Rock-a-Bye Your Baby With a Dixie Melody," a medley of "You Made Me Love You," "For Me and My Gal," "The Trolley Song," and "Get Happy," among other favorites before the inevitable final number, "Over the Rainbow."

The reviews of the show were marvelous, and the set was recorded for a Decca album released with liner notes by Louis Untermeyer, who wrote, *"Judy projects the buoyant spirit of the 'two-a-day' with everything she has: bounding vitality, spirited gestures expressing a vibrant personality, and an extraordinarily flexible voice. This is Judy, the phenomenon, the sophisticated film star—but at the same time the girl who can communicate genuine emotion with a delicate quaver, follow it with comic pratfalls, and, distaining the use of a microphone, send her vibrato straight up to the second balcony."*

Judy Garland sits among flowers sent by adoring fans.

The four-week booking was extended repeatedly until Judy wrapped up an astonishing 19-week run in February of 1952, taking only a few days off for the holidays. In 1956, Judy returned to the Palace for another sold-out stint of shows beginning in September. Once again, she was scheduled for four weeks, which was immediately

extended to eight by the demand for tickets. This time, veteran funnyman Alan King shared the bill amongst a variety of vaudeville acts. King, however, was not a vaudevillian but a rising young comic from Brooklyn who, while overlooked in the shadow of Judy, would see his career rise to a higher level from his Palace performance. It was not because he was on the bill with Judy, but because he "killed," as they say in comedy. Suffice it to say, King became a king of comedy.

Then, following the intermission, it was Judy's turn to dazzle a New York audience. And, as the saying goes, "when in Rome . . .," or in this case, "when in New York," Judy decided to celebrate the city with "Take Me Back to Manhattan," "Give My Regards to Broadway," and "New York, New York," from the show *On the Town* (with music by Leonard Bernstein and lyrics by Betty Comden and Adolph Green)—not to be confused with her daughter Liza Minnelli's signature song of the same name by Kander and Ebb. And, speaking of Liza, it was at the age of 10 that she joined her mom on stage to sing "Swanee." Despite a brief break as Judy was experiencing exhaustion, the run continued for 17 weeks, just two short of her own Palace record.

While Judy Garland's appearances highlighted the 1950s, other notable performers were booked to do their own stage shows under the Palace lights, some of which were also emotionally charged, dynamic appearances. For example, in 1953, Danny Kaye took to the Palace stage with his own magical mix of talent and personality that mesmerized his audience. Leading his international vaudeville production with acts from around the globe, the amicable Kaye, comic, singer, dancer, and actor, was the charismatic crowd pleaser the Palace needed to light up Broadway once again.

Like Garland, Kaye had proven his merits on tour and in a host of films, including *The*

Danny Kaye was an American actor, comedian, singer, and dancer, as well as the first ambassador-at-large of UNICEF in 1954. He also received the French Legion of Honour in 1986 for his work with the organization.

Inspector General and *White Christmas*, with Bing Crosby and Rosemary Clooney. He was also no stranger to Broadway, appearing with Imogene Coca in *The Straw Hat Revue* and making a splash in Moss Hart's *Lady in the Dark*. He would then star in the Cole Porter musical comedy *Let's Face It*, along with Eve Arden. Later in the 1960s, like so many talents of the era, Kaye would have his own television show.

Unfortunately, Kaye's marvelous appearances only gave the Palace a lifeline, but it wasn't enough to keep the Palace financially afloat for long. While comic Jerry Lewis and songstress Edie Gourmet, respectively, had their own successful runs at the Palace, as did several other performers, it became increasingly difficult to book enough major stars to maintain a steady income stream at the box office. Even the great showman himself, legendary pianist Liberace, did not pack the seats.

Therefore, the Palace remained primarily a movie house with the occasional headline star. As it turned out other movie emporiums weren't doing much better. In fact, the famous Roxy, one of the first stunning movie theaters built in Manhattan, closed entirely.

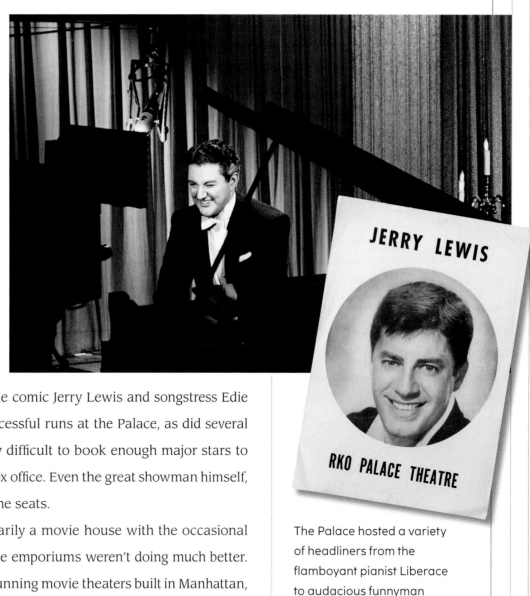

The Palace hosted a variety of headliners from the flamboyant pianist Liberace to audacious funnyman Jerry Lewis.

Sheet music published by Irving Berlin Limited in London for the 1946 Broadway musical *Annie Get Your Gun* with lyrics and music by Irving Berlin and from a book by Dorothy Fields and her brother Herbert Fields.

THE GOLDEN ERA OF MUSICALS

While the Palace remained a movie theater throughout the 1950s and early '60s, Broadway was enjoying the golden era of musicals, featuring a host of dazzling productions unlike ever before. Theatergoers and visitors from around the globe were treated to fascinating stories, captivating characters, and unforgettable songs that took them on journeys from the heartland of America to the Royal Palace in Bangkok, to Wimpole Street in London, and to the Bavarian Alps.

The golden age began a few years before the fabulous fifties when Rodgers and Hammerstein introduced the quintessential American musical *Oklahoma!*, which opened at the St. James Theatre in 1943 and changed the face of Broadway musicals forever. A few years later, Irving Berlin, along with Herbert and Dorothy Fields, in the classic ode to Annie Oakley, *Annie Get Your Gun*, opened in 1946. Rodgers and Hammerstein would then round out the 1940s with their portrayal of American troops and army nurses in the World War II epic musical *South Pacific*.

The cavalcade of soon-to-be legendary musicals continued through the 1950s, with theater marquees posting one timeless hit after another. These were the original cast performances of everlasting musicals that continue as standard fare for productions in grade schools, high schools, colleges, community theaters, and touring companies seven decades later. It was in 1950 that audiences were first introduced to Sky Masterson and Sarah Brown in Frank Loesser's marvelous musical comedy *Guys and Dolls*. The dynamic duo of Broadway, Rodgers and Hammerstein, would return shortly thereafter with a 1951 musical about the unlikely pairing of a British school teacher with the king of Siam (now Thailand) in *The King and I*.

Then, in 1956, Lerner and Lowe turned *Pygmalion* into *My Fair Lady* with incredible results. In 1957, Leonard Bernstein, Arthur Laurents, and Stephen Sondheim brought the epic story of ethnic tension between New York street gangs to Broadway in *West Side Story*. It was also the year that Meredith Willson introduced *The Music Man*. Appropriately, the 1950s would conclude like the 1940s, with a masterpiece from Rodgers and Hammerstein. This time, it was the epic story of the Von Trapp family's escape from Austria in the 1959 blockbuster hit *The Sound of Music*. Other musicals that made a splash during this unforgettable decade of magical musicals included *Carousel*, *Damn Yankees*, and the story of stripper Gypsy Rose Lee in *Gypsy*. The Palace did not stand by idly, ending the decade with a two-month run of sold-out performances by the marvelous Harry Belafonte.

Meanwhile, as all of this unfolded on Broadway, an astute producer and one of six children in a family known for theater ownership became quite aware of the impact of the golden age of Broadway musicals. Indeed, these lavish productions were all the rage, and James M. Nederlander understood the Palace Theatre, with a massive stage and many dressing rooms, was certainly more than a movie house . . . much more. While the Palace waited patiently as an onlooker during the golden age of musicals in the 1950s, that would all change in the coming decade. Although Judy, Danny, and Harry generated their own headlines at the Palace, it was time for something new.

In 1965, James M. Nederlander and his father, David T. Nederlander, bought, renovated, and prepared the Palace Theatre for a triumphant return. Only this time, it would be a new home for Broadway musicals.

Stewart F. Lane, James M. Nederlander, and James L. Nederlander.

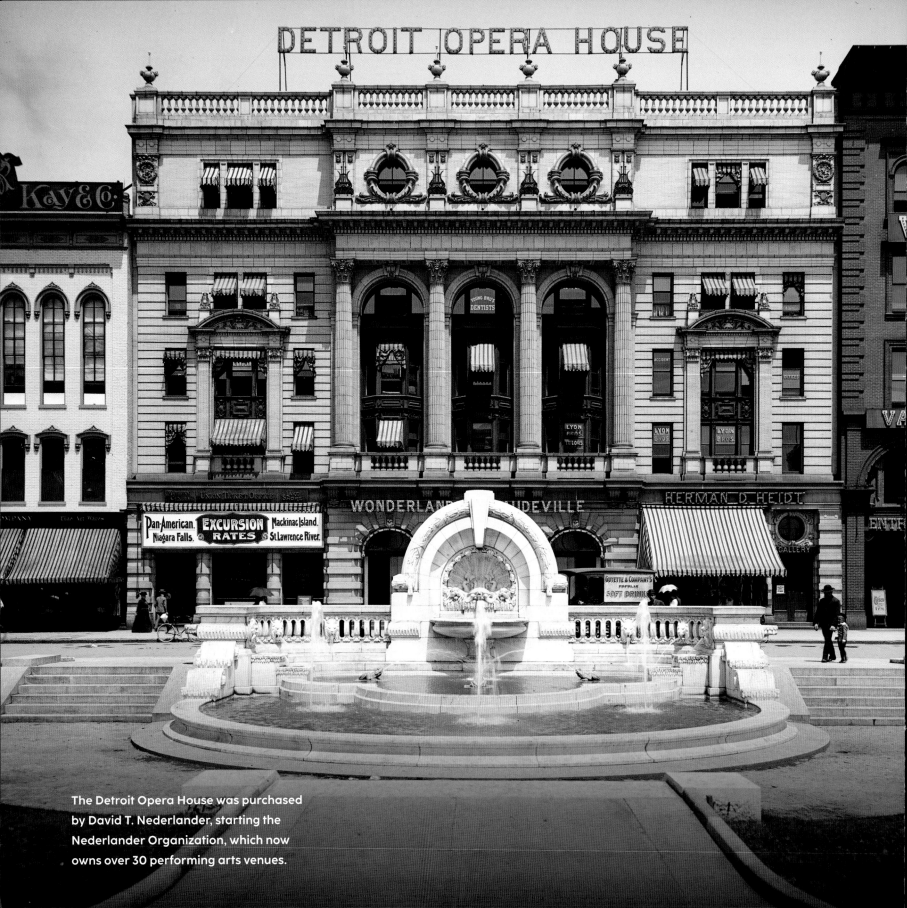

The Detroit Opera House was purchased by David T. Nederlander, starting the Nederlander Organization, which now owns over 30 performing arts venues.

FROM MOVIES TO MUSICALS: REVIVING THE PALACE

In 1912, David T. Nederlander purchased the 99-year lease on the old Detroit Opera House and started the Nederlander Organization. At this time, Martin Beck also had his dream theater, the Palace, constructed in New York City.

It was more than half a century later that David T. Nederlander would join his son James M. Nederlander in purchasing the Palace Theatre. Over the five decades prior to the purchase of the Palace, the Nederlander Organization had grown into one of the largest theater ownerships in the nation. Then, following the death of their father in the early 1960s, the Nederlander brothers would continue expanding the organization by purchasing venues coast to coast with a focus on California and, of course, New York City. Today, the Nederlander Organization, under the leadership of James L. Nederlander (son of James M.) has ownership, or part-ownership, of nine Broadway theaters, as well as 21 theaters in various cities in the United States and abroad including venues in Los Angeles, Chicago, Durham, Greensboro, North Charleston, Oklahoma City, San Diego, San Jose, Tuscany, Washington D.C., Anchorage, and London. The Nederlanders also own concert halls in Anaheim, San Jose, and Paso Robles, California.

The 1964 New York World's Fair five-cent stamp postage depicting Unisphere (a spherical stainless steel representation of the Earth).

PURCHASING THE PALACE

In 1965, while New York City was hosting the World's Fair and *Fiddler on the Roof* was adding a new chapter to the ongoing story of the golden years of Broadway, James M. and David T. Nederlander went into negotiations with RKO regarding the Palace, which would culminate with their ownership of this classic theater for about $1.6 million. The land lease, as noted in Chapter 1, was due to expire in 2017. The Nederlander's purchase

of the Palace led to a metamorphosis for the aging movie theater. The grand stage at the Palace, sitting beneath the meticulously detailed 44-foot-long proscenium arch, once home to great entertainers, was now in the dark. Cinematic images of celebrities had replaced live performers; for the Nederlander Organization, this simply would not do. The theater was struggling to turn a profit and needed a fresh look and a boost of adrenaline. This time it would be transformed into a legitimate Broadway theater featuring a wide range of musicals, plus the occasional star in their own solo appearances.

The transition from movie house back to stage productions would require many alterations, so the Palace was given a face lift, not unlike the renovations made during the previous New York City World's Fair in 1939. This time, however, the wear and tear of over fifty years became painfully obvious without the giant movie screen in the way. James M. Nederlander told reporters that the look they wanted was "plush, not plastic."[17]

Nederlander called in the versatile Ralph Alswang to help with the renovation. Alswang's credits included designing scenery, lighting, and costumes for numerous productions. As it happened, Alswang also designed venues and agreed to take the lead role in transforming the Palace. Much of the transition involved taking out what was installed over the original lavish interior design. It was also an opportunity to add

The *Hollywood Reporter* writes about the Palace Theatre becoming a two-a-day picture house with the premier of Eddie Cantor's "The Kid From Spain" in 1932.

Gwen Verdon in the stage production of *Sweet Charity*.

more comfort for the Palace patrons by adding new red cushioned seats to replace the worn older ones. A modernized star dressing room was added in the basement, while most of the thirty-plus original dressing rooms on the premises were also updated. Part of the half-million-dollar Nederlander redesign was the addition of two bars, one in the lobby and the other in the basement. Now sporting 1,732 comfy seats, the Palace returned as one of the five largest theaters on Broadway.

The first production at the new Palace was Neil Simon's *Sweet Charity* with music and lyrics by Cy Colman and Dorothy Fields. The younger Coleman had already worked on five Broadway productions. At the same time, Broadway veteran Dorothy Fields had already accumulated 20 Broadway credits before her first collaboration with Coleman. While *Sweet Charity* was brand new, Simon had already written half a dozen Broadway hits, including *Come Blow Your Horn*, *Little Me* starring Sid Caesar (which, as noted earlier, introduced me to Broadway), *Barefoot in the Park* with Robert Redford and Elizabeth Ashley, and *The Odd Couple* with Walter Matthau and Art Carney. The opening night production of *Sweet Charity* starred Gwen Verdon, who had hit a home run in the mid-fifties as Lola in baseball's premier Broadway musical, *Damn Yankees.*

Some 53 years after Ed Wynn took the stage as the opening night headliner, the new era of the Palace was about to begin. Unlike the Palace opening in 1913, there was no fierce competition from talent bookers, no battles over dressing room supremacy, and no beach on the sidewalk in front of the venue with fans and hopeful performers milling about. The Palace was now a legitimate Broadway theatre and, as such, located in the most acclaimed theater district in the world.

THE PALACE RETURNS AT LAST

On January 18, 1966, the lights went on, the curtain rose, and *Sweet Charity* began the first of 10 previews prior to opening night. The previews went very well, and finally, on Saturday, January 29, the Palace was ready to officially reopen with all the grandeur and fanfare deserving of a palace.

A swarm of reporters and photographers were perched in front of the royal entrance where the beach was once the gathering place of Palace fans and celebrity wannabes. As celebrities approached the theater, a flood of flashbulbs summoned attention to the Palace, where a theatrical coronation was about to begin.

Scene from the stage production of *Sweet Charity*.

Playwright Neil Simon not only wrote *Sweet Charity*, which premiered at the Palace, but a host of other notable plays including *California Suite*, *The Odd Couple*, *Barefoot in the Park*, *I Ought to Be in Pictures*, and *Brighton Beach Memoirs*.

The grand reopening of the Palace was indeed a major event, especially around New York City, where the theater had once reigned supreme as the Valhalla of Broadway. Most of the competitive theaters that grew up near the Palace were long gone in favor of high-rise office buildings, luxury hotels, and movie theaters. Yet, somehow, through the Great Depression, the demise of vaudeville, and fierce competition from movies and television, the Palace had survived.

It was a packed opening night, with a number of celebrities in the house, including Ethel Merman and Milton Berle. Once again, an enthusiastic audience took in the celebrated theater as they had done a quarter of a century earlier for the premiere of *Citizen Kane* in 1941 and several decades before when the Palace opened in 1913.

Some members of the audience were there to see the latest work of what would become a legendary run of hit shows by Neil Simon, others who adored her as Lola in *Damn Yankees* turned out to see Gwen Verdon in her latest featured Broadway role. Some came anticipating the dazzling choreography of Bob Fosse (Verdon's husband). But everyone who showed up in their finest attire on a cold, snowy night wanted to be part of history. As the curtain rose, all eyes were focused on the grand stage, under the enhanced lighting fixtures flanked by the elegant new décor. And just like that, once again, there was life on the Palace stage—yes, actual people performing. It was indeed the start of a new era.

Despite some mixed reviews, crowds packed the house on a nightly basis, and two of the show's songs soon became Broadway standards, "Big Spender" and "If My Friends Could See Me Now." Nederlander had his own appraisal several years later when he told a reporter, "We opened the theater on time with Neil Simon's *Sweet Charity*—it was a hit. I got lucky."[18] Clearly, it was more than luck. *Sweet Charity* ran for 18 months and closed after 608 performances. Bob Fosse received a Tony Award for choreography and staging.

As for the theater, the painstaking months of arduous work to recreate the Palace of old while adding the comforts and conveniences of the modern era received rave reviews. Opening night belonged to the Palace and to New York City, which created and forever embraced Broadway theatre. It belonged to the many who sang, danced, joked, and juggled in the heyday of vaudeville and to those who wrote their own chapters in Palace history, including Orson Welles and Judy Garland.

The first-ever Broadway musical at the Palace was a success, but it would take a few months to get the next show in and ready to go. In the meantime, two weeks after *Sweet Charity* closed, the princess would return to the Palace.

On July 31, 1967, Judy Garland began her third engagement at the Palace and what would be her final engagement. Opening for Judy was funnyman Jackie Vernon, very early in his long and celebrated

"If My Friends Could See Me Now."

—Nederlander

career, along with a tap dancer, Johnny Bubbles, and a fantastic juggler, Francis Brunn. Yes, these acts were a throwback to vaudeville, and the audience was very appreciative.

Then, Judy took the stage for the second half of the bill and, as always, captivated the full house. Vincent Canby of the *New York Times* wrote, "Slim and trim, dressed in a gold slacks suit, she was in total command of the performance from her entrance (through the audience) until that last encore of 'Over the Rainbow.' Most importantly, the shape of Garland's personality—wry and resilient—is intact, whether she is wrestling with a microphone cord that looks like the Loch Ness monster or calming an over-exuberant balcony claque that was behaving like a group of aging Beatles fans."

Both Lorna and Joe Luft, Judy's youngest children at the time, 12 and 14 years old, joined their mom onstage for some poignant family time during the production. The show was a smash hit as the four-week engagement turned into a lengthy run of 27 performances, netting Judy roughly $200,000.

In 1967, ABC Records rushed to release what is billed as the official concert album from the latest Palace engagement, appropriately titled "At Home at the Palace." Suffice it to say no performer was ever more at home at the Palace Theatre than Judy Garland.

Tap dancer Johnny Bubbles opened for Judy Garland at the Palace in 1967.

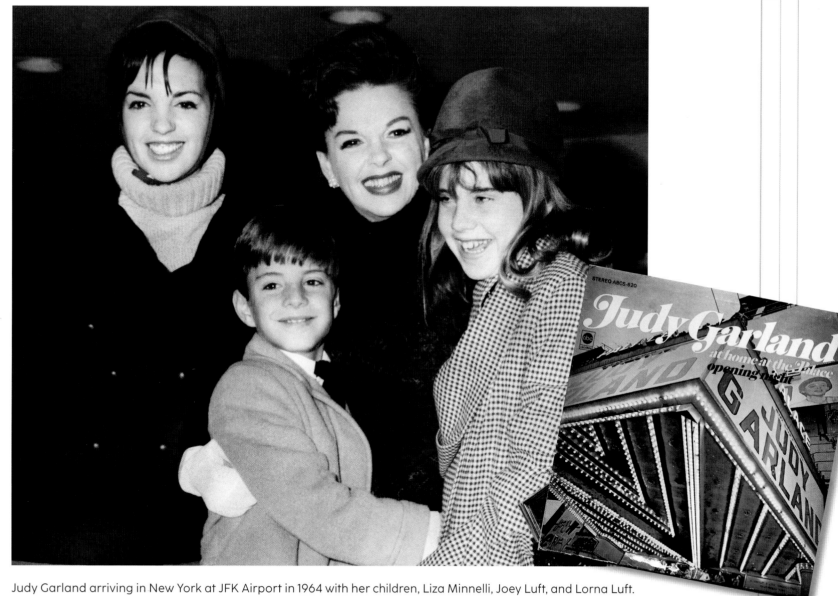

Judy Garland arriving in New York at JFK Airport in 1964 with her children, Liza Minnelli, Joey Luft, and Lorna Luft. Her children would often accompany her to New York, where she played a second residency at the Palace in 1967.

New York City in the late 1960s.

CLOSING OUT THE SIXTIES

The Palace finished 1967 with a musical called *Henry Sweet Henry*, which closed after 80 performances, despite featuring veteran film star Don Ameche and a young Louise Lasser whose career would take off a decade later with the television hit *Mary Hartman, Mary Hartman*. A scathing newspaper review was blamed for the quick demise of the musical comedy. Nonetheless, Michael Bennett was nominated for a Tony Award for his choreography. It was shortly thereafter, in the 1970s, that Bennett

and Joseph Papp would upend all the traditional rules of Broadway Musicals when they brought *A Chorus Line* from the Public Theatre to Broadway.

Then, in 1968, a brand-new show about the legendary George M. Cohan, simply titled *George M!*, opened at the Palace with Joel Grey in the leading role. "It was the hardest show I ever had to do. I played the Palace as George M. Cohan," recalled Grey in a *Spotlight on Broadway* video. "I wasn't a tapper, [but I was] playing one of the greatest tappers in American theatre. We ran for over a year . . . there was not a night when I

didn't go downstairs and practice under the stage my solo right before the show," recounts Gray of the challenging job of playing "The Man Who Owned Broadway" in the early years of the 20th Century.

Along with his penchant for writing classic patriotic songs such as "Yankee Doodle Dandy" and "It's a Grand Old Flag," George M. Cohan rose from vaudeville, where he was one of the Five Cohans, to becoming one of the most prolific producers of musical comedies. In fact, the man who wrote "Give My Regards to Broadway" even has a statue in the Broadway theater district.

The statue of famed producer and musician George M. Cohan watches over the bustling pedestrian plaza in the heart of Times Square. Fittingly, *George M!* played at the Palace, just steps away from where his statue stands.

Having Grey play Cohan seemed almost obvious as a testament to the versatility of both legendary performers, especially if one considers that the actor, singer, dancer, and director Grey already had an impressive Broadway resume, including Neil Simon's *Come Blow Your Horn*, and David Merrick's production of *Stop the World: I Want to Get Off*.

At this point in his career (1966), Grey was also fresh off his unforgettable role as the Master of Ceremonies at Germany's Kit Kat Club in the Harold Prince musical *Cabaret*. Grey was transitioning from a role as a cabaret ring leader in a decadent environment to America's most patriotic producer, George M. Cohan, who also happened to be a prolific songwriter, as well as an incredibly talented singer, dancer, and actor. And yet, Grey nailed it.

George M! also marked the Palace debut of Bernadette Peters in her fourth of what would be 16 Broadway productions spanning over 60 years! Peters was wonderful for five months in the show before she decided to take a gamble, leaving *George M!*, in which she had two songs to take a lead role in the off-Broadway musical *Dames at Sea*, which gave her six songs and provided a greater chance to show off her talent. Peters' gamble paid off as she appeared in Steven Sondheim's *Into the Woods* and took on the lead roles as Annie Oakley in *Annie Get Your Gun*, Rose in *Gypsy*, and Dolly Gallagher Levi in *Hello Dolly!* Peters would go on to win three Tony Awards.

Joel Grey, Bernadette Peters, and unidentified cast members in *George M!*

WELCOME TO THE 1970S

If there was one thing lacking at the Palace during most of its movie theater years, it was the applause. This was the most familiar, uplifting, and encouraging sound echoing throughout the spacious venue day and night during the heyday of vaudeville. Along with receiving payment for their hard work, hearing the applause of a full house was the intangible that made the many rehearsals and nightly performances worthwhile. The applause touched the performers' hearts as a collective "thank you" from everyone in the auditorium.

It was, therefore, both ironic and appropriate that one of the earliest hit musicals to play in the revamped Palace Theatre was *Applause*, which opened in 1970 and played for 896 appearances during a triumphant two-year run. Featuring music by Charles Strouse, lyrics by Lee Adams, and book by the incomparable team of Betty Comden and Adolph Green, *Applause* had all the ingredients for success. The show was based on the 1946 short story "The Wisdom of Eve," which later evolved into the Academy Award-winning best motion picture of 1950, *All About Eve*. It also featured the incredible talents of film star Loren Bacall. Beautiful, alluring, and engaging, Bacall was best known for her film roles in *To Have and Have Not*, *How to Marry a Millionaire*, and *The Big Sleep* with Humphrey Bogart, whom she married in 1945.

A PALATIAL HOME FOR THE TONY AWARDS

In 1971, the Palace Theatre was selected to host the annual Tony Awards. Having the night off from *Applause*, Bacall had the honor of co-hosting the annual Tony Award presentation along with stage and screen performers Angela Lansbury, Anthony Quinn, and popular British actor Sir Anthony Quayle. The theme for the evening's production, airing on ABC television, was to highlight the first 25 years of Tony Awards, which kicked off in 1946, with Swedish actress Ingrid Bergman and legendary American screen and stage actress and activist Helen Hayes among the first winners. The special 25th-anniversary program saluted previous

award-winning shows including *Finian's Rainbow, Kiss Me, Kate, South Pacific, The King and I, Guys and Dolls, The Sound of Music, Hello Dolly!, Fiddler on the Roof, Cabaret* and, of course, *Applause.*

The packed audience also enjoyed watching performances by some of Broadway's best talents, including Carol Channing, Lauren Bacall, Leslie Uggams, Gwen Verdon, and Zero Mostel. As was always the case, the Tony Awards was once again the theater's magical night to celebrate. And in this case, it was extra special because it happened at the Palace.

Lauren Bacall starring in *Applause*.

No stranger to the theatre, Bacall came to *Applause* after a two-year stint in the David Merrill and Abe Burrows hit comedy *Cactus Flower*, in which she played the leading role of the witty, vivacious Stephanie. In *Applause*, Bacall embraced the lead role of the elegant, sophisticated, determined, yet vulnerable Broadway star Margo Channing . . . and she made the role hers.

Several years later, Mark Beckett would write in a 2020 article about Bacall's musical theatre abilities in *Applause*, "Who can resist Bacall, in full diva mode, discovering that she's worshiped in a Greenwich Village gay bar before launching into a dance that involves literally swinging from a chandelier? No wonder she won a Tony Award!" Not only did Bacall walk off with a Tony for her work in *Applause*, but the production garnered the Tony Award for Best Musical of 1970. It should also be noted that actress Bonnie Franklin, known for her role as the mom of two daughters (played by Mackenzie Phillips and Valerie Bertinelli) on the hit sitcom *One Day at a Time*, debuted on Broadway as part of the original cast of *Applause*.

Arlene Dahl and Janice Lynde in the stage production of *Applause* at the Palace.

When Bacall left *Applause* at the end of May 1972, actress Arlene Dahl stepped in as her replacement. Dahl had divided her time primarily between film and television roles while running a successful business, Dahl Enterprises, which sold lingerie, nightgowns, and cosmetics. Upon making her debut on the stage at the Palace at age 47, Dahl quipped, "My dream was always to play the Palace. Like the song goes, unless you played the Palace, you were nowhere."[19]

STRUGGLING THROUGH THE 70S

While the Palace in the 1970s was showcasing Broadway musicals such as *Applause*, *Goodtime Charlie*, and a brief revival of *Man of LaMancha*, the Times Square neighborhood around the theater had descended into a state of total disarray, highlighting the worst of New York City. An infestation of drug dealers, derelicts, prostitutes, illegal Three-Card Monty games, and a host of porn theaters made Times Square, and the Broadway Theater district, a sordid and downright dangerous area, especially after dark. It was an era when muggers were taking in more money than theater box offices.

The 70s brought a wave of crime to Broadway and Times Square.

With crime running rampant, theatergoers were no longer eager to venture out to the latest productions on Broadway or anywhere in the Times Square or 42nd Street area. It wasn't just 42nd Street but many parts of the city that were seriously declining. The financial crisis of the '70s, significantly higher crime rates, and a loss of 8.2 percent of jobs due to companies moving out of New York City (or just shutting down) caused skeptics to predict Armageddon for the Big Apple. And yet, the Palace stood tall, albeit treading water financially.

As for Broadway theatrical productions, there were fewer shows than usual. In fact, there were barely enough shows running to select nominees for categories at the Tony Awards. A lot of what was running was nostalgia, as well as revues. Their music fueled a few big shows. Whether rock, funk, or gospel, musicals such as *Jesus Christ Superstar*, *Godspell*, *Evita*, and *The Wiz* set the tone for the 1970s.

Yet, putting a new show up that would run for any length of time was an ongoing challenge. Of all the productions that opened throughout the '70s, roughly four shows a year ran for more than 500 performances . . . and that was still no guarantee that the show was making money.

The 1970s, however, did introduce the "concept musical." These productions were, as described on John Kenrick's on his website Musicals101.com, in a quote from American author and musical theatre researcher Ethan Mordden, "a presentational, rather than strictly narrative work that employs out-of-story elements to comment upon, and at times take part in, the action . . . there is a solid storyline, but all the major elements of these shows are linked in some way to the central theme."

Jesus Christ Superstar was a hit in the 70s, which lead to many revivals in the decades that followed.

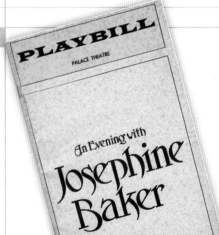

Stemming from the success of *Hair* in 1968, the 1970s would offer several concept musicals such as *Company*, *Pippin*, and, of course, *A Chorus Line*.

Meanwhile, the Palace continued the trend of the 1950s by booking notable stars throughout the decade, including Shirley MacLaine and Diana Ross, to name a few.

A unique booking was that of Josephine Baker, who opened a week-long run at the Palace on New Year's Eve of 1973. Born into poverty in St. Louis in 1906, Baker led a most extraordinary life. By age 15, she had made her way from a street performer to a chorus girl before traveling around the country with a vaudeville troupe. Disenchanted by the steady stream of racism she encountered during her travels, Baker took off for Paris at the age of 19, where she quickly rose to stardom at the famed cabaret and music hall the Folies Bergere.

Singer Josephine Baker in uniform during WWII.

A powerful singer and extraordinary dancer, the exotic Baker was truly beloved all throughout France. Yet when she returned to the United States for the Harlem Renaissance, appearing uptown at the Plantation Club and on Broadway in the revues *Shuffle Along* in 1921 and *The Chocolate Dandies* in 1924, she was not made to feel welcome by audiences, who believed she had "turned her back," on the United States. So, Baker returned to France.

Despite her fading image at home, Baker worked diligently as a spy for the French Resistance during World War II and was later decorated for her wartime efforts. Nonetheless, accused

of being a Communist during the McCarthy Era, she was told she was no longer welcome in the United States.

And yet, by the 1970s, Baker finally won back American audiences with her talent and her activism as an outspoken advocate and participant in the Civil Rights Movement.

At the Palace Theatre, Baker, now in her late 60s, was met with a standing ovation and proceeded to mesmerize the exuberant audience with song and dance while also taking time to chat with and hand out mementos to those seated nearest to the stage. It was a week-long, much-overdue love affair between Baker and her American fans. And it happened at the Palace.

It should also be noted that Josephine Baker was not the only one to play Josephine Baker at the Palace in the 1970s. Diana Ross brought her own magic to the Palace three years earlier with her show, *An Evening with Diana Ross*. At one point in the show, Ross donned a form-fitting body stocking for a fantastic impersonation of Josephine Baker. Ross dazzled the crowds nightly during her 16 sold-out performances at the Palace with a flair for captivating an audience night after night with her voice, style, and charisma.

There was a sense of awe and profound respect for the legendary Ross during her run at the Palace. She had already enjoyed a marvelous career that took her from a waitress job in the Motor City to a steady stream of hit songs and world tours, first with The Supremes and later as a soloist playing everywhere from plush nightclubs to major arenas to the Super Bowl halftime show, and onto the silver screen in films such as *Lady Sings the Blues* and *The Wiz*.

A promotional button from Bette Midler's appearance at the Palace. She is one of many who have performed concerts at the famed venue.

Ellen Burstyn and Charles Grodin in a scene from the Broadway production of the play *Same Time, Next Year*.

As the 1970s continued, with a down economy particularly in New York City, the ongoing challenge for the Palace was once again finding a show "with legs," aka one that would last and post box office success.

From a personal perspective, I probably couldn't have picked a more difficult decade to launch my own career on Broadway. It was during the mid-1970s that I shifted my personal goals from acting to the business end of theatre. I began cutting my teeth as a script reader and shortly thereafter as the assistant manager at the Brooks Atkinson Theatre, which is now the Lena Horne Theatre. One of the first shows I worked on was the Bernard Slade comedy *Same Time, Next Year*, starring Ellen Burstyn and Charles Grodin, which ran for a total of 1,453 performances, finishing up at the Ambassador Theatre. I also worked at the Alvin Theater during the long run of *Annie*. The Alvin later became the Neil Simon Theatre.

I learned early on in my career that the most challenging part of managing or owning a theater was, and still is, maintaining a steady cash flow. In the theater, this meant putting on productions that would steadily draw paying ticket holders. Following the triumphant run of *Applause*, which ended in 1972, the Palace, not unlike its neighboring Broadway theaters, had difficulty filling the seats. Aside from the success of celebrity appearances throughout the year, the Palace tried all sorts of offerings to boost ticket sales. They brought in the Trocadero Dance Company, Toller Cranston's Ice Show, a week-long revue called *From Israel with Love*, and a variety of musicals, each of which had a short run. Even a musical version of *Cyrano*, with book and lyrics by Anthony Burgess, best known for the dystopian film *A Clockwork Orange* and music by Michael J. Lewis, did not last long despite renowned actor

Christopher Plummer (making his tenth Broadway appearance) in the role of Cyrano. Unfortunately, while Plummer received positive reviews from critics and won a Tony Award for his performance, the show did not fare very well, closing after just 49 performances. Along with Plummer's performance, a high note from *Cyrano* was that it featured the Broadway debut of Tovah Feldshuh, who played two small roles. Feldshuh later appeared as defense attorney Danielle Melnick on the television series *Law and Order* and on Broadway in *Yentl*, *Pippin*, *Funny Girl*, and as Golda Meir in *Golda's Balcony*.

Then came *Lorelei*, in 1974, a musical rooted in the 1949 film *Gentlemen Prefer Blondes* (and subtitled *Gentlemen Still Prefer Blondes*). The updated musical comedy version featured lyrics by Betty Comden and Adolph Green and music by Jule Styne. The well-traveled *Lorelei* had successfully toured the county for months before moving into the Palace led by affable, laughable, lovable Broadway star Carol Channing, who was reprising the role of Lorelei Lee in her Palace debut. Channing had played the same character 23 years earlier in *Gentlemen Prefer Blondes* at the Ziegfeld. This was over a decade after Channing introduced the world to Mrs. Dolly Gallagher Levi in what would become her signature role in *Hello Dolly!*

Unlike some of the other '70s musicals that followed *Applause* into the Palace, Lorelei enjoyed a year-long run of 320 performances. It was, however, a big production with a large cast, plenty of costume changes, and major sets. In the end, *Lorelei*

TOP: Actress Carol Channing in a scene from the Broadway musical *Lorelei*.

BOTTOM: Original costuming art from *Lorelei*.

Ann Reinking and Joel Grey in *Goodtime Charley*, 1975.

"kept the house lights on" at the Palace but didn't bring in much when it came to profits.

The second half of the 1970s also brought a variety of musicals to the Palace stage, none of which had remarkable staying power. *Goodtime Charley* brought Joel Grey back to the Palace, this time with singer, dancer, and actress Ann Reinking, fresh from her stint in the Andrews Sisters tribute musical *Over Here!* As it turned out, *Goodtime Charley* served as a stepping stone for Reinking, who then proceeded to sing and dance her way through a string of Broadway blockbusters, dancing her way seamlessly from *Chicago* to *A Chorus Line* to the Bob Fosse, Jules Fisher hit *Dancin.* Years later, she would perform in *Fosse*, paying tribute to the man she was quite familiar with, her ex-husband Bob Fosse.

As for *Goodtime Charley*, despite the talent of the two leads, there were signs from early on that this production might be doomed. The first choice for the lead role was Al Pacino, who had appeared in a dozen Broadway plays but gave no evidence of being a song and dance man – hence the move to Grey, who was trying to manage his schedule between the musical and work in a motion picture. Another issue was that the *Goodtime Charley* was initially clocking in at over three-and-a-half hours long, which might not have been a "goodtime"

for the audience. Shortening the production was among many changes made before the musical finally opened. Three months later, it closed after 104 performances. Nonetheless, while not a big box office show, *Goodtime Charlie* was nominated for seven Tony Awards.

Then, while New York City and much of America were gearing up for the Nation's Bicentennial Anniversary, Shirley MacLaine checked into the Palace for a two-week run in the spring of 1976. Known for her many film roles, including *The Apartment* and *Irma La Douce*, both with Jack Lemmon, *The Children's Hour* with Audrey Hepburn, and *Terms of Endearment* with Jack Nicholson, for which she won an Oscar for Best Actress, MacLaine made such a splash in her Palace debut that she was booked for three more weeks in the summer of '76. Besides the talent of MacLaine, one reason for the show's success was the writing of Fred Ebb and the music and lyrics from Palace alumni Cy Coleman and Dorothy Fields.

Shirley MacLaine, known for iconic roles in movies like *Terms of Endearment*, played a multi-week stint at the Palace in 1976.

Elton John wrote in the liner notes of MacLaine's subsequent album *Live at the Palace* when it was re-released on CD in 2020, "Every facet of her act was superb—singing, comedy, dancing and most of all warmth and complete mastery of her audience. The lady is quite simply a lesson in professionalism for any other performer."

Then, following her 34 dates at the Palace in 1976, MacLaine returned to Broadway in 1984 taking her Vegas show to the Gershwin Theatre.

As for me, I took an apprenticeship as a script reader at the Nederlander Organization in the late 1970s, working with James L. Nederlander, who became my mentor. When he had the opportunity to expand Nederlander's chain of theaters, he decided to sell an interest in the Palace. Times Square real estate was not considered a good investment in the 1970s, but James saw the value, and I believed in his long-term vision. I secured enough financing to buy half of the Palace, and he used those funds to open other theaters in New York City and London.

AND THEN CAME OKLAHOMA!

One of the most difficult tasks of any theater owner is (as noted earlier) finding and booking a production "with legs," as they say in theatre terms. For this reason, there has been a windfall of revivals in recent decades. The benefit of a revival is that you are re-exploring familiar territory rather than trying to experiment with a show never seen or heard on the grand stages of Broadway. In the early years of the twentieth century, new shows came and went in the blink of an eye. At that time, putting on a Broadway production did not resemble what it takes to stage such a production today. The costs and risks have become infinitely higher than ever. Therefore, if you don't have an original show in your sights, preferably with seasoned Broadway veterans creating the book, music, and lyrics, or a choreographer and director the likes of Bob Fosse, Jerome Robbins, or Susan Stroman with a show in the making, you might want to play it safe by presenting a revival of a proven production, with a new cast, perhaps some additional music, or even a slightly different setting. And what better show to

bring back than one that was not only a Broadway smash but packed high school auditoriums and community theaters all over America for decades, a true American classic . . . *Oklahoma!*

Based on Lynn Riggs' 1931 play, *Green Grow the Lilacs*, *Oklahoma!* is set in a dusty town circa 1906 and recounts the story of a farm girl who has two rival suitors trying their best to court her. It's been called the "All-American Musical," an ultimate portrayal of an American story and America's first modern musical.

Oklahoma! proved groundbreaking in 1943, despite the naysayers at the time, allegedly including notable producer Mike Todd, who had brought nearly 20 productions to Broadway between 1937 and 1950. As the story goes, Todd walked out of a pre-Broadway musical production in New Haven, Connecticut, convinced that the show would be dead on arrival. When asked why Todd had such a pessimistic response, he replied, "no legs, no jokes, NO Chance!" Todd, or whoever made the often-quoted comment, was forever proven wrong.[20]

Act 2, Scene 3 of *Oklahoma!*

The original musical went on to break Broadway box-office records. Not only were audiences and critics enthralled by the production, but *Oklahoma!* would forever chart a new direction for the future of musicals.

In 1979, *Oklahoma!* brought the renowned characters and ageless songs back to Broadway for the first time in 26 years, making its Palace debut. Oscar Hammerstein's son William directed this revival of Rodgers and Hammerstein's classic, with Gemze de Lappe recreating Agnes de Mille's choreography. The cast included Christine Andreas as Laurey, Laurence Guittard as Curly, Martin Vidnovic as Jud Fry, and Christine Ebersole, in her fourth of 15 Broadway productions, in the role of Ado Annie Carnes. While most of the 34 opening night cast members were too young to remember the 1943 original (if they were even born yet), they were certainly well-versed on the significance of *Oklahoma!* in Broadway history and how imperative it was to do justice to this earthy masterpiece.

" . . . it is utterly unself-conscious about what it is doing."

The cast and crew succeeded at bringing new life to this timeless classic. Audiences left smiling and even humming a song while garnering praise from critics. William Kerr of the *New York Times* wrote, "*Oklahoma!* remains the gently enchanting sampler it is because, after its hundreds of imitations have come and mostly gone, it is utterly unself-conscious about what it is doing. Rodgers and Hammerstein weren't necessarily determined to change the face of musical comedy forever when they took their curtain up on a woman at a butter-churn listening idly to a strolling cowhand singing a beginning salute to the morning with no musical accompaniment at all."

It was also a box office hit, partly because it played to a new and curious audience, many of whom had played Laurey, Curly, Aunt Eller, or Will in school productions. Others simply wanted to see how this musical version of this simple story transcended expectations rapidly from Lynn Riggs' 1931 play, which lasted for only 64 Broadway performances.

From a financial perspective, (or that of a producer) several cost-cutting benefits helped the production turn a profit. For example, the show had already been successfully touring, meaning there would be no need for setting up an out-of-town run. The cast is also usually slightly smaller than a full Broadway production, and the set for touring is also typically modified and less complicated to build. Also, since touring companies are built to load shows into a theater and move them out quickly, the load-in and load-out were swift and cost-efficient. As a result, expenses were lower, making it easier to recoup if the show had a good run . . . which it most certainly did. The revival of *Oklahoma!* spent nine months pleasing long-time fans while introducing newcomers to America's most significant musical. The show ran from December 13, 1979, through August 24, 1980, closing after 293 performances before returning to the road shortly thereafter.

As for the Palace, it had survived the economic struggle of the 1970s and was ready for a new decade and a brighter future. As New Yorkers and theatre lovers, we all were.

Original promotional still image for the original 1943 Broadway stage production of *Oklahoma!* at the Palace Theatre.

A view of Broadway looking south
from Times Square in 1980.

CHAPTER 5

SMASH HIT MUSICALS, DISNEY, AND LIZA

As is always the case, New Yorkers stuck together throughout the turbulent '70s, withstanding budget cuts, layoffs, power outages, gas shortages, increased crime, box office woes on Broadway, and even disco. While those of little faith left the great city, others stayed, trusting that the Big Apple would ripen and shine again.

Then, after years of asking for help from Washington, President Ford reluctantly signed legislation granting New York City federal loans. This happened, according to a *New York Daily News* headline, came after he had allegedly told the city to "drop dead" in a speech at the National Press Club on October 29, 1975. The loans enabled the city to avoid bankruptcy and started a much-needed change in the fiscal direction of the city.

As 1980 began, Broadway was also showing new energy and enthusiasm. In fact, the 1980-81 season set new highs with 11.42 million people attending Broadway shows according to the Broadway League, setting an attendance record which stood until the 1997-98 season.[21] Part of the reason for this surge was that for the first time in quite a while three strong American musicals, *Woman of the Year*, *Sophisticated Ladies* (featuring the music of Duke Ellington) and David Merrick's *42nd Street* all opened on Broadway, making theatre once again exciting and relevant.

As for the Palace, the theater was certainly getting more than its fair share of visitors, many from other parts of the country and various parts of the world, who not only wanted to take in

Sophisticated Ladies, one of three strong shows debuting in the 1980-81 season, helped usher in an era of renewed life on the Great White Way.

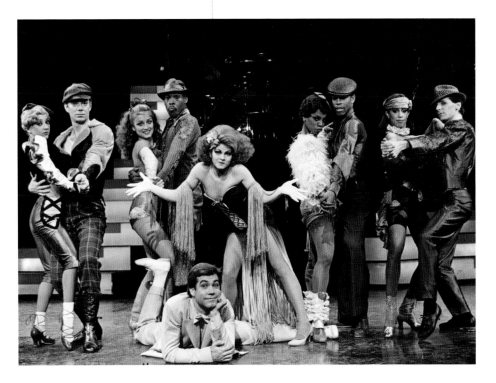

a Broadway show but wanted to take in a larger-than-life musical production while soaking up the ambiance of the renowned Palace Theatre.

Shortly after the Palace bid farewell to a classic (*Oklahoma!*), it would soon welcome back a classy celebrity in a first-run Broadway production. The classy celebrity was Lauren Bacall, and the show was *Woman of the Year.* Bacall loved playing the Palace in *Applause*, and the Palace, the critics, and the audiences loved her. It was a match made in heaven—or on Broadway and 47th Street in this case.

Woman of the Year first appeared on the big screen in 1942 as a film by Ring Lardner, Jr. and Michael Kanin featuring Katharine Hepburn as progressive political newspaper journalist Tess Harding at a time when there were few notable female journalists. Considered the Barbara Walters of her time, Harding meets Sam Craig, a well-known sportswriter, played by Spencer Tracy, who works at the same newspaper. The couple falls in love and gets married, claiming the idea of an "odd" couple, years before the Neil Simon comedy lay claim to the title.

In the cinematic version, she was ballroom, and he was ballpark, which made for a universally appealing marital comedy. While much had changed regarding the acceptance of women in the workplace and men's increasing domestic responsibilities over the forty years between the making of the film and the opening of the Broadway musical adaptation, there was still enough marital sparring between a contemporary career woman and an old-school traditionalist to adapt the film into a plausible, entertaining musical comedy for Broadway. For the musical, Tess Harding (Lauren Bacall) was now a nationally acclaimed TV news reporter while Sam Craig, played by Harry Guardino (best known for his character in *Dirty Harry*),

Stewart F. Lane and Lauren Bacall, who graced the Palace stage in both *Applause* and *Woman of the Year*.

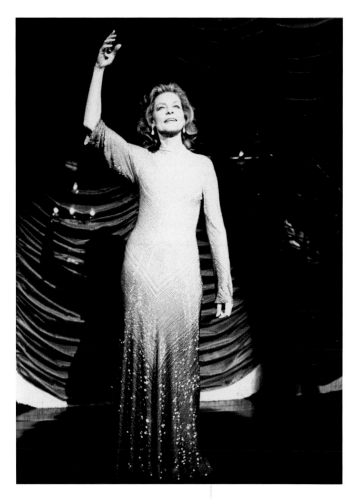

Lauren Bacall in a scene from the Broadway production of the musical *Woman Of The Year.*

was a notable syndicated newspaper cartoonist. The results were just as universally appealing as they were in the original film. It helped, of course, to have a creative team featuring the talents of Peter Stone, who wrote the book and incorporated the music by John Kander, and the lyrics of Fred Ebb.

Opening on March 29, 1981, *Woman of the Year* ran for 770 performances and kick-started a string of long-running hits at the Palace. Frank Rich of the *New York Times* wrote of Bacall, "This star's elegance is no charade, no mere matter of beautiful looks and gorgeous gowns. Her class begins where real class must—in her spirit. Even when her leading man, Harry Guardino, dumps a pot of water over her head, she remains not only mesmerizing, but also completely fresh."

While in my early years as a theater owner, it was a pleasure working with Lauren Bacall, who embodied grace and professionalism. When she left the show, everyone associated with the production agreed that the role of Tess Harding would not be easy to re-cast, as Bacall's shoes would be hard to fill. After considering several options, the role went to Raquel Welch, who had stepped in quite admirably for Bacall when she took a much-needed two-week vacation. Having never played Broadway before, Welch was exhilarated by her brief Broadway stint and eager to prove her acting chops finally. And she did just that. Welch was not better than Bacall, nor was she trying to be; she was a brand-new version of

Tess Harding, a sexier yet strong-willed Barbara Walters-esque character. She was also the consummate professional, never missing a performance and always giving it 100 percent. Not only did she prove to any naysayers that she could hold her own in a leading role on the Broadway stage, two years later, Welch would take on the lead role in *Victor/Victoria*.

When Welch left the show, once again, the shoes of the latest Tess Harding would be hard to fill. And once again, we hit the jackpot, casting another rendition of Tess Harding. The third of the trio of multi-talented women of the year was less statuesque than Welch but nonetheless a multi-talented actress with a wealth of experience and her own legion of fans. The third was none other than Debbie Reynolds, who delighted audiences with her own inimitable personality. While Bacall brought a worldly, somewhat imposing version of Tess Harding, and Welch was provocative, Debbie Reynolds was down-to-earth, witty, and comical in her own distinctive manner. It didn't hurt that all three could sing and dance until dawn, or at least until the final curtain.

"Her class begins where real class must— in her spirit."

It was a rarity to find three notable, talented performers who stepped into the same role, and each successfully made it their own. I recall people telling us that they had seen the show several times simply to see the variations of the Tess Harding character, and they were hard-pressed to decide which was the best Tess.

Lauren Bacall won her second Tony Award as the first Tess Harding on Broadway. Kander and Ebb, Peter Stone, and Marilyn Cooper would also walk off with Tony Awards. While praising the music, lyrics, and Bacall, the team at Musicals101.com wrote, "the most memorable thing in this sophisticated musical comedy was Marilyn Cooper, whose mousy housewife character stole the comic duet 'The Grass is Always Greener' from the glamorous Bacall." Cooper appeared in 19 Broadway productions, including *West Side Story*, *Mame*, *Broadway Bound*, and *Grease*.

STANDING TALL WHILE OTHERS FALL

While the Palace enjoyed box office success in 1982, three Broadway theaters and two Off-Broadway theaters were slated for demolition, some of which were on the land slated for the construction of the brand-new Marriott Marquis hotel at the corner of Broadway and 46th Street in the heart of the theater district and a stone's throw from the Palace. Few theaters were demolished in the 1970s as the financial crisis made it difficult to afford such demolition and even more difficult to afford the construction costs of new office buildings or hotels.[22]

The ill-fated theaters on execution row in early '82 were the Morosco, Helen Hayes, Bijou, Victoria, and Astor. As word spread of their impending demise, protests began in front of the doomed theaters as well as in front of Radio City Music Hall and throughout the Times Square area. Organizations such as the Actors' Equity Association, the National Endowment of the Arts, and the New York City Landmark and Preservation Commission all joined the outcry against the destruction of these time-honored Broadway venues. Celebrities including Alan Alda, Woody Allen,

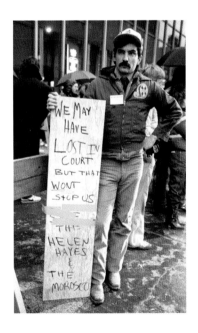

An unidentified man holding a sign that reads, "WE MAY HAVE LOST IN COURT BUT THAT WON'T STOP US/ SAVE THE HELEN HAYES AND THE MOROSCO" during an unsuccessful protest over the demolition of two Broadway theaters.

Carol Burnett, Colleen Dewhurst, Susan Sarandon, Richard Gere, Paul Newman, Joseph Papp, Christopher Reeves, and Joanne Woodward were among those who took to the streets of New York to protest, along with theatre enthusiasts, patrons of the arts and New Yorkers who were simply troubled by the concept of tearing down historic theaters for yet another high-rise hotel.

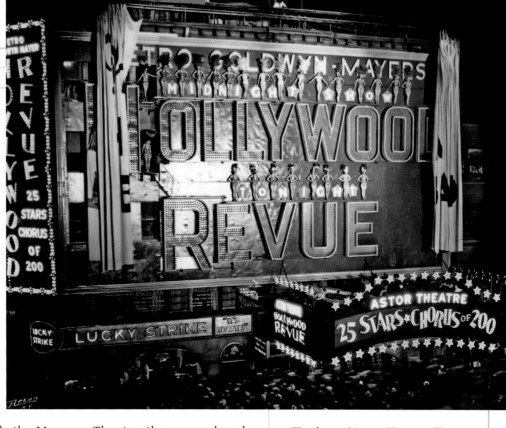

The famed Astor Theatre, like the Palace, was home to both live entertainment and movies. Along with the Morosco, Bijou, Helen Hayes, and Victoria theaters, the Astor was razed to make way for the Marriott Marquis hotel.

On a cool afternoon in March of 1982, as the wrecking crews arrived outside the Morosco Theatre, the scene played out as if it was right out of a motion picture or, in this case, a scene from the stage inside one of these doomed theaters. Demolition crews and theater's most faithful forces stood face to face in a standoff, which would inevitably lead to the final act for what would later be dubbed as the Fallen Five. Police were summoned to disperse the crowd. The local evening news reports showed footage of police handcuffing and moving celebrities off the premises and into police custody. Yet, while word of the fate of the theaters was spreading across the media (more slowly in a pre-internet age), the wrecking ball hit the side of the Morosco. After the first strike of the wrecking ball, esteemed producer, director, advocate, and the dearest friend of theatre New York has ever had, Joseph Papp, told reporters, "I felt like I was being hit . . . I started to cry."[23]

The five fallen theaters were demolished quickly, and in their place stood the massive new Marriott Marquis. Tucked away inside the hotel was the sleek new 1,600+ Marriott Marquis Theatre. But one new Broadway theater did not make up for the loss of five others. The silver lining to the story was that the plight of the fallen five and the outcry from those in the industry who opposed the demolition of these beacons of Broadway provided a new-founded motivation for the New York Landmarks Preservation Commission (LPC) to make a greater effort to prevent such future demolition by bestowing landmark status on many of the older Broadway theaters, including the Palace.

In the meantime, a musical comedy about drag queens at a Parisian nightclub would become the longest-running Broadway musical ever to play the Palace. Opening in 1983, *La Cage aux Folles* was adapted from the highly popular 1973 French Farce called *The Cage of the Madwomen*, which was transformed into a musical comedy by a marvelous production team led by producer Alan Carr along with director Arthur Laurents and yours truly. The show featured music and lyrics by Jerry Herman and a book by Harvey Fierstein, who discussed his initial involvement in the show in a "Spotlight on Broadway '' video segment. "It was a whirlwind," recalled Fierstein in his distinctive raspy voice. Fierstein had received a phone call from Alan Carr inviting the young writer and star of *Torch Song Trilogy* to his apartment for a meeting. "I came from Brooklyn, and I was not a wealthy kid . . . I remember walking into Alan Carr's apartment—the penthouse of the San Moritz hotel, and he handed me four dozen roses and a check for $10,000 and asked: Would you write this?"

Les Cagelles in *La Cage aux Folles*.

Actors Gene Barry and George Hearn (in drag) in a scene from the Broadway production of the musical *La Cage aux Folles* at the Palace.

With Alan Carr's blessing, Fierstein transformed the marvelous film comedy into the long-overdue first Broadway musical to break through the many barriers and present an openly gay relationship on stage. George Hearn took on the original role of Albin, while Gene Barry introduced the role of Georges to Broadway. At the start of *La Cage aux Folles*, Hearns, a Broadway veteran, had already appeared in a wide range of productions from *1776* to *Hamlet* to *Sweeney Todd*. He would later appear in a number of musicals after *La Cage aux Folles*, including *Sunset Boulevard* and *Wicked.* Barry, meanwhile, had built an esteemed career in more than 50 films and television shows and was well known for his role as the title character in the TV series "Bat Masterson." He had appeared in eight previous Broadway shows but rarely had time to unpack his suitcases before each show closed abruptly. The lengthy run of *La Cage aux Folles* significantly changed Gene Barry's Broadway standing forever.

The show was a box-office smash, winning six Tony Awards for Best Musical, Best Book of a Musical (Harvey Fierstein), Best Original Score (Jerry Herman), Best Actor in a Musical (George Hearn), Best Director of a Musical (Arthur Laurents), and Best Costume Design (Theoni V. Aldredge).

After having endeared itself to audiences worldwide through ongoing touring companies in both the United States and Great Britain, *La Cage aux Folles* returned to Broadway for two revivals, one in 2004 and one in 2010. Although it was no longer the ground-breaking trend-setter it was in 1983, the musical still maintained the

uproariously funny predicament in which a gay couple must try being something they are not. The show continues to make a significant statement regarding acceptance in a world that still demands such ongoing reminders.

Lawrence Bommer, in an article from *Stage and Cinema* magazine, celebrating the 30th anniversary of *La Cage aux Folles*, wrote: "Gay activists who deride this delight forget just how radical the musical was in 1983 . . . for all its sex-smashing glitz and farcical laughs, Harvey Fierstein and Jerry Herman's flagrant, Tony-winning *La Cage aux Folles* pushes today's hot buttons: gay marriage, gay parenting, sexual freedom, and the family's ever-evolving makeup."

LANDMARKING AND RENOVATION

When *La Cage aux Folles* closed in 1987, it would be four years before another major musical would move into the Palace. During that time, significant changes took place. Just five years after the wrecking ball demolished the fallen five theaters, despite protests by theatre enthusiasts and Broadway celebrities, the New York City Landmark and Preservation Commission (LPC), determined not to make the same mistake twice, stepped up and declared landmark status for 28 Broadway theaters including the Palace.

The goal of the LPC was, and still remains, to safeguard buildings and other locations that represent the city's social, economic, political, and architectural history. Essentially, it's a way to protect the city's cherished past from being obliterated

A glimpse of Times Square, circa 1987.

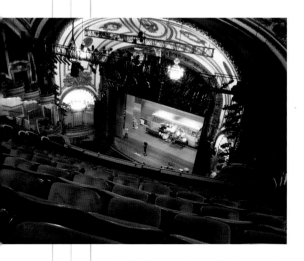

A bird's-eye view of rehearsal for *Priscilla Queen of the Desert* from the upper balcony of the old Palace interior.

by progress. Nonetheless, in this case, progress also means meeting the needs of theatergoers by providing a safe, comfortable, contemporary atmosphere while running a profitable business.

While the LPC was well aware that owners wanted to make changes to improve and modernize their facilities, they were somewhat surprised when the three biggest theater owners in the city, the Shubert Organization, the Nederlander Organization, and Jujamcyn Theaters, with a combined ownership of 22 of the 28 designated theaters, joined together in a lawsuit against the city in an effort to have the land-marked designations overturned. They wanted to be able to do more with the theaters through expansion, remodeling, and modernization.

Many theater owners were concerned at the time over the limits that might be set on the need for upgrades and changes to their properties. Owners explained that by restricting the theaters from further development, they could not maximize the value of their theaters. In the end the LPC prevailed and as a result, the theaters received various rulings on whether the landmark status protected the interior, exterior, or both and what renovations would be allowed. When the New York City Board of Estimate ratified the landmark designation in March 1988, only the Palace interior received landmark status.

The ruling would prove to be of great significance to the Palace, as the theater's interior would be protected in upcoming renovations. As it was, plans for the future of the Palace were already underway, as New York real estate developer Larry Silverman had proposed a huge hotel project that he wanted to build on the site where the Palace had stood for over 70 years. The LPC distinction opened the door for Silverman to

build around the actual interior of the theater, hence saving the Palace from becoming another casualty of the city's rejuvenation. Several external changes were made, but somehow, despite the construction of the 43-story Embassy Suites Hotel (which later became a DoubleTree Suites), the interior of the Palace remained intact.

The brand-new luxury hotel sat above and around the Palace Theatre's auditorium. It was supported by steel and concrete columns that safely surrounded the long-time showplace below.

While not included in the LPC-protected areas, the theater lobby remained largely intact on the ground floor of the new structure, along with the entrance to the hotel and some brand-new retail shops. And while the theater interior could not be touched, restrooms, an air-conditioning system and expanded backstage space were all added.

As the construction continued into 1990, those overseeing the project were getting closer to determining a completion date. This was significant when it came to booking the first new production in the revamped theater. It would allow us time to bring in a show that would justify the long wait between productions and bring in some new revenue. We needed something uplifting and very entertaining.

What better way to re-open the Palace than to have an original musical based on the life of rodeo, vaudeville, radio, and film star Will Rogers? Known as "Oklahoma's Favorite Son," Rogers generated a large following for his own brand of homespun, colloquial humor, and satirical views of the world around him. Bringing the lighthearted charm of Rogers to the Broadway stage, complete with original music and choreography, would once again be the challenge of a host of talented Broadway veterans. Once again, Peter Stone was brought in to write the book, Cy Coleman to

write the music, and the team of Betty Comden and Adolph Green to pen the lyrics. And then there was Tommy Tune, who enthusiastically took on the dual roles of director and choreographer.

Since Will Rogers was a regular in Ziegfeld's ongoing *Midnight Frolic*, which lit up the night at the Roof Garden high atop the New Amsterdam Theatre, Tune wanted to work the enthusiasm and high energy of a dazzling Ziegfeld show into the production . . . and he did. "For me, *The Will Rogers Follies* belonged in the Palace Theatre because Rogers was a Ziegfeld star, and the Palace Theatre looks like a venue in which Ziegfeld would put on his famous follies. If you put the right show in the wrong theater, you will hurt it. I got the Palace, and it really made the show," explained Tune regarding *The Will Rogers Follies* playing the Palace in an episode of the "Spotlight on Broadway" series.

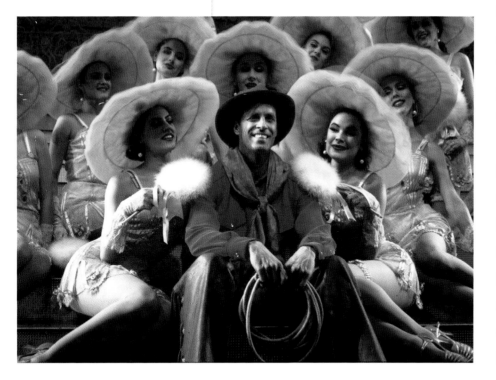

Actor Keith Carradine and cast in a scene from the Broadway musical *The Will Rogers Follies*.

Despite rumors of John Denver playing Rogers, the show opened with actor and cowboy Keith Carradine in the leading role. Already known for his many film and TV credits, including the 1975 hit movie *Nashville*, *The Dualists*, *Pretty Baby*, and later, *Deadwood*, Carradine stepped up in his first leading role on Broadway. He had just two previous

Broadway credits, *Hair* and a lesser-known production called *Foxfire*, a play in which he performed with esteemed actress Jessica Tandy, known for her Academy-Award-winning performance in the 1989 film *Driving Miss Daisy* and Tandy's husband, film and stage actor Hume Cronyn.

The Will Rogers Follies was well received by the critics and by an audience that was unfamiliar with much of Rogers' work or even his notable quips. Yet Carradine and a strong cast, including Dee Hoty as Rogers' wife Betty, introduced the easy-going gentleman that was Will Rogers amid a dazzling production complete with song, dance, and sparkling western themed showgirl costumes that took the audience back to the heyday of the *Ziegfeld Follies*, which was just what Tune was seeking. The musical ran for 981 performances over a span of two and a half years. Upon leaving the Palace, *The Will Rogers Follies* launched a tour with many Broadway cast members staying onboard. As anticipated, the Tony Awards became Will Rogers' big night. On March 12, 1992, the show won in six of the 11 categories in which it was nominated, including a double win for Tune, for directing and choreography, as well as awards for Best Musical, Best Original Score (Coleman, Comden, and Green), Best Costumes (Willa Kim), and Best Lighting Design (Jules Fisher).

Actors Dee Hoty and Keith Carradine in a scene from *The Will Rogers Follies*.

BEAUTY AND THE BEAST PLAYS A REAL PALACE

The next musical to play the Palace was unique in so many ways. First, the Palace would have the distinct honor of hosting the first-ever full-length Broadway musical from the folks at Disney, *Beauty and the Beast.* After decades of Broadway productions written, designed, and performed with an adult audience in mind, *Beauty and the Beast* would upend the typical Broadway demographics by presenting a family-friendly musical created with kids in mind. Adapted from Disney's 1991 animated blockbuster film of the same name, *Beauty and the Beast* would bring the characters to life on stage thanks to Linda Woolverton, who had also penned the screenplay. Alan Menken wrote the music for the movie, with lyrics from Howard Ashman. Menken later wrote additional songs specifically for the musical with Tim Rice, following the death of Ashman.

Beauty and the Beast was an ideal fit for the Palace. The large stage, the many dressing rooms and the large seating capacity of the theater were all factored into the decision to bring Disney's first foray to Broadway into the landmark setting. The closest Disney had come to a Broadway musical was a full production of *Sleeping Beauty* at Radio City Music Hall on Sixth Avenue in 1979. While it was close, it wasn't quite Broadway.

As for *Beauty and the Beast* playing the Palace, I was totally on board with the concept. I had worked with Alan Menken before, and I loved the music. I also believed that the opening sequence was just like a Broadway show. Critics and the brass at Disney agreed that this show with a basic storyline, *one as old as time*, would be the

LEFT: The new memorabilia display case graces the newly restored Palace, featuring treasures from the storied theater's history.

Beauty and the Beast at the Lunt-Fontanne Theatre.

ideal opportunity to transition Disney into fresh territory. The movie had already scaled new heights, becoming the first-ever animated film to receive an Oscar nomination for Best Picture, while winning Best Original Score and Best Original Song, "Beauty and the Beast."

I also loved the fact that the production introduced all the main characters and established where they were, who they were, and what the situation was, right from the beginning. It had a brilliant structure for a musical and came with a built-in audience who grew up watching the film repeatedly.

Beauty and the Beast opened on April 18, 1994, bringing a magical Disney production that takes place in a palace, to a real palace. Meanwhile, the critics, who were unfamiliar with "family" fare on Broadway, were baffled. But for those of us at the Palace, the clamor for tickets and ongoing excitement in the air gave us all a rather good idea of what was to come—another huge Disney success, only this time with live performers on a Broadway stage.

The musical was so successful that Disney moved quickly to secure a lease with the New Amsterdam Theatre, which they would refurbish for *The Lion King*, which opened in 1997. *Beauty and the Beast* played the Palace for nearly six years before moving to the Lunt-Fontanne because Disney knew it would be less expensive. Disney brought in a whole culture of being in the service business and totally changed the environment of the theater district, making it more family friendly than ever before.

Casting Belle

Beauty and the Beast came to life thanks to the creative teams that had worked on the film while also carefully selecting new talent to help bring the animated favorites to life. As for casting, some 500 young women auditioned for the role of Belle, many of whom tried to emulate the voice and style of the character in the movie. However, it was one of the few who tried to embrace the idea of a human version of Belle who won the coveted position as the first of what would be 17 Belles over the 13-year run of the musical. The selection for the role of Belle was 22-year-old actress Susan Eagan, who hailed from California and debuted on Broadway in the coveted role. Eagan's closest brush with Broadway had been being cast by Tommy Tune in the role of Kim for his touring production of *Bye Bye Birdie*. Tune's selections for any production carried some weight, but Eagan had what it took to embrace Belle's enchanting, compassionate, and curious character.

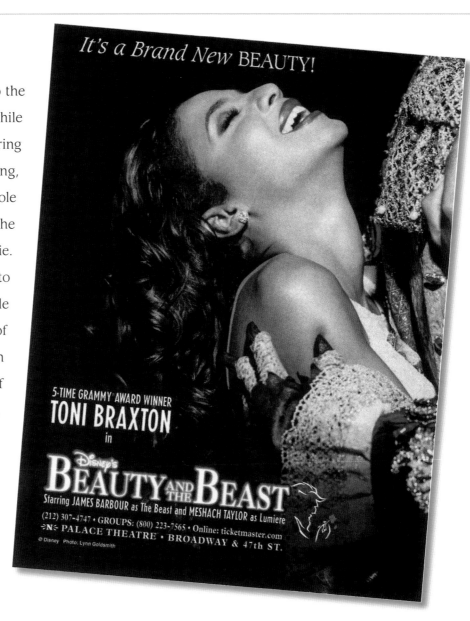

1998 poster for Disney's *Beauty and the Beast* at the Palace Theatre showing Toni Braxton as Belle.

Terrence Mann at rehearsal for *Beauty and the Beast* in 1994.

A newcomer in the role of Belle would necessitate "a beast" more familiar to Broadway theatergoers. This highly sought-after role went to the multi-talented Terrance Mann. In his 14 years on Broadway, Mann had already demonstrated his adaptable acting abilities in *Barnum*, *Cats*, *Rags*, *Les Miserables*, and *Jerome Robbins' Broadway*. Ironically, one of the most familiar members of the cast was Tom Bosley, who played Belle's father Maurice. Bosley was best known as Howard Cunningham (Richie Cunningham's father) in the long-running television sitcom *Happy Days*. He also had the honor of playing the former mayor of New York City in *Fiorello!* for which he won a Tony Award,

When *Beauty and the Beast* closed, it was (as of the writing of this book) the tenth longest-running Broadway production in history. Touring the globe afterward, the musical has grossed more than $1.7 billion while visiting 13 countries and playing in 115 cities.

The success of *Beauty and the Beast* not only opened the door for a host of Disney musicals, but it also gave Disney a stronger presence in New York City. To further win the hearts of New Yorkers, Disney took on a significant role in revitalizing a decaying 42nd Street area and transforming it back into the notable, bustling, crosstown artery it once was. They changed the face of 42nd Street with renovated theaters, theme restaurants, modern office facilities, and a Disney Store. Knowing that *Beauty and the Beast* was just the first of Disney's vault full of animated feature films, Disney wanted to change the Times Square environment, and they spent millions of dollars doing just that. They also generated hundreds of millions of corporate and entertainment dollars for the surrounding Times Square businesses.

The success of *Beauty and the Beast* paved the way for a steady flow of Disney Broadway productions. It also set the stage for other producers to bring family-oriented productions to Broadway stages, such as non-Disney hits such as *Harry Potter and the Cursed Child*, *Wicked*, and *SpongeBob SquarePants*, which landed at the Palace.

MINNELLI ON MINNELLI: LIZA PLAYS THE PALACE

People often ask me: how does a show get to Broadway? Many routes come to mind, including adapting a book or film, attending readings of new material, checking out Off-Broadway, and even Off-Off-Broadway productions or visiting venues around the country (or around the world), where something new and intriguing is taking place. Rarely, however, does someone invite you to their home to see and hear the entire musical performed live. Yet, that was the invitation I received from Liza Minnelli. It was Fred Ebb of the fabulous songwriting team of Kander and Ebb who suggested to Liza that if she wanted to play the Palace, she should invite me over to discuss a possible show and see a preview.

Liza wanted ever so much to play the Palace. While I must admit I was initially on the fence about it, I was honored to

A FAMILY AFFAIR

You might call *Minnelli on Minnelli* a family affair. The show was based on music from the movies of Liza's father, director Vincent Minnelli, and was playing on the stage her mother Judy Garland called home. Her godfather, Ira Gershwin, wrote the lyrics later heard at the Palace in the musical *An American in Paris*, and her second husband, Jack Haley Jr., prepared a film sequence used in *Minnelli on Minnelli*. Meanwhile, Haley's father (aka Liza's father-in-law), Jack Haley Sr., performed at the Palace back in the vaudeville days and traveled down the yellow brick road as the Tin Man along with Liza's mom, Judy, in *The Wizard of Oz*.

Liza Minnelli and Fred Ebb on stage at the final performance of *Minnelli on Minnelli* at the Palace Theatre on January 2, 2000.

be invited to her apartment to discuss the show and perhaps hear a few of the songs she would include in her Palace performance. So, I met her at her beautiful Upper East Side apartment in Manhattan, where her manager and another business associate joined us. Moments later Liza appeared, welcomed us, thanked me specifically for coming and proceeded to do the entire show for an audience of three. She was fabulous. Any doubts I had were quickly forgotten during this special matinee performance of *Minnelli on Minnelli* at Minnelli's.

Minnelli on Minnelli officially opened at the Palace on December 8, 1999. Charles Isherwood reminded readers in his *Variety* review that Minnelli's month-long stand at Broadway's Palace Theatre was "not a routine return to the concert stage," noting that "at one point in the evening, and in a scripted bit of interplay

that nevertheless has the ring of truth, [she] admits, 'I'm making a comeback!'"

Isherwood also dipped ever so slightly into the family tree, by referring to her mother's legendary comebacks several decades earlier when Judy Garland triumphantly followed up her magical Palace debut in 1951 and then returned in 1956 and 1967. If there are ghosts somewhere in the Palace Theatre, you can bet that some of the Minnelli family from years gone by was on hand to see Liza . . . and once again, she made them proud.

Minnelli on Minnelli was not just a big hit but a fantastic way to end a successful decade for the Palace Theatre. From the charm of Will Rogers to the magic of Disney to the showmanship of Minnelli, those of us watching the box office and the audiences taking in the performances were all riding high as Liza ushered in the new millennium.

From the dazzling variety of vaudeville to the struggles of the great recession, through two World Wars, and some tumultuous times for the city of New York, the Palace remained the classic showplace Martin Beck had dreamt about way back at the start of the twentieth century.

The old exterior of the Palace facing Times Square with the DoubleTree Suites sign and entrance below the marquee.

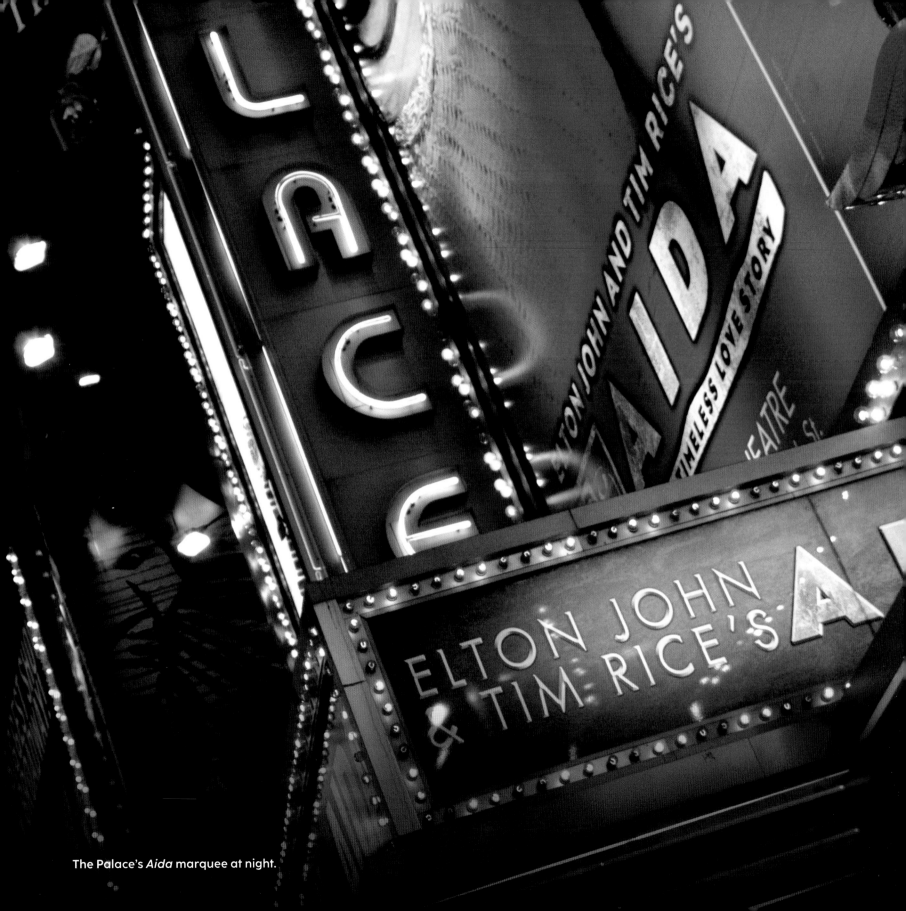

The Palace's *Aida* marquee at night.

FROM DISNEY TO SPONGEBOB

n March of 2000, the Palace introduced another Disney show to Broadway. The show was *Aida,* featuring music by Elton John, lyrics by Tim Rice, and book by Linda Woolverton who had not only written the book for *Beauty and the Beast* but had also provided source material for *The Lion King.* Unlike most Disney productions, the subject matter came from an outside source rather than the Disney vault. The story, set in ancient Egypt, is one of love and betrayal centered around the captive Princess Aida, who first appeared on stage in Verdi's 1871 opera.

PLAYBILL

PALACE THEATRE

AIDA

WWW.PLAYBILL.COM

David Beckham and his then-fiancee Victoria Adams of Spice Girls fame, Sir Elton John, Lulu, and Heather Headley at the launch of the *Aida* project, a Disney stage musical by Elton John and Tim Rice, at the Whitfield Recording Studios, London.

Aida became a major box office hit running for 1,852 performances spanning over four and a half years. Much of the acclaim and success was a result of the Elton John-Tim Rice collaboration, which won the Tony Award for Best Original Musical Score. Also factoring high on the list of praiseworthy commentary about *Aida*, the musical, were the multi-talented performers in the title role, which included Heather Headley, who won the Tony Award for Best Actress in a Musical for her role as Nala in *The Lion King*, Toni Braxton, who had already made her Palace debut in *Beauty and the Beast* and Deborah Cox, who would later enjoy a leading role in the Broadway

production of *Jekyll & Hyde*. Long-time Broadway designer Bob Crowley also won Tony Awards for both scenic design and costumes. Crowley worked on nearly 30 Broadway productions, including Disney's *Tarzan*, *Mary Poppins*, and *Aladdin*.

Unlike many of Disney's Broadway success stories, *Aida* also did not come with a built-in audience of young attendees. The movie version came out in the early 1950s and starred iconic Italian actress Sophia Loren, about whom most of the young Disney audiences would have simply asked "Who's she?" The musical about a prisoner who is a princess did not fall into place through the magic of Disney alone, but through a lengthy process of carefully recreating the fabled tale from the tragedy of an opera to a more Disney-esque story that would be more suitable for a younger audience. In his review for *Variety*, Charles Isherwood called the up-tempo production "a pretty pop fantasy." In this case the audience was made up of teens who returned often to enjoy the music and hard work of a young cast in what became a winning, vibrant musical.

Bob Crowley in the press room for The 66th Annual Tony Awards, 2012. Crowley was one of many *Aida* contributors to home a statuette. In fact, he took home two—for both scenic design and costumes.

FROM ELTON TO ELVIS

In 2005, Elvis debuted at the Palace . . . sort of. You might say better "late" than never. It was the songs made famous by Elvis in the jukebox musical *All Shook Up* that had the Palace rocking. Jukebox musicals rose to prominence with *Mamma Mia* in 2001, which utilized the music of the world-renowned Swedish pop group ABBA as a backdrop to an original musical comedy with various twists and turns. For those unfamiliar with the term, jukebox musicals are unique in that they feature popular musical selections made famous typically by a single artist or group. Often the story is fictional, but in some cases musicals like *Jersey Boys* or *Beautiful*, feature the

actual background of the artists, in this case Frankie Valli and the Four Seasons and Carole King, respectively.

All Shook Up, with a book by Joe DiPietro (who later wrote the music and lyrics for the show *Memphis*) was not unlike the storyline of *Bye Bye Birdie*, which presented a fictional account of the frenzy created by the arrival of a new pop idol. In this case, DiPietro's storyline of young lovers was also influenced by Shakespeare. Hence you had the distinctive pairing of the music of the King and a storyline by the Bard. As Kenneth Jones wrote in *Variety*, "The musical's characters and plot twists conjure the sparring lovers and surprise couplings of Shakespeare's *Much ado About Nothing*, *Twelfth Night*, *As You Like It*, and *A Midsummer Night's Dream*. Jones also wrote, "If music is the food of love, as Shakespeare said, then the characters of *All Shook Up* are lining up for a lavish buffet."

While *All Shook Up* did not boast any current well-known stars, the opening night cast presented a wealth of talented performers, each of whom had credits in significant Broadway productions, including *Hairspray*, *Guys and Dolls*, *Spamalot*, *Fosse*, *Oklahoma!*, *Phantom of the Opera*, *Me and My Girl*, *Chicago*, *Mama Mia!*, *The Producers*, *Miss Saigon*, *Footloose*, and *Rent*, to name a few. For six months, *All Shook Up* shook the Palace for over 200 performances that left audiences singing the timeless hits of Elvis Presley as they left the theater.

MIRROR-IMAGE ELVIS PRODUCTIONS ON BOTH COASTS

In the summer of 2023, the GEM Theatre in Garden Grove, California, put on a production of *All Shook Up*. Ironically, the Gem Theatre is now over 100 years old, much like the Palace. It was home to vaudeville in the 1920s, not unlike the Palace. It became a movie theater in the 1930s, not unlike the Palace. It then began featuring stage productions of musicals in the 1960s, not unlike the Palace. And, not unlike the production at the Palace, the GEM production of *All Shook Up* was "a rocking, heartwarming show about following dreams, opening up to love, and the power of music."

The original Broadway production of *All Shook Up* opened at the Palace Theatre March 24, 2005. The musical, featuring the songs of Elvis Presley, played 33 previews and 213 performances before closing September 25, 2005. Pictured above is a promotional sampler CD of song recordings from the musical by the original Broadway cast.

FROM ELVIS BACK TO ELTON

In the spring of 2006, the music of Elton John returned to the Palace Theatre, or you might say, "The bitch was back." This time, Elton teamed with his long-time lyricist and cohort, Bernie Taupin. The musical was *Lestat*, based on the Anne Rice novel *Interview with the Vampire*. Linda Woolverton once again wrote the book for the musical. *Lestat* was well timed, capitalizing on the awakening of vampires in the 1990s and early 2000s with films like *Buffy the Vampire Slayer*, *Bram Stoker's Dracula*, *From Dusk Til Dawn*, and *Blade*, while setting the tone for the many more vampire productions to come including HBO's *True Blood*.

ELLE WOODS HITS THE STAGE

The next main attraction at the Palace Theatre came from the mega-hit movie starring Reese Witherspoon which grossed over $140 million. It only made sense to transform *Legally Blonde* into a Broadway musical. And why not? This was an ideal, timely, upbeat tale of a young woman, Elle Woods, who proved to her doubters and herself that she could defy and far exceed stereotypical expectations imposed upon blondes. Instead, the character of Elle Woods brought a bright, savvy, determined and quite funny female to the Broadway stage.

We knew from the start that the key to the musical adaptation of *Legally Blonde* would be to find someone who could step into the shoes of Reese Witherspoon and bring Elle to Broadway with the same joyful, outgoing personality and positivity. To assist with the task and bring his comedic flair back to the Palace stage we brought in Jerry Mitchell, who was quite familiar with musical comedy, having also

Composer Sir Elton John and author Anne Rice join the Broadway cast of *Lestat* for their April 25, 2006, opening night curtain call bows at the Palace.

choreographed *The Full Monty*, *The Rocky Horror Show* and *Hairspray*. This time he would step into the choreographer role and make his Broadway directorial debut.

The lengthy search for Broadway's Elle Woods concluded with Laura Bell Bundy landing the coveted role. Bundy debuted on Broadway five years earlier in *Hairspray*. This time, however, she was taking on a high-profile, high-pressure role, which is often the case when a hit film with a well-known lead like Reese Witherspoon is adapted for Broadway.

In *Playbill*'s 2019 article: "Blonde Ambition: Laura Bell Bundy Goes to Elle and Back in *Legally Blonde*, Christopher Wallenberg sums up the transformation in simple terms: "Like the radiant Reese Witherspoon, who brought the character to fuchsia-colored life on the big screen, Elle is very positive, optimistic and bubbly." Wallenberg goes on to write that Bundy "is no Malibu Barbie. Indeed, she's actually made something of a career out of playing the kind of bad girls that audiences love to hate."

As it turned out, Bundy's career did indeed have a dark side. At the age of ten she played a monstrous little Shirley Temple-wannabe in the Off-Broadway show *Ruthless* in which she strangles her rival with a jump rope to land the lead role in a play. Then, after playing Tracey Turnblad's bratty nemesis Amber von Tussle in *Hairspray*, Bundy grabbed a broomstick and swooped in to tackle the esteemed role of the self-centered witch Glinda in *Wicked*.

After a few weeks of running the show in San Francisco, it was time to bring the fun-filled musical with music and lyrics by Laurence O'Keefe and Nell Benjamin and a book by Heather Hach, to Broadway. *Legally Blonde* debuted on April 29, 2007, and ran for 595 performances, closing on October 19, 2008.

Stewart Lane outside the Palace's marquee featuring *Legally Blonde: The Musical*.

Actress Laura Bell Bundy takes her opening night curtain call bows at the Palace for *Legally Blonde: The Musical* on April 29, 2007.

Theatre critics were not overwhelmed, but in a new era of advertising, clever marketing campaigns and social media, the "critics" no longer held the fate of a new Broadway show in the palm of their hand. Today, posts by fans of a show often have a far greater influence on the success of a show. Consider just a few of the multitude of social media reviews by audience members of *Legally Blonde*:

"It was absolutely incredible, everything about it was so well done and the cast was phenomenal! It was non-stop fun and such an amazing show! I give it 10 stars out of 5!"

"It's non-stop entertainment from start to finish. Great technical design (lights, sound, etc.) as well."

"It's a must see. If you're coming to New York City to see a Broadway show . . . you may see Lion King or Wicked or whatever, BUT before you LEAVE New York treat yourself to the best dessert money can buy, Legally Blonde the musical."

"Don't let the thought of too much fluff deter you! This is the best show ever--energetic, colorful, fast, fun!!!! Great music and superb talent. Laura Bell is off the charts! Must see."

"OMIGOD, is all I have to say about this musical. The cast is wonderful, the scenery is well done, but most of all the music is just great! I recommend this musical to anyone that wants to see a happy, upbeat musical. This is great for ages 10+ . . . trust me, you'll be happy you went!"

Tons of social media posts, such as these, plus word of mouth across the show's demographic audience impacted box office success more than the critics. In addition, a big boost for the Broadway musical and for touring versions of *Legally Blonde* came from MTV which filmed the musical on stage in front of an adoring packed house at the Palace in September of 2007. The broadcast was then aired the following month.

Traditional thinking, at one time, was to air a theatrical show on television when the show had closed. You wouldn't want to dissuade potential ticket buyers by providing the show free of charge on TV. Such thinking flew out the window as the MTV presentation served as great entertainment and brought more fans out to see the musical in person.

Later on, when Laura Bell Bundy was planning to leave the show, MTV doubled down on their commitment to the growing legion of fans of Elle Woods and the musical. They introduced *The Search for Elle Woods*, which was an eight-episode competition television program designed to find the young actress who would follow in Bundy's footsteps. Hosted by Haylie Duff, the show took viewers through the arduous process of learning the role and auditioning for the part. The winner, 20-year-old Bailey Hanks, became the next Elle Woods on Broadway.

A South Carolina native, Hanks made her Broadway debut on July 23rd and remained in the role for the final three months of the run. Hanks

"It was absolutely incredible . . . so well done and the cast was phenomenal!"

The doors to the Palace lobby welcoming guests to enter the world of Elle Woods in *Legally Blonde: The Musical.*

would later appear in the movie *Step 3D* and on the soap opera *The Guiding Light.*

Meanwhile, without all the fanfare that comes from playing Elle Woods, another young aspiring talent in the musical was Annaleigh Ashford, who went from being one of the many Glindas in *Wicked* to playing Margot in *Legally Blonde* before landing a lead role in *Kinky Boots* and eventually the leading role of Mrs. Lovett (joining Josh Groban's tortured anti-hero Sweeney) in the 2023 revival of *Sweeney Todd* turning Ashford into a major force on Broadway.

The MTV airing of *Legally Blonde* from the Palace stage not only encouraged multiple performances of *Legally Blonde* in high schools, colleges, and at regional theaters, but also promoted many worldwide touring companies of *Legally Blonde* that took the show to the stages of Great Britain on several occasions, as well as France, Germany, Australia, South Korea, China, Malaysia, Japan, the Netherlands, Philippines, Sweden, Finland, Austria, the Dominican Republic, Panama, and New Zealand. And to think, it all started at the Palace Theatre.

A TRIUMPHANT RETURN

When Elle Woods made her exit from the Palace, Liza waltzed back in eight years after *Minnelli on Minnelli* for five more weeks of top-notch entertainment in her show *Liza at the Palace*. David Rooney summed up her performance in *Variety* with the key set of "standard questions" and answers Liza fans wanted to know:

"1. How did she Look? 2. How did she sound? 3. Did she open wearing black, white, or red? 4. How many superlatives did she spout? 5. Did she mention David Gest? 6. Was she fabulous?"

The answers provided a thumbnail review: "1. Terrific. 2. Pretty darn good. 3. White (vintage Halston). 4. Lost count 5. Only obliquely, not by name. 6. Kinda fabulous."

And indeed Liza, in her early sixties, wowed the crowds nightly for 22 performances through the holiday season of 2008 and into opening week of 2009.

In a more traditional review, *The Guardian* wrote of opening night: "Once the iconic performer had the audience in the palm of her hand, playing shamelessly to the crowd, she declared, 'John Kander', and with a few notes, made a city stand up again,' and she went into 'New York, New York' . . . then she killed everyone by singing 'Have Yourself a Merry Little Christmas.'"

Liza Minnelli's triumphant return to Broadway in *Liza at the Palace*.

A RECORD-BREAKING SEASON

As the final year of the new millennium's first decade got underway, Broadway was enjoying unparalleled box office success. In fact, according to the Broadway League statistics, the 2008-2009 season broke all attendance records to date as Broadway musicals and plays grossed approximately $943.3 million. This was impressive in the face of a major economic recession that rocked the U.S. and global economies in 2008.

Some producers believed that just as movie attendance grew during the Great Depression years of the 1930s there would still be theatergoers during the recession. In an article for Reuters.com, reporter Claudia Parsons quoted Broadway League Executive Director Charlotte St. Martin saying, "Research has shown that theatre provides escape from everyday life and especially during these tough times, we have given the audiences a reason to see a show."

With that in mind, some producers provided added incentives during the recession of 2008 by offering discounted prices to Broadway shows, especially the newer ones. Others, however, took the more cautious route, postponing openings, and in some cases shutting down long-running hits such as *Spring Awakening* and *Hairspray*.

Nonetheless, despite the recession, *Billy Elliot*, which opened in November of 2008, led Broadway through the recession with the 2008-2009 season seeing the most shows open on Broadway (43 according to the Broadway League) since the 1982-83 season.

It was also a time in which new revivals of old favorites continued to provide a safety net for keen producers knowing that audience familiarity with these classic shows would simplify the challenging process of marketing a new production

to get people in the seats. In fact, the month of March alone brought in three openings of classic, yet quite diverse, musical revivals. The month began with the return of the beloved Abe Burrows, Jo Swerling, Frank Loesser musical comedy *Guys and Dolls*, which opened at the Nederlander. The month would end with a throwback to the days of Aquarius by reviving the rock musical *Hair* at the Hirschfeld. And nestled in between on March 19, 2009, was the revival of the modern musical adaptation of *Romeo and Juliet* that came from the collaboration of Arthur Laurents, Leonard Bernstein, Stephen Sondheim, and Jerome Robbins. This was, of course, *West Side Story*, which opened at the Palace.

The characters, the dancing, the music, the story . . . everything this classic show offers makes it so easy to be captivated by *West Side Story*, the timeless tale of forbidden love based

Actors Matt Cavenaugh and Josefina Scaglione take their opening night curtain call bows as Maria and Tony in the revival Broadway production of *West Side Story* on March 19, 2009.

on Shakespeare's *Romeo and Juliet*. The show remains relevant today as evidenced by Stephen Spielberg's 2021 theatrical reboot of the film, illuminating the issues of racial tension and discrimination as it did when it first appeared on Broadway at the Winter Garden Theatre in 1957.[24]

If you do a Google search for "lists of the top ten all-time greatest Broadway musicals" you'll find that critics, those working in the industry, and theatergoers alike will have *West Side Story* high on nearly every list.

For decades, Broadway had "literally" provided a stage on which to shed light

on contemporary culture and societal norms and struggles. Once again, *West Side Story* would bring a confrontational subject matter to the stage in an emotionally charged production.

Just over fifty years after the show first ran on Broadway, those of us at the Palace Theatre all agreed that it was time for a triumphant return of Tony, Maria, the Sharks, and the Jets. I had been on board as an associate producer for the previous *West Side Story* revival in 1980, with Debbie Allen in the role of Anita. While it was a challenging time for Broadway as New York was working its way out of the financial woes of the '70s, the show still managed an impressive run of 333 performances at the Minskoff Theatre. Nearly thirty years later, the Palace Theatre would have the honor of introducing a new generation to the classic production, which included a few contemporary changes.

The updated version of *West Side Story* re-introduced some of the musical's favorite songs in Spanish. "I Feel Pretty" and "A Boy Like That" became "Me Siento Hermosa" and "Un Hombre Asi," respectively, having been carefully translated by a young man named Lin-Manuel Miranda, prior to becoming a household name from the award-winning box office sensation, *Hamilton*. Spanish lyrics were also added to the song *"Tonight."* Some dialogue within the book was then translated into Spanish, without detracting from the storyline. Other small, yet pertinent, facets of the story took on an enhanced

Debbie Allen in a scene from the Broadway revival of the musical *West Side Story*.

streetwise robustness such as the intensity of the gang's actions and Maria waving a gun around in the final scene.

The cast of the revival included Broadway newcomer George Akram as Bernardo, Matt Cavenaugh as Tony, Cody Green as Riff, Josefina Scaglione as Maria, and Karen Olivo as Anita. A native New Yorker, Olivo came to *West Side Story* from *In the Heights*, which also depicted New York's West Side, though a bit further north in Washington Heights. Olivo won a Tony Award for Best Featured Actress in a Musical for her role as Anita. More recently she has appeared in *Moulin Rouge!*

The Critics Have Their Say

Tulis McCall of the *New York Theatre Guide* wrote: "In the final analysis, despite reservations, those of you who've never seen *West Side Story* will be enthralled. And for those who remember the original, you'll still love it. Just brush up your Shakespeare and reacquaint yourself with some lyrics."

David Sheward of *Backstage* wrote: "An air of immediacy and spontaneity infuses all of Arthur Laurents' high-impact staging."

David Rooney of *Variety* wrote: "Under the knowing direction of Arthur Laurents, the 1957 show remains both a brilliant evocation of its period and a timeless tragedy of disharmony and hate."

And Linda Winer of New York's *Newsday* simply wrote, "It's still a wonderful show."

When all was said and done, *West Side Story* was a huge hit . . . again. In fact,

the 2009 revival played the Palace for 748 performances before closing on December 18, 2010. What made this number particularly impressive was that the original *West Side Story* in 1957 played for 732 performances at the Winter Garden, and briefly at the Broadway Theatre, meaning that the revival at the Palace topped the original by 16 performances.

FROM STREET GANGS TO DRAG QUEENS

Not long after *West Side Story* closed, *Priscilla Queen of the Desert* was ready to roll into the Palace. And, in March, the jukebox musical stage version of the popular 1994 cult film about the travels of two drag queens and a transgender woman opened at the Palace. The musical had already gained traction in Sydney in 2006 before the glittery comedy moved to Melbourne in 2007. Next came a long engagement on London's West End before *Priscilla* moved to Toronto where a new cast would finally bring it to Broadway. It was only fitting that the musical traveled as much as the three main characters Tick, Bernadette, and Adam did in the show, which chronicled their antics and escapades across Australia in a lavender bus called Priscilla, which was, of course, their very own queen of the desert.

On March 20, 2011, the flamboyant, comical, disco-fueled musical parked on the Broadway stage led by Nick Adams, as Adam (aka Felicia). Adams had already sung and danced his way across several Broadway hits including *Chicago, A Chorus*

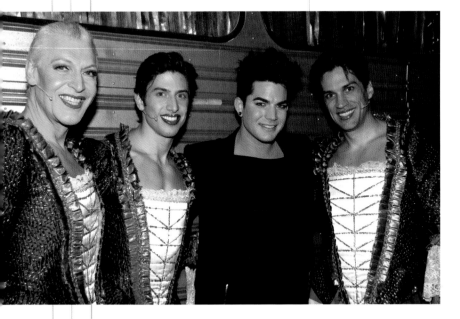

Tony Sheldon, Nick Adams, Adam Lambert and Will Swenson Backstage at the Broadway musical *Priscilla Queen of the Desert* at the Palace, 2012.

Line, Guys and Dolls and *La Cage aux Folles.* In their Broadway debuts, C. David Johnson from Montreal and Australia's Tony Sheldon would take on the roles of Bob and Bernadette with the appropriate pizzazz. Sheldon, while new to Broadway, had already played the role in over 1,700 global performances before his Palace debut. Johnson, meanwhile, had built a successful acting career spanning over 25-years in movies and television, most notably on the CBS series *Street Legal.*

It's also worth noting that *Priscilla* made it to the Palace stage in part because of the rousing success of *La Cage aux Folles.*

Continuing a long tradition of LGBTQ+ representation, *Priscilla Queen of the Desert* opened at the Palace in 2011 on the same stage that once hosted the legendary *La Cage aux Folles.*

GHOSTS AT THE PALACE

Many great performers have played the Palace since 1913, some of whom may have yet to leave the building. *Playbill* magazine says, "more than one hundred ghosts are said to haunt the Palace." Of course, the latest renovations may have exorcized many.

It is thought that the ghosts remained from the days of vaudeville, perhaps angered by the demise of their entertaining mixed bag of variety acts. One of the featured alleged ghosts that appeared to be seen was that of Judy Garland herself, who allegedly hung out by the special door built for her stage entrances leading to what became known as the Judy Garland Staircase.

Beyond random sounds of laughter, the occasional mysterious shriek and various devices suddenly turning themselves on and off, is the creepy account of Louis Borsalino, an acrobat who also walked the high wire. In an often-told tale, Borsalino had a mishap and fell to his death during a performance in the 1950s. Contrary to accounts of the incident say he "just" sustained serious injuries. And yet, it is believed that Borsalino would return to perform the same stunt late at night, only to fall tragically again.

For years, the many Palace hauntings remained part of the mystique of the illustrious theater. While the latest renovation might have cleared away the ghosts, workers on the project claim some strange unexplained things took place during the latest transformation of the great theater. While the ghosts may be gone for now, it is highly likely that they will return to check out the new Palace and find some new locations to haunt.

Judy Garland, Palace legend and possibly a Palace ghost?

Broadway opened the door to a drag nightclub complete with all the glitz, glitter, and sequins the Palace could accommodate. And yet amongst the music, dancing, laughter, and party atmosphere the book for *Pricilla* also included a poignant reminder that the fight for equality had not been vanquished; disapproval and homophobia arose during the trio's Australian journey reminding us that global acceptance still has a way to go.

Queen of the Reviews

Jesse Oxfeld of the *New York Observer* wrote: "What's playing at the Palace is a high-volume, high-energy, never-let-up disco-drag spectacular with a pulsing soundtrack full of Donna Summer, Gloria Gaynor, and Madonna. It's perhaps the best jukebox musical I've seen."

Steven Suskin of *Variety* wrote, "Priscilla, a tricked-up tour bus with a shoe on the roof, rolls onto the stage of the Palace Theatre to roars from the audience, and proceeds to turn, twist, and light up pink and purple. And then does it again (and again and again)."

In the end, *Priscilla* drove on and off the Palace stage for 526 performances before moving on to touring productions in Athens, Stockholm, Buenos Aires, Seoul, Madrid, Paris, Cape Town, Johannesburg, Tokyo, and many other cities worldwide as well as rolling onto the Norwegian Cruise lines—yes, a musical about a bus on a boat . . . what better way to travel *and* party?

"It's perhaps the best jukebox musical I've seen."

The Empire State Building was one of few buildings still lit during Hurricane Sandy.

SANDY AND SANDY ARRIVE AT THE PALACE

On October 3, 2012, the revival of the Tony Award classic musical *Annie*, inspired by Harold Gray's much-loved comic strip "Little Orphan Annie" opened for previews at the Palace Theatre. Featured as part of the opening night cast would be a terrier named Sandy, Annie's beloved pet, played by a well-trained two-year-old Broadway newcomer named Sunny. Little did Sunny (Sandy) know that in the weeks of previews prior to the musical's official opening night, another Sandy would get top billing in, and around New Your City, but not at all for being loveable.

Call it a hurricane or superstorm, but Sandy was also known as the brutal weather pattern that wreaked havoc on the New York area and brought Broadway to its knees.

For several days in late October of 2012, the weather reports warned New Yorkers and millions of people in several other east coast states that Sandy was approaching. Then, on Sunday, October 28, while final flood precautions were being taken and hundreds of thousands of people along the coastline of New Jersey and lower Manhattan were ordered to evacuate, the New York City Transit Department undertook the tedious process of shutting down the city's entire mass transit system. By Monday,

few cars were seen on the city's streets, schools were closed along with the stock exchange, and federal buildings and all Broadway and Off-Broadway productions were canceled.

Over the next 48 hours, on October 29 and 30, Broadway, along with the rest of the city, Long Island, and several nearby states experienced Sandy's wrath with pouring rain leading to flash flooding and winds gusting up to 80 miles per hour. By the time the hurricane finally moved on, it had devastated parts of 24 states along the entire eastern seaboard from Florida to Maine, leaving mass destruction and power outages affecting millions of people. Included in the aftermath was severe damage to homes and businesses in New Jersey and New York.

A NEW LOOK FOR MISS HANNIGAN

For those who thought Miss Hannigan looked a lot like Jane Lynch during the run of *Annie* at the Palace, they were correct. Emmy Award-winning actress Jane Lynch, at the time best known for playing a bullying cheer coach on TV's hit *Glee*, stepped into the role of orphanage matron, Miss Hannigan from May 16-July 14, 2013.

In a statement for *Entertainment Weekly*, Lynch commented, "Some may say I know a thing or two about playing intimidating authority figures. So, I am excited and honored to be making my Broadway debut with the wonderful *Annie* company at the Palace Theatre and joining the pantheon of women who have taken on the great and irresistible role of wicked Miss Hannigan."

Lynch would gain further notoriety in films and on several memorable comedic television roles, including the sarcastic therapist on several episodes of *Two and a Half Men*, and Mrs. Maisel's nemesis, Sophie Lennon, in *The Marvelous Mrs. Maisel*.

Stewart F. Lane and his children at the Palace production of *Annie*.

By Tuesday, the sun had indeed "come out tomorrow" as the song lyric goes in *Annie*. However, much of the city, including the Palace and all Broadway theaters, remained closed. Finally, as the transit system slowly re-emerged, the Broadway League announced that performances would return on Wednesday, October 31. Several shows could not be staged on Wednesday afternoon matinees as cast and crew members were unable to get to the theaters. There were also stories of dedicated performers who did reach their destinations and performed after walking for hours.

Finally on Thursday, November 1, Broadway returned to their regularly scheduled performances. While many people would be refunded for the canceled performances, others were still unable to attend performances that were staged in the days following the wrath of Sandy.[25] Travel was extremely difficult while debris was still being cleared away. Keenly aware of the situation, theater managers issued refunds for those who could not get to the theater.

At last, after 38 previews, on November 8, 2012, *Annie* officially opened at the Palace. The special 35th Anniversary production featuring a book by Thomas Meehan, the music of Charles Strouse, and lyrics by Martin Charnin once again came to life, with James Lapine as director and young Lilla Crawford starring as Annie, with Katie Finneran as Miss Hannigan, and Anthony Warlow as Warbucks. Brand new dances by Andy Blankenbuehler were added to the updated production, along with some changes by Lapine, which were designed to bring a more contemporary flavor to the traditional story.

Audiences of all ages turned out to see *Annie*, some remembering the original production, others even recalling the old comic strip, while many young faces

were seeing and hearing *Annie* for the first time. It was also likely that some of the young ladies in the audiences had played the role of Annie in school productions. Perhaps *Playbill* best summed up the popularity of Annie when Logan Cullwell-Block wrote: "Thanks to three Broadway productions, almost non-stop national tours and now three major motion picture adaptations, the show holds a place in the hearts of millions of fans."

One *Annie* fan, Terry Teachout of the *Wall Street Journal*, gave the show a "10 out of 10," writing; "This revival of *Annie* is fabulous. Creatively staged by James Lapine, Stephen Sondheim's longtime collaborator, and smartly cast from top to bottom, it makes a convincing case for a musical widely regarded by cynical adults as suitable only for consumption by the young. Even if you're a child-hating curmudgeon, you'll come home grinning despite yourself."

Crawford, who had won the role of *Annie* over roughly 5,000 auditioners, proceeded to win over audiences of all ages. In doing so, she joined a brief list of beloved Annies on Broadway, including the first Annie, Andrea McArdle, and Sarah Jessica Parker. Crawford, however, had the distinction of being the first Annie at the Palace.

Of course, one cannot discuss *Annie* without mentioning the music of esteemed composer Charles Strouse, who won

Jane Lynch starred as Miss Hannigan in the Palace production of *Annie*, 2013.

HOW MANY NORMA DESMONDS CAN YOU NAME?

For those who are still unsure, Norma Desmond is a fictional character, the Hollywood femme fatale version of Frankenstein, an assemblage of bits and pieces of several silent movie actresses, such as reclusive Mary Pickford, and 1920s movie idol Norma Talmadge, whose quirky acting technique could be easily construed as eerily disturbing.

Playing the role Desmond, the fictional screen legend, has long been a desire of many non-fiction actresses. While Mae West was originally considered for Gloria Swanson's role in the 1950 film, many notables have landed the role on the stages of Broadway, London, Los Angeles and in other parts of the world. Patti LuPone, for example, originated the stage role in London and won an Olivier Award. Other Norma Desmonds, prior to Glenn Close, have included Diahann Carroll, Elaine Paige, Betty Buckley, Rita Moreno, and Petula Clark. Then there was, of course, Carol Burnett, whose send-up of Norma Desmond on the *Carol Burnett Show* was priceless.

the Tony Award for Best Original Score with lyricist Martin Charmin back in 1977. Strouse had struck gold several years earlier when he teamed with lyricist Lee Adams to write the music for *Bye Bye Birdie*, which won a Tony Award for Best Musical in 1961. The music of Strouse has spanned over seven decades on Broadway, and his songs were previously featured at the Palace in the Tony-Award-winning Musical *Applause*.

Annie played the Palace for 487 performances into early 2014 with the last three weeks each grossing over one million dollars as fans of the acclaimed musical took in the opportunity to see the show one more time knowing that it might be a long wait for Annie, Sandy, Miss Hannigan, Oliver Warbucks to appear on Broadway again.

Charles Strouse, Lilla Crawford, and Martin Charnin during a meet and greet with cast and the creative team of *Annie*.

GERSHWIN'S MUSIC BRINGS PARIS TO THE PALACE

After a successful nostalgic holiday week with the Palace hosting two of Motown's legendary vocal groups, the Four Tops and The Temptations, the music would switch to Gershwin as *An American in Paris* moved in.

Adapted from the 1951 Gene Kelly-Leslie Caron film musical set in post-war Paris in 1945, this extraordinary dance production choreographed by Christopher Wheeldon would generate widespread attention. Wheeldon had gained worldwide acknowledgment from his work with the Bolshoi Ballet, Mariinsky Ballet, Joffrey Ballet, Paris Opera Ballet, and a host of other ballet companies worldwide. This would also be the directorial debut for Wheelan, and the results of his efforts, while differing in style, recalled the superb stage work of Jerome Robbins and Bob Fosse.

As is often the case with a first-time stage musical, the production would open out of town. In this case, "out of town" did not refer to Connecticut or Rhode Island, but more appropriately in Paris, where the adaptation first premiered in December of 2014 at the Théâtre du Châtelet, with Robert Fairchild and Leanne Cope in the lead roles of Jerry Mulligan and Lise Bouvier.

Leslie Caron, who starred with Gene Kelly in the film version of *An American in Paris*, attends the stage production at the Palace in 2016.

Both Fairchild and Cope had rich ballet backgrounds. He had been a principal dancer at the New York City Ballet. She had performed with The Royal Ballet in London. The emphasis on ballet proficiency was particularly necessary when it came to staging the 17-minute ballet segment that concluded the classic film. Not only did the young team of Fairchild and Cope bring their extraordinary ballet skills to the stage of the Palace Theatre, but the pair also proved that they could sing and act as well.

Linda Winer, of New York's *Newsday* wrote, "From the first moments of *'An American in Paris'* two things are clear about this new Gershwin musical. First, it is far more than just another Broadway remake of a Hollywood movie. And [second], the ballet world's choreographer Christopher Wheeldon, in his theater-directing debut, has made something special."

Jennifer Farrar of the Associated Press spread her praise even further when she wrote that the production included "an intriguing new book by Tony-nominee and Pulitzer Prize finalist Craig Lucas. Scenery and costumes by Tony-winner Bob Crowley are bold and witty, with inventive props whirling around amid the dancers, such as artfully aged mirrors to simulate a ballet studio."

And Nancy Walz of NewYorkArts.net likened the production to the show created during the Golden Age of Broadway, noting that the "singing, acting, lighting, costumes and scenery (which seems to dance as well) are all built on the vision of the newest brilliant choreographer-director, and the effect is overwhelmingly thrilling." Walz also added, "Fairchild has said that Gene Kelly inspired him to become a dancer. If

the roles were reversed, no doubt he would do the same for Kelly."

Excellent reviews, impressive numbers at the box office and enthusiastic audiences, which included many dance community members, kept *An American in Paris* on its toes for 625 performances over 18 months.

Shortly after the closing of *An American in Paris* that October, we set our sights on bringing in something cheerful for the holiday season. With the influx of tourists in November and December, if a show was not already up and running to carry us into the New Year, we'd seek something uplifting to end the year. Of course, it didn't have to be a holiday-themed show. Other than the 1993 holiday season family show, *Candles, Snow & Mistletoe*, which brought in a heaping dose of good cheer, we did not go out of our way to bring in a holiday show, especially with the annual Radio City Christmas extravaganza in such close proximity to us, just up the way in Rockefeller Center.

"all built on the vision of the newest brilliant choreographer-director . . . the effect is overwhelmingly thrilling"

So, to end the year in style, we followed the spectacular ballet of *An American in Paris* with a month of *The Illusionists—Turn of the Century* featuring what *Playbill* called "the golden age of magic . . . showcasing the origins of some of the greatest and most dangerous illusions ever built." *The Illusionists* provided a climactic conclusion to a terrific year for the Palace.

THE PALACE GETS READY FOR ITS CLOSEUP

Perhaps it was *The Illusionists* working over time, but somehow, in January of 2017 the Palace Theatre was brilliantly transformed into Los Angeles, circa 1949, *Sunset Boulevard* to be more specific.

Glenn Close and Andrew Lloyd Webber during curtain call of *Sunset Boulevard*.

On February 2, 2017, Glenn Close would once again don the persona of the immortal Norma Desmond as previews of the latest reincarnation of the Billy Wilder, Charles Brackett 1950 noir classic *Sunset Boulevard* opened at the Palace. Close won a Tony Award playing the aging silent movie star in 1994. This time, however, both Close and Desmond were making their Palace debut in typically extravagant style, with a forty-piece orchestra accompanying them on the majestic Palace stage.

The story of the dismissed silent movie star, cast aside by the emergence and popularity of talkies, was quite appropriate for the Palace Theatre. This landmark theater bore witness to an entire genre of entertainment, vaudeville in particular, which was also dismissed and cast aside by those very same talking pictures. However, unlike Norma Desmond, forever awaiting her return to the footlights, the Palace returned to live theatre triumphantly in 1965. And yes, one of those ghosts haunting the Palace might be that of Norma Desmond.

Featuring a book by Don Black and Christopher Hampton, music by Andrew Lloyd Webber, and lyrics by Don Black and

Christopher Hampton, *Sunset Boulevard* came to life once again on Broadway and, following in the footsteps of the iconic film and the original musical production from twenty years earlier, the show did not disappoint.

Ben Brantley of the *New York Times* wrote, "The scenery may have shrunk, but that face—oh, that face—looms larger than ever. So does the ego that animates it, both indomitable and irreparably broken. Yes, Hollywood's most fatally narcissistic glamour girl, Norma Desmond, is back in town."

In a limited engagement of 138 performances, the pared-down production was large enough to place a beloved character not under the footlights of Hollywood, but under the spotlights of New York City . . . and it happened at the Palace Theatre.

ACCIDENTAL AUTHENTICITY

There are many stories about the making of *Sunset Boulevard*, the movie, and some oddities about the musical as well. For example, in the 1994 Broadway production, Glenn Close descends the staircase as Norma Desmond only to be greeted with a glut of photographers snapping away. No, they were not part of the production, but audience members seeking a photo keepsake of the iconic film/stage moment. While Norma may have adored the attention, Close halted the show saying, "We can either have a press conference or continue with the show." And without further distraction the show would continue.

Then, 23-years later, one such photographer emerged clicking away as Close sang the song "With One Look." Once again, Close stopped the performance, stating, 'Now we can have a show, or we can have a photo shoot.' And once again, the message was clear, and the show continued. Talk about authenticity! It came right down to rude behavior from the audience.

WHO LIVES IN A PINEAPPLE UNDER THE SEA?

The final act to play the Palace prior to the remarkable changes that would lie ahead was the original musical *SpongeBob SquarePants*. Until 2017, the opulent Palace Theatre had played home to a wide variety or performers including the famous Finks' Mules (an act which included monkeys, dogs, and ponies along with the high-kicking mules), an act featuring three miniature elephants, a number of amazing acrobats and aerialists from around the world, a trampoline comic, the most amazing escape artist of them all . . . Harry Houdini, and of course the never-to-be forgotten Norma Desmond. This would, however, be the first time ever that the star of a Palace production would be a sponge.

The television cartoon *SpongeBob SquarePants* first debuted on Nickelodeon in 1999. The hit series was originally created by a marine science educator who also just happened to be an animator, and a good one at that. It did not take long for the undersea exploits of SpongeBob and his aquatic cohorts, including Squidward Q. Tentacles, Eugene Krabs, Sandy Cheeks, and Patrick Star to make a splash on Broadway. The cheerful, childlike SpongeBob and his friends set out on adventures in the city of Bikini Bottom which is rumored to be found somewhere in the Pacific Ocean.

After winning 20 Kids' Choice awards and a bevy of other honors, SpongeBob and the gang moved to the big screen for three animated motion pictures. The worldwide response to the television program and the films was so overwhelming that the next logical step was clearly to bring the character to life on stage. Where else? At the Palace, of course.

The original cast of *SpongeBob SquarePants: The Broadway Musical* included Ethan Slater in the role of SpongeBob, and Danny Skinner as Patrick Star who were both making their Broadway debuts. Gavin as Squidward came from London's West End where he had played Burt in *Mary Poppins*. He would later return to the role of Burt in 2006 on Broadway. Lilli Cooper, as Sandy Cheeks, went from a standby role in *Wicked* to the role of Martha in *Spring Awakening* before diving into the city of

Throngs of theatergoers descend on the Palace Theatre to see a matinee performance of *SpongeBob SquarePants: The Broadway Musical* in 2018.

Stewart F. Lane and his children at the premiere of Nickelodeon's *SpongeBob SquarePants: The Musical*. This would be the last musical that played the Palace before it was closed for renovation.

Bikini Bottom. Cooper would later go on to a key role in *Tootsie*. Gavin Lee, meanwhile, in the role of Squidward, displayed great versatility transitioning from *Mary Poppins* to *Les Misérables* to *SpongeBob SquarePants*.

As anticipated, the colorful, upbeat, goodtime production was a big hit with kids as well as teens and other long-time SpongeBob fans now in their twenties. And while parents claim they went because the children wanted to see it, many could be heard humming the tunes with a smile while leaving the theater.

The *New York Theatre Guide* summed it up best: "The Broadway musical has captured all the silly, goofy, broadly camp, good-natured fun of the Nickelodeon TV series. Tina Landau, the conceiver and director, succeeds marvelously. She leaves no shell unturned in Bikini Bottom, the show's oceanic locale."

The musical also highlighted original tunes penned by Steven Tyler and Joe Perry of Aerosmith, Sara Bareilles, Cyndi Lauper, John Legend, Panic! At the Disco, and They Might Be Giants, among other notable songwriters and musicians.

From 2017 to September 16, 2018, *SpongeBob SquarePants*, not unlike *You're A Good Man, Charlie Brown*, *Annie*, and a host of Disney characters, proved that the artistic brilliance of animation can come to life on the Broadway stage amid their own habitat that captivates both children and adults, giving them a joyful two and a half hours away from the real world.

When the show closed after 327 performances, the Palace would shut down for over five years in which the theater would go on a magnificent ride of its own in a renovation unlike anything ever witnessed before in the city of New York.

In the final few years preceding the "Great Renovation" of the Palace, we were able to present a wide range of musical productions that presented a wide range of theatrical styles and songs. We heard the songs of Ira and George Gershwin, Steven Sondheim, Charles Strouse, Elvis Presley, and Elton John. We witnessed brilliant choreography from the frenzied actions of street-fighting in upper Manhattan to the graceful, poetic movements of ballet.

We took audiences to prime locations worldwide from the deserts of Australia to Paris, New York City, Hollywood, and Bikini Bottom. We watched as an orphan joyfully hoped for what tomorrow will bring, an aging actress clinging to her memories, new lovers finding one another abroad, and star-crossed love shattered. Through the magic that is Broadway theater, the Palace was home to a little of everything, including shows representing the need for acceptance, tolerance, unity, and inclusion.

As the Palace shut down for unprecedented renovations, theatergoers, performers, and all of us associated with the great venue began anticipating the marvelous productions that lay ahead. What Broadway musicals might emerge from novels, films, television shows, social media, newsworthy events, or the prominent trends of our collective culture? What would the playwrights of tomorrow be focusing on, and which shows would audiences clamor to see in revivals? In time we would get the answers . . . but first it was time to raise Palace Theatre.

SpongeBob SquarePants: The Broadway Musical at the Palace Theatre in Times Square.

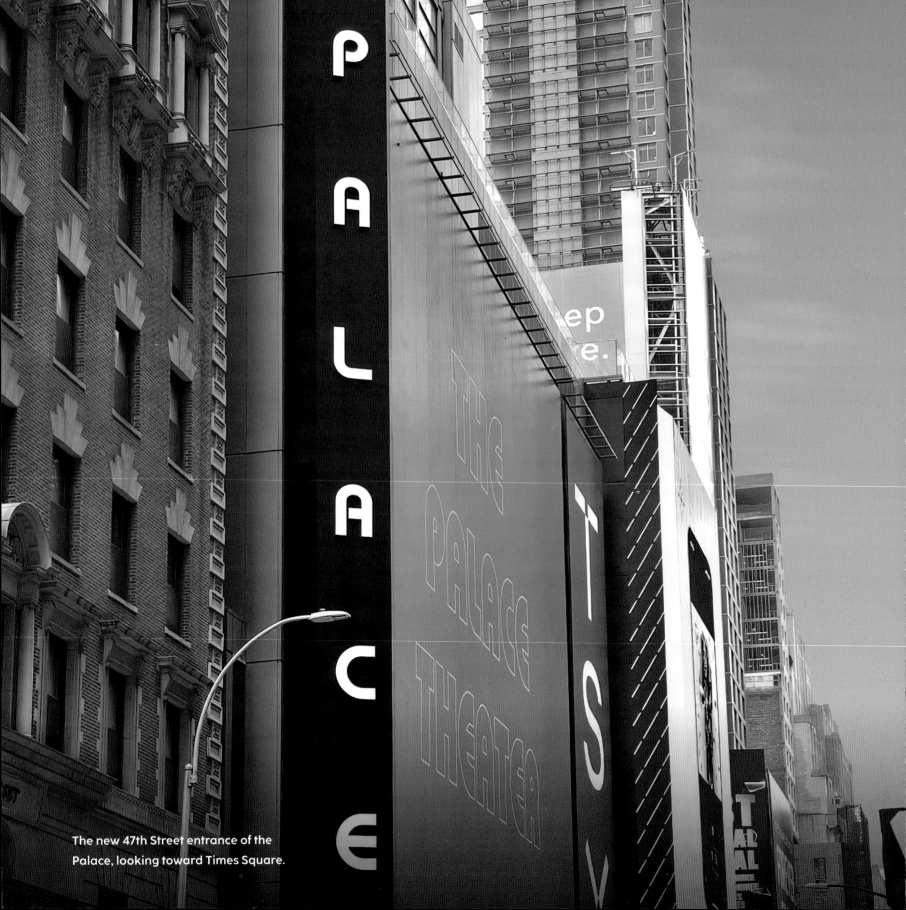

The new 47th Street entrance of the Palace, looking toward Times Square.

TIME TO RAISE THE PALACE

Like other Broadway theaters, the Palace has had its fair share of facelifts during its long history. After all, the wear and tear of two-shows-a-day vaudeville entertainment, three decades of feature films, and more than six decades of Broadway musicals required renovating, repairing, repainting, and making various changes to the theater on several occasions. And why not pamper the Palace a little? Not unlike any Broadway star, the Palace always wanted to look its best. So, when a plan was being formulated to demolish most of the 43-story DoubleTree Suites Hotel, which has sat above the theater in Times Square for more than three decades,

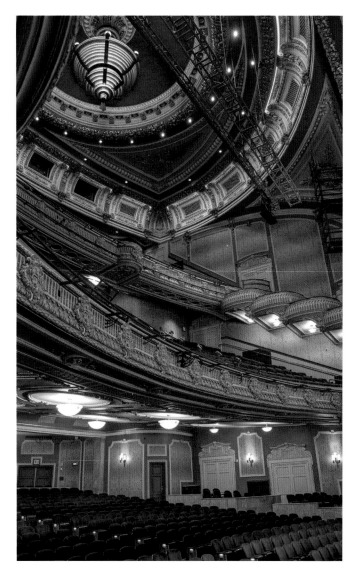

The newly renovated house of the Palace features all new seating and a custom chandelier.

there was concern as to what might happen to the Palace. Fortunately, it could not be demolished since the interior of the theater gained landmark status in 1987.

There was, however, a way to maintain the Palace, or the interior thereof, while still constructing a new high-rise luxury hotel and much more. The Palace could be incorporated into a multi-faceted facility, unlike anything Times Square had ever seen before (and Times Square has borne witness to all sorts of activities).

A plan to finance, design, and build a 585,000-square-foot, multi-use building in the heart of Times Square called TSX Broadway was spearheaded by L&L Holding Company (a privately held real estate company), Maefield Development, architectural and design companies including PBDW, Perkins Eastman, and Mancini Duffy along with Fortress Investment Group (a New York based private equity firm). The new structure would include 100,000 square feet of retail stores, a nightclub, galleries, eateries, plus outdoor areas for entertainment and, of course, the (mostly) brand new DoubleTree by Hilton (the first 16 floors remaining from the previous hotel). The new hotel would feature 661 brand-new luxurious hotel rooms, 18 of which to be designated ball-drop rooms, overlooking the annual Times Square New Year's Eve ball drop.

So, how would the Palace fit into all of this? The plan, which we first saw in 2015, was to incorporate the land-marked theater interior on the third floor of this massive hotel/entertainment venue. This would mean lifting the entire theater 30 feet in the air so it could be placed on the third floor with retail stores built below. Many of us, especially me, being the co-owner of the Palace Theatre along with James L. Nederlander, had to determine whether this plan was feasible.

A vintage stage light that once shown on the boards of the Palace.

This plan provided an opportunity to make changes while protect-ing the landmark status of the interior. Built in 1913 and landmarked in 1987, the Palace is one of the most revered and coveted theater venues in New York City, thus requiring special maintenance. It was the only theater with an entrance, box office, and lobby directly on Seventh Avenue. In 2009, when new pedestrian walkways replaced car lanes in Times Square between West 42nd and West 47th Streets, this became a safety issue. Thanks to this technologically advanced plan, we could lift the Palace, increase the size of the lobby, and move it out of the pedes-trian walkway traffic in Times Square.

The New York City Landmarks Preservation Commission (LPC) worked with us, closely watching every step of the process. The LPC carefully examined all aspects of the plan to ensure everything was done properly. LPC members came with us to all meetings and asked questions based on their years of knowledge when it came to preserving classic structures.

"...checked with various people involved in creating the plan and found out it was no mistake."

Presentation materials from the various companies involved in the planning showed the logistics of how such a project would work. Since the interior of the theater sits in a "rigid box," the entire theater could be lifted one inch at a time by using hydraulic jacks while the engineering team would continuously monitor the vibrations during the lift. The plan for the actual move of the theater would take several weeks. Of course, it was hard to know for sure since theaters are not typically hoisted 30 feet into the air and moved elsewhere.

The closest comparison to such a feat on Broadway took place in 1998 when the Empire Theatre was moved 170 feet down 42nd Street. This entailed putting I-beams in the street to serve as rollers to roll the 3,700-ton theater to its new location. Rolling an entire theater down 42nd Street also took quite some time. Of course, the theater probably got caught in typical New York City cross-town traffic! However, the plan for the Palace would be the first time an actual Broadway theater would be hoisted into the air. Those who knew the history of the Palace could only think how much the legendary Harry Houdini would have loved witnessing such a feat.

To put the sheer magnitude of this plan into perspective, even Robert Israel of L&L Holding Company, who was hired to lead and direct all aspects of the 2.4-billion-dollar TSX Broadway project's development, design, and construction recalled being amazed in an interview for the "Manage This" podcast where he was asked what his

first reaction was upon seeing the plans. "I got this set of drawings which were quite large, and I reviewed them, and I had to look at the plans multiple times to make sure that I was looking at them, reading them, understanding them, and interpreting them correctly. It showed us lifting the theater. I wrote it down several times on my note-pad, 'lifting theater.' Then I said, no, it must be a mistake." Sure enough, Israel checked with various people involved in creating the plan and found out it was no mistake.

WHAT'S IN IT FOR THE PALACE?

The plans explained how the Palace would benefit. While the interior seating area will stay intact (as mandated by the LPC agreement), many other aspects of the theater will receive significant upgrades. For example, 10,000 square feet of back-of-house space would be added, including brand-new dressing rooms for performers, new lighting and sound rooms, plus a backstage manager's office. Patrons will be able to enter an exquisite new lobby complete with bar and box office. There will be a separate entrance to the theater on 47th Street, where a new marquee will welcome theatergoers into the venue via escalators that usher everyone up to the third floor and into a spacious new lobby.

The theater will also have additional room for more seats, potentially bringing the seating capacity up 25 percent to more than 2,000. Improved acoustics, upgraded lighting, plus the installation of chandeliers in their original positions throughout the Palace to enhance the theatergoer's experience. Behind the

A look at the old interior of the Palace prior to renovation.

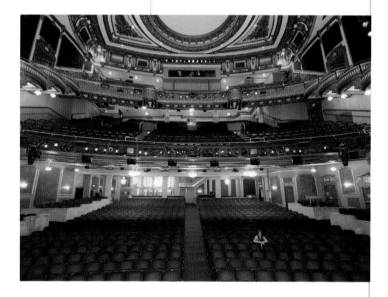

scenes, a new HVAC system and various other technical changes will improve the comfort for patrons while meeting safety codes and ADA compliance. Ultimately, the rejuvenated Palace Theatre will maintain its old-world charm, elegance, and décor while adding today's technology and modern conveniences.

In addition, visitors to the TXS complex will be able to shop, dine, see a Broadway show, and take in whatever additional entertainment is taking place in the venue at the time. Plus, those visiting New York City can enjoy all the above and even stay overnight in one of the 661 lavish rooms in the luxury hotel.

The initial plans included construction, demolition, lifting the theater, and multiple other activities taking place simultaneously. Numerous teams were brought in to participate in this monumental job which was expected to commence not long after the closing of the musical *SpongeBob SquarePants* in late 2018. However, the project was delayed because the contractors needed to inspect an adjacent building and the property owners of the structure in question did not grant permission for the inspection for over a year. Finally, in 2019 the inspection of the adjacent

The newly renovated house of the Palace with a fresh, modern take on classic jewel tones and soft metallics is ready to welcome a new generation of audiences.

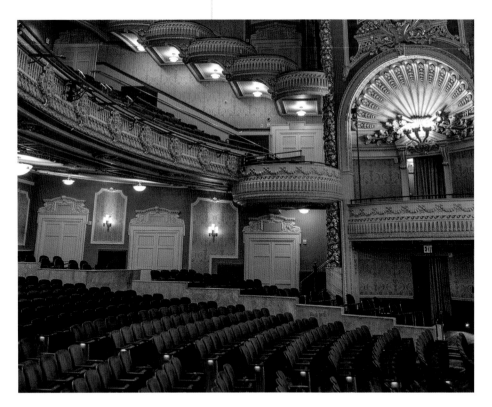

building was completed, and the project began with the partial demolition of the former DoubleTree by Hilton.

THE DAY EVERYTHING STOPPED

On March 12, 2020, Andrew Cuomo, governor of New York at the time, announced at a press conference that as of 5 p.m. that day, Broadway theaters would shut down. By the following morning, Broadway and everything around it came to a stop with the outbreak of COVID-19. There was an eerie silence in Times Square, on the streets of New York City, and in cities and towns throughout the nation and around the world. The silence was only pierced by the sound of ambulances and emergency vehicles.

Not only was construction on the TSX project completely stopped for nearly a month, but the 41 theaters on Broadway closed their doors for what was anticipated to be a six-month pause, and then a year . . . which finally turned out to be an 18-month-long intermission. During this time, no one, from those working at the box offices to production assistants, stage managers, set builders, theater managers, choreographers, directors, or performers were sure what to do next as their jobs were suddenly on hiatus. No one knew if or when their productions would resume. And while the primary focus was universally on health and safety, job security (if there is any such thing in the theater) was also of great concern to the thousands of people who work in the many aspects of Broadway productions.

Many of us pondered the questions: When would the lights of Broadway shine again? Who would turn out to see a show in a potentially crowded theater until we all knew we were safe?

The 'Fearless Girl' statue by Kristen Visbal in front of the New York Stock Exchange wearing a surgical face mask during the COVID-19 pandemic. Broadway shows closed for an unprecedented 18 months during the pandemic.

Before the pandemic, 250,000 people saw a Broadway show every week in New York, supporting the thousands of theater related jobs and bringing nearly $15 billion into New York's economy each year. In fact, during 2018-2019 Broadway was singing and dancing to a record-breaking tune of $1.8 billion dollars. In 2020, nearly all that revenue was lost and for most of 2021 things did not get better.

Evening view of Times Square area in Manhattan, empty and void of tourists to prevent the spread of COVID-19.

Meanwhile, after only a month-long pause, the TSX construction continued. Many teams resumed work with masks and other health precautions in place. Robert Israel noted of the empty streets around Times Square, "When it came to coordinating around people and cars and traffic, it [the pandemic] has actually been a help."

Nonetheless, safety remained a priority when working through the pandemic. "We had to make the building safe because we didn't know how long we were going to be shut down for. Then we had to get people back to work and redo what we had made safe. So, we still ended up with a substantial delay when it came to the overall COVID

impact based on what we had to do and how we had to do it, even though we were working," explained Israel on the effect of the pandemic on the TSX project.

While construction moved forward, Broadway theaters reopened in September of 2021. It was a relief for the nearly 97,000 employees whose jobs depend on Broadway revenue. However, theaters did not return with packed houses and the same level of excitement typically found on the Great White Way.

The pandemic brought well-justified concerns about being in crowds, including those of well-meaning theatergoers. Attendance did not soar in the returning months after the theaters first reopened despite various safety precautions, including wearing masks, checking to see that ticket holders had their COVID vaccinations, and in some theaters, safe seating policies which meant empty seats used as buffers between audience members. There were also far fewer tourists visiting New York City in 2021. It was estimated that there were half as many visitors to the city than in the years prior to the pandemic.[26] This was a bad sign for theater economics since tourists make up a sizable portion of Broadway theatre audiences. To make matters worse, there was a crime surge in the city, reminding many of us of the seedier version of the city in the 1970s. Once again it became intimidating to travel around the city, especially at night or by subway.

As a result, a number of major productions shut down for good not long after returning, including the longest-running show in Broadway history, *Phantom of the*

Theatre fans enter the Richard Rodgers Theatre in New York on Tuesday, September 14, 2021, for the reopening of the musical *Hamilton*. Masks and vaccinations were required for the attendees.

Phantom of the Opera, the longest-running Broadway show in history, returned post-pandemic and took its final curtain in April 2023.

Opera, which ended a phenomenal 35-year run with losses of $1 million per month after returning from the shutdown. Other shows that closed during the shutdown or shortly after returning, included *Beetlejuice*, *Mean Girls*, *Waitress*, and *Frozen*. There was also a revival of *Who's Afraid of Virginia Woolf* that closed before its official grand opening. Ticket sales for many shows were still below expectations throughout most of 2022. It was a long, slow, and understandably cautious return for Broadway theatre which by 2023 was finally beginning to see the light at the end of a long tunnel.

THE LIFT!

Once the interior of the theater was strengthened, a large crew of workers added a six-foot-thick layer of concrete around the base before sinking 34 columns 30 feet deep into the existing ground below. Not unlike a telescope, smaller beams could then be moved within the larger ones. Massive hydraulic jacks were then carefully positioned under the inner beams to push them upward, thus lifting the theater on top of them five inches at a time. The entire lift of the theater, roughly 30 feet, or 360 inches, was then carefully witnessed by a team of engineers and consultants who checked after each stoppage in the process to ensure nothing unusual occurred. Throughout the process, Robert Israel, who was also watching closely, commented to reporters that "a slight tilt less than half a degree one way or another would have been enough for a hard stop."[27]

Besides having consultants monitoring the vibrations, photographers took countless photos of the theater from all possible angles to ensure everything remained intact

during the lift. Consultants were given the task of determining if everything was stable. Even the moisture and humidity of the theater had to be closely monitored. And, at the end of the day, as soon as the power was shut off, temporary power was set in place to run humidifiers, dehumidifiers, heaters, coolers, and so forth. After all, you can't just leave a theater out there hanging around.

Then, in March of 2022, once the theater reached 16 feet, or just more than the halfway point on its vertical journey, the process was halted briefly while a new structural frame was installed and new floors were constructed in the freshly made space for the theater, which would further support the weight of the incoming tenant. Those who looked up from street level during these weeks and thought they saw a theater hanging overhead, were correct.

Once again, the process resumed, and the theater continued its slow climb into the annals of New York City construction history. On April 5, the Palace Theatre reached its destination of (roughly) 30 feet. It was then moved into the cavity space opened for it on the third floor of the TSX structure. Of course, the theater had to be moved into the space slowly and steadily and then secured in its new home. Work was then started on a separate entrance for the theater and access from inside the TSX facility.

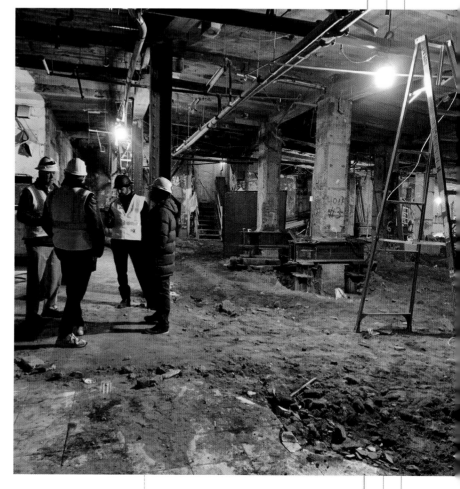

Stewart F. Lane meets with the construction team below the Palace floor as it is being raised. When complete, the Palace will sit 30 feet above street level.

HOW TO HOIST A THEATRE 30 FEET

Prior to lifting the Palace Theatre, a lot was going on in and around the theater's new Times Square home in TSX Broadway. Carefully, demolition was already taking place on parts of the DoubleTree by Hilton. Since the bottom 25 percent of the existing structure would remain and the theater would be preserved with additional stories being built above it, there was no "wrecking ball approach." The upper 30 floors of the structure were mechanically demolished, and the debris was lowered to the ground floor for removal off-site.

In this case, the interior of a rather large landmarked theater would need to be carefully removed from its street level location below the original DoubleTree by Hilton while making sure the remaining floors of the structure (remember, several floors of the old hotel were part of the new plan) would remain stable when the team removed the Palace from the first floor. It was not unlike a game of Jenga, only much larger and with billions of dollars at stake.

Securing and carefully extracting the Palace from its current location would be just one of many significant challenges. Before moving and lifting the actual theater, a significant layer of protection had to be added to ensure the theater would sustain the lift. The structural theater itself, the interior, including the historic plaster throughout, needed to be preserved. It took many hours of demanding work by specially trained teams to carefully preserve the plaster as well as secure all the pieces that made up the protected interior of the Palace. The four interior columns that stand as sentries around the magnificent stage also had to be secured. To do that properly, a robust concrete ring beam was integrated with the theater lift system to minimize the possibility of cracking the century-old masonry walls. I must say, it was very reassuring to see the amount of detailed work taking place to maintain the safety of the venue.

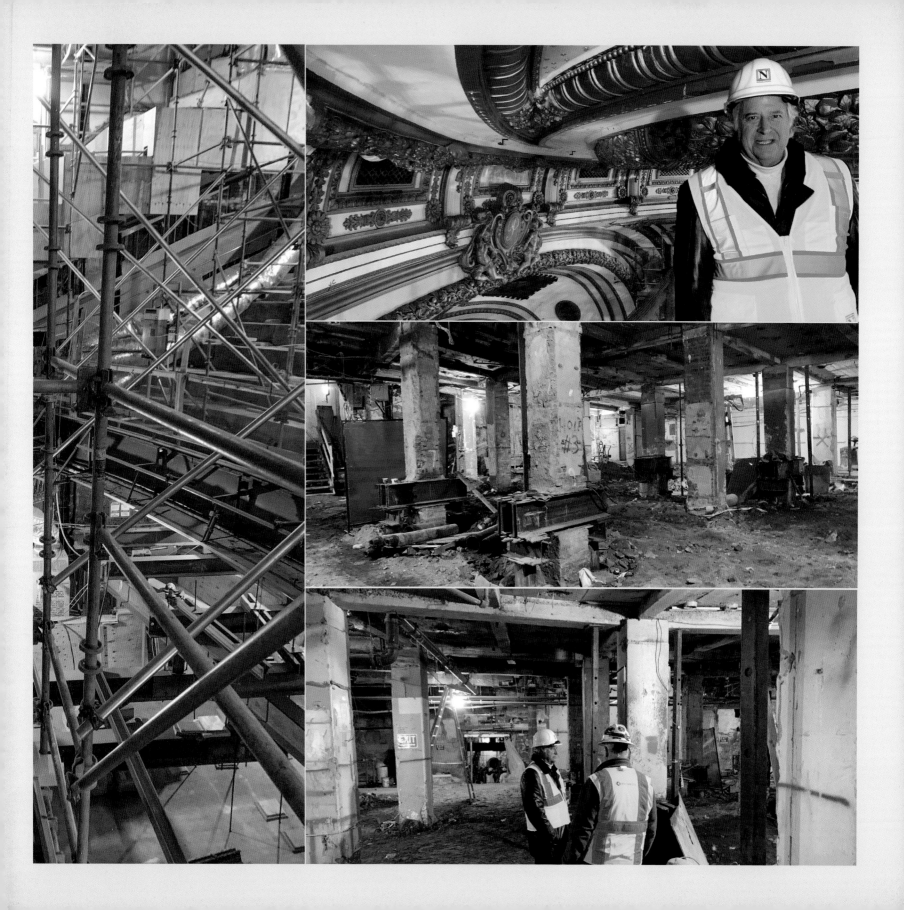

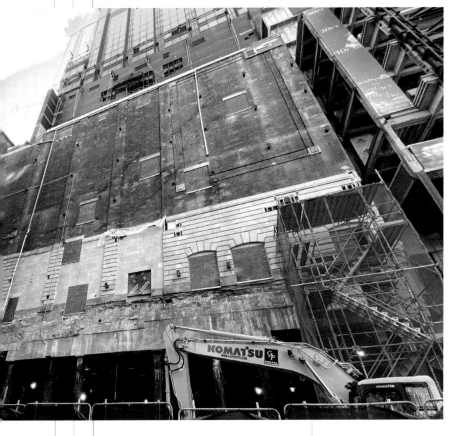

A sign indicating the current location of the Palace as it was being lifted.

The process took seven weeks and those of us deeply connected to the theater felt relieved knowing that the most difficult aspect of the renovation was completed. Yet, there was more to go in this huge multi-faceted process. For example, while the 46-story hotel was also being constructed, hundreds of LED panels that would create a massive L-Shaped wrap-around screen were also being placed around several grand tower floors. After all, since the entire TSX complex would be sitting within the bright lights and giant signs that define Times Square, it would only be appropriate to adorn the building with a massive 18,000-square-foot LED sign wrapping around the western and northern sides, as well as a smaller 3,000-square-foot LED sign on the southern tower wall. Three additional 420-square-foot signs would also be added to the crown of TSX Broadway. Overall, Times Square would shine even brighter and bolder than ever.

LOOKING FORWARD

Now that the Palace is in its new home, the goal is to bring back the excitement of award-winning Broadway musicals. Of course, a lot has changed over the past 60 years since the Palace made the triumphant transition from film to live theatre. Technology has provided new ways in which to create the sound, the sets, the lighting, the special effects, and the marketing of Broadway musicals.

We are also seeing more interactive productions featuring audience participation, whether through cell phones or just getting the audience to sing and dance along with the show. This was reflected in the disco setting of the David Byrne and Fatboy Slim's interactive musical *Here Lies Love.* Interactive theater has also been found in the long running Off-Broadway hit *Sleep No More* which takes a departure from the traditional seating in front of the stage to having the audience walking around from set to set to watch the various scenes of the show. I think we'll see many more such interactive productions on Broadway and even at the Palace.

Today's audiences also represent a different generation than in the past: tweens who have fallen in love with shows like *Legally Blonde* and *Wicked*, and their parents, who grew up watching *Sesame Street* and Disney films on VHS, illustrate a demographic shift over the past several decades, and as a result musicals have also changed accordingly. Going to a Broadway show, once a luxury afforded only to well-to-do society, has now become a much-enjoyed family activity.

We also have many more ways in which to promote Broadway theatre including social media, online videos, and even streaming videos of Broadway productions which is what my wife and co-producer Bonnie Comley do at our streaming company BroadwayHD, which has been called theatre's

The sleek new lobby area of the Palace features all-new custom lighting fixtures.

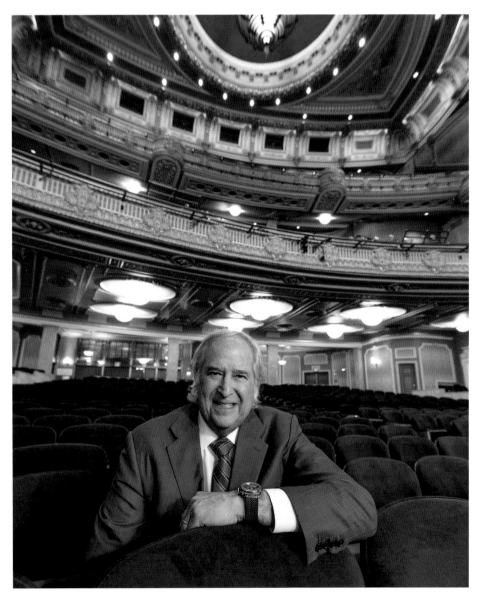

Stewart Lane enjoys the view of the newly renovated Palace.

version of Netflix. Worldwide tours have also introduced theatre to more theatrical productions than ever before. Visitors from around the world have been enjoying Broadway shows for decades. Now they can not only learn about a show they may have interest in seeing, but they can order tickets in advance of their trip and not even have to wait at the box office to pick them up.

In the coming years, we will continue to see greater diversity on stage and backstage at Broadway shows. Such diversity has already been reflected in the narratives of new productions and even in remaking old shows with new elements. There is still a growing appetite for stories that closely reflect the experiences of diverse cultures.

However, the biggest challenge for Broadway musicals today remains the increasing cost of staging a production. Costs have tripled in recent years,

resulting in higher ticket prices. This presents the question: How far can you push the public to buy a Broadway ticket? In the aftermath of the pandemic, stalwarts such as *Wicked*, *Lion King*, and *Aladdin* continued doing well, while many of the newer shows have had trouble getting a foothold.

And yet Broadway continuously adapts. For example, higher costs have led to more creative ticket discounts and smaller casts in the new century. In the 1950s and '60s, more than 70 percent of Broadway musicals had casts of at least 30 performers; in the 2000s, however, the number of 30+ performers in a musical has dropped to 27 percent. And yet productions such as *Six*, with a cast of six, *Jersey Boys*, with a cast of 13, and *Hadestown*, with 14 cast members, have all done extremely well. The point is that Broadway has always had the flexibility to adjust as necessary, and the legendary 111-year-old Palace Theatre, now sitting 30 feet above the sidewalks of Times Square, is the perfect example of such adaptability.

As new musicals play the legendary theater, and new stories abound, we will once again hear the refrain: "It happened at the Palace!"

Ben Platt's residency reopens the Palace in May 2024.

BROADWAY TIMELINE

September 17, 1894: *Arms and the Man* became the first of many George Bernard Shaw plays to open on Broadway.

February 1902: The *New York Evening Telegram*, one of the city's prominent newspapers at the time, printed a headline referring to Broadway as "The Great White Way," inspired by the many white lights on the signs and marquees. The nickname apparently stuck.

January 21, 1903: Some 36 years before the classic film took the world by storm, *The Wizard of Oz* opened on Broadway at Majestic Theatre, where it ran for 293 performances.

1904: George M. Cohan rose to fame with the show *Little Johnny Jones* for which he wrote the music, lyrics, and book. He also directed and starred in the hit musical. The same year also made architectural history when the historic building at One Times Square was completed. It housed the headquarters of the *The New York Times* for many years. It remains notable today because it is where the ball has been dropped annually on New Year's Eve since 1907.

September 19, 1904: The show *Mr. Wix from Wickham* opened on Broadway featuring the music of Jerome Kern. While the show only lasted a month, Kern's music has been played in numerous Broadway shows for over 100 years.

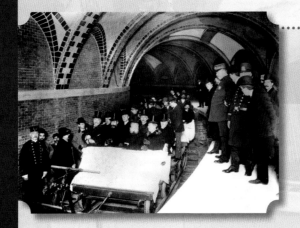

October 27, 1904: The Times Square subway station officially opened. It was one of the original 28 stations of the New York City Subway System, which made access to Broadway theaters quick and inexpensive.

July 8, 1907: Flo Ziegfeld introduced the first lavish production of the *Follies*, which would become the *Ziegfeld Follies* in 2011. New renditions were introduced almost annually until 1931.

1910: Flo Ziegfeld invited Bert Williams to join his esteemed *Follies*, making Williams the first black performer in an otherwise white production.

January 6, 1910: Irving Berlin's lyrics were performed in the show *The Jolly Bachelors*. It was the first of over 100 Broadway productions to include music, lyrics, and/or songs by Berlin.

March 24, 1913: The Palace first opened in New York City. It has since been refurbished, renovated, and lifted and is still going strong over 120 years later!

July 22, 1915: The show *Hands Up* opened on Broadway showcasing the music and lyrics of Cole Porter for the first time.

August 7, 1919: The Actors' Equity Association (AEA) went on strike. It was the first union to shut down Broadway. The strike lasted a month and affected theaters in Boston, Chicago, and Philadelphia.

May 23, 1921: Early in the Harlem Renaissance, Eubie Blake and Noble Sissle brought jazz to Broadway with the hit show *Shuffle Along*.

1922: The first Drama League Awards were presented. The awards, which are chosen by the entire theatre community, were formalized in 1935.

1923: The play *Vengeance of God* was shut down by the police during its opening night performance on Broadway. The play, which was performed at the Yiddish theater in 1906 was about the daughter of a Jewish brothel owner falling in love with one of his prostitutes.

December 24, 1924: The opening of *Lady, Be Good* which was the first Broadway collaboration of George and Ira Gershwin.

March 5, 1927: Famed restaurant Sardi's opened on 44th Street just off Broadway. Along with numerous caricatures of Broadway celebrities, Sardi's became known for many years as *the* place where producers, directors, choreographers, playwrights, performers, critics, and anyone involved in Broadway theater dined.

December 27, 1927: *Show Boat* docked at the Ziegfeld Theatre with music by Gerome Kern and lyrics by Oscar Hammerstein II. It changed the course of musicals by integrating the songs into the storyline of the show.

October 14, 1930: Ethel Merman made her Broadway debut in the George and Ira Gershwin musical *Girl Crazy* in which she introduced the song "I Got Rhythm."

April 11, 1931: The opening of the Empire State Building on 34th Street, a short walk from Times Square and the Theater District.

December 26, 1931: The George and Ira Gershwin, George S. Kaufman, and Morrie Ryskind musical *Of Thee I Sing* became the first Broadway show to spoof the presidency. It then became the first musical to win a Pulitzer Prize.

December 27, 1932: The grand opening of Radio City Music Hall.

January 30, 1936: Four years after the death of Flo Ziegfeld, The Ziegfeld Follies of 1936 opened starring Fanny Brice as Baby Snooks, along with Bob Hope and Josephine Baker.

March 2, 1942: The first Stage Door Canteen opened on Broadway to provide service members with a place to relax, unwind, and enjoy entertainment during World War II.

July 4, 1942: Irving Berlin's *This is the Army* became the first of several patriotic musicals to play Broadway during World War II. The musical toured throughout the rest of the war.

December 10, 1942: Producer David Merrick's first Broadway show, *The Willow and I* opened. He would produce over 80 more Broadway productions in his long and esteemed career.

March 31, 1943: The first musical by Rogers and Hammerstein, *Oklahoma!*, opened on Broadway introducing the concept of integrated storytelling through music and dance, along with the dialogue, which further changed the direction of Broadway musicals forever.

December 28, 1944: *On the Town* opened featuring the debut of composer Leonard Bernstein, writers and performers Betty Comden and Adolf Green, and Jerome Robbins as a choreographer.

April 6, 1947: The first Tony Awards (known at the time as the Antoinette Perry Awards) took place. The presentation was held in the ballroom of the Waldorf-Astoria Hotel in New York City. Arthur Miller's *All My Sons* won as best play; there was no award for best musical at the time.

April 7, 1949: The original production of *South Pacific* opened, tackling issues of race and prejudice, earning it critical acclaim.

1952: The houselights in all Broadway Theaters were dimmed for the first time in history to honor Gertrude Lawrence, who passed away at the age of 52. At the time, Lawrence was starring in *The King and I*.

1953: By the end of this year, the New York Yankees had already won all four World Series played in the decade, on their way to 27 titles. This helped inspire the 1955 Broadway musical comedy *Damn Yankees* featuring Gwen Vernon as Lola . . . *who gets whatever she wants*.

November 24, 1954: Bob Fosse made his Broadway debut as a choreographer for the George Abbott, Harold Robbins musical *The Pajama Game*.

March 22, 1956: Opening night for the musical comedy *Mr. Wonderful*, in which Chita Rivera would make a splash on Broadway. She would later star in *West Side Story*, officially catapulting her remarkable Broadway career.

March 15, 1956: Lerner and Loewe's epic adaptation of George Bernard Shaw's *Pygmalion*, *My Fair Lady*, debuted on Broadway starring Julie Andrews and Rex Harrison.

September 26, 1957: A contemporary adaptation of *Romeo and Juliet* set on the gang-ridden Upper West Side of Manhattan opened as *West Side Story*. The riveting musical brought together the talents of Arthur Laurents, Jerome Robbins, Leonard Bernstein, and Stephen Sondheim.

1959: The bronze statue of George M. Cohan (aka The Father of Broadway) was unveiled in Times Square.

March 11, 1959: *A Raisin in the Sun* opened, making Lorraine Hansberry the first Black woman to write a play that appeared on Broadway.

November 16, 1959: Rodgers and Hammerstein's *The Sound of Music* opened, starring Mary Martin as Maria Rainer. Martin had already risen to fame starring in *South Pacific* and *Peter Pan*.

February 22, 1961: Debut of the first full-length Broadway show, *Come Blow Your Horn*, written by Neil Simon. More than two-dozen hit comedies would follow.

1962: After several years of battling with New York mayor Robert Moses, Joseph Papp's Shakespeare in New York moved uptown and premiered in the brand new Delacorte Theater in Central Park. The opening production was *The Merchant of Venice*, starring George C. Scott and James Earl Jones.

May 8, 1962: Zero Mostel made his first starring role as Prologus / Pseudolus in the Burt Shevelove, Larry Gelbart, Steven Sondheim musical *A Funny Thing Happened on the Way to the Forum*.

January 16, 1964: The original production of *Hello, Dolly!* opened on Broadway taking the career of Carol Channing, as Dolly Gallagher Levi, to a new level.

September 22, 1964: Harold Prince's *Fiddler on the Roof*, starring Zero Mostel as Tevye opened for a record-setting run of 3,242 performances. The classic musical was directed and choreographed by Jerome Robbins and featured a book by Joseph Stein, music by Jerry Bock, and lyrics by Sheldon Harnick.

June 26, 1964: Barbra Streisand would make her second and (thus far) final appearance on Broadway as Fannie Brice in *Funny Girl*, helping launch her outstanding career. Previously she starred in the musical *I Can Get It For You Wholesale*.

January 29, 1966: Bob Fosse and his real-life wife Gwen Verdon star in the Neil Simon musical comedy *Sweet Charity*, which became the first full-length Broadway production to play at the Palace.

November 20, 1966: Joel Gray starred as the Master of Ceremonies in the opening of the Harold Prince musical *Cabaret*, one of a dozen Broadway productions featuring Gray.

March 26, 1967: The Tony Awards were nationally televised for the first time on ABC.

April 29, 1968: Broadway's first rock musical, *Hair*, opened. The controversial anti-war production was also the first Broadway musical to include nudity.

1973: The Theater Development Fund (TDF) opened the TKTS booth in Duffy Square at 47th Street and Broadway to provide discount day-of-the-show theater tickets.

1974: The exterior of the Lyceum became the first Broadway theater to receive the landmark status designation from the New York City Landmarks Preservation Commission (LPC).

July 25, 1975: *A Chorus Line* opened, becoming one of Broadway's longest-running shows while redefining the genre and structure of musical theater.

July 15, 1982: Nathan Lane's Broadway debut in Noel *Coward's Present Laughter*, directed by George C. Scott.

October 7, 1982: Andrew Lloyd Weber's *Cats*, based on the works of T. S. Elliot, launched an 18-year run on Broadway.

1983: The Uris Theatre officially became the Gershwin Theatre, and the Alvin Theatre became the Neil Simon Theatre.

August, 21, 1983: Jerry Herman and Harvey Fierstein's *La Cage aux Folles* opened at the Palace as the first Broadway musical about an openly gay couple.

March 12, 1987: *Les Misérables* debuted on Broadway, captivating audiences for years to come with its sweeping score and classic storytelling.

January 26, 1988: Andrew Lloyd Weber's hauntingly romantic musical *The Phantom of the Opera* opened a record-shattering 35 year run of 13,981 performances.

1990: The 46th Street Theatre became the Richard Rodgers Theatre.

April 18, 1994: Disney' first Broadway musical, *Beauty and the Beast*, opened to rousing reviews at the Palace.

October 12, 1995: *Patti LuPone on Broadway* opened, providing the highly celebrated star (who had already appeared in 15 Broadway shows) with her own weeklong run. She would then star in 11 more productions.

November 15, 1995: The opening of Terrance McNally's *Master Class* marked the first starring Broadway role for Audra McDonald.

April 29, 1996: Jonathan Larson's rock musical *Rent* opened a 12-year run on Broadway. The dramatic musical about impoverished young artists struggling to survive during the height of the AIDS crisis won a Pulitzer Prize.

November 13, 1997: Disney's *The Lion King* opened a spectacular run on Broadway. The majestic musical features unique costumes designed by Julie Traymor, who would become the first woman to win a Tony Award for best director.

April 19, 2001: Mel Brooks' musical comedy *The Producers* set a record for the most Tony Awards won by a musical.

September 11, 2001: Theatres were shut down for two days in the wake of the 9/11 attacks. Performances resumed on September 13. The decision to reopen quickly was made as a symbol of resilience and as a statement to the world that New York City would not be defeated by the acts of terrorists.

January 13, 2002: Off-Broadway hit musical *The Fantasticks* closed after 42 years and 17,162 performances, making it the longest-running show of any kind in American history. F. Murray Abraham, Kristin Chenoweth, Glen Close, Elliott Gould, and Liza Minnelli were among the many that performed in the musical.

2003: The Martin Beck Theatre became the Al Hirschfeld Theatre.

October 30, 2003: The night before Halloween, the musical *Wicked* officially opened on Broadway, taking a new spin on the witches from the *Wizard of Oz*. Kristin Chenoweth, Idina Menzel, and Joel Grey were among the notable performers in the original cast.

2005: The Virginia Theatre became the August Wilson Theatre.

2008: The Biltmore Theatre became the Samuel J. Friedman Theatre.

February 11, 2012: *The Phantom of the Opera* celebrated its 10,000th performance at the Majestic Theatre.

August 27, 2011: A blackout caused by Hurricane Irene shut down Broadway for two days. The following fall, on October 28, 2012, Hurricane Sandy caused even greater destruction, shutting down Broadway for four days.

2015: Lin Manuel-Miranda's *Hamilton* opened on Broadway introducing a unique fusion of hip-hop, history, and diverse casting. The smash hit musical was later nominated for a record-breaking 16 Tony Awards.

April 24, 2016: *Waitress* opened, becoming the first Broadway show with an all-female creative team including music and lyrics by Sara Bareilles, book by Jessie Nelson, choreography by Abbey O'Brien, and direction by Diane Paulus.

March 12, 2020 to September 14, 2021: All 41 Broadway theaters were shut down for 18 months due to the COVID-19 outbreak.

February 2022: The 14-million-pound Palace Theatre was lifted a few inches, thus beginning an unparalleled 30-foot ascent, which would move the theatre into the brand new TSX Broadway hotel and entertainment complex in Times Square.

ABOUT THE AUTHOR

STEWART F. LANE, Chief Executive Officer, President and Co-Founder of BroadwayHD, and Chief Executive Officer of Theater Venture Inc. is a six-time Tony Award-winning producer for *Jay Johnson: The Two & Only*, *Thoroughly Modern Millie*, *The Will Rogers Follies*, *La Cage aux Folles*, *A Gentleman's Guide to Love and Murder*, and *War Horse*. As a producer, he is also a nine-time Tony Award nominee for *Fiddler on the Roof* (revival) starring Alfred Molina, *Gypsy* (revival) starring Bernadette Peters, *1776* (revival) starring Pat Hingle and Brent Spiner, *The Goodbye Girl* starring Martin Short and Bernadette Peters, and *Woman of the Year* starring Lauren Bacall.

Stewart Lane and Bonnie Comley at the unveiling of their portrait in famed Broadway restaurant Sardi's in 2016.

LEFT: (images are shown left to right)
TOP ROW: Stewart F. Lane and Bonnie Comley with their Tony Awards/Doug Reside, NYPL Curator of Billy Rose Theatre Division, Stewart F. Lane, and Broadway legend Joel Grey/ Stewart F. Lane and his daughter Leah Lane with Charles Strouse, famed composer and lyricist of *Bye Bye Birdie*, *Annie*, and *Applause*.
MIDDLE ROW: Bernadette Peters and Stewart F. Lane/Nederlander Organization Executive Vice President Nick Scandalios, President James L. Nederlander, Margo MacNabb Nederlander, Disney Theatrical Group's Thomas Schumacher, Stewart F. Lane, and Bonnie Comley.
BOTTOM ROW: Broadway lyricist Adolph Green and Stewart F. Lane/Producer Barry Grove, Stewart F. Lane, Producer Paul Libin, and Nederlander Organization Executive Vice President Nick Scandalios/Ric Swezey, Nick Scandalios, Bonnie Comley, and Stewart F. Lane.

Lane is also the recipient of four Drama Desk Awards, a Drama Critics Circle Award, an Outer Circle Critics Award and a Drama-Lounge Award. His other Broadway producing credits include *Cyrano De Bergerac* starring Kevin Kline, Jennifer Garner and Daniel Sunjata; *Legally Blonde: The Musical*, *Minnelli on Minnelli* starring Liza Minnelli, *Wait Until Dark* starring Quentin Tarantino and Marisa Tomei, *Can-Can* starring Zizi Jeanmaire, *Frankenstein* starring Dianne Wiest, *Teaneck Tanzi* starring Deborah Harry and Andy Kaufman, *A Change in the Heir*, *The Grand Tour* starring Joel Grey, *West Side Story* starring Debbie Allen, and many more.

Off-Broadway and regionally, Lane produced *Jay Johnson: The Two and Only*, *Fortune's Fools*, *Sarah and Abraham* by Pulitzer Prize-winning playwright Marsha Norman, *Eating Raoul: The Musical* and *The Apprenticeship of Duddy Kravitz* composed by Allen Menken.

Stewart F. Lane and Bonnie Comley have won several awards not only for producing, but also to honor their service to the Broadway community.

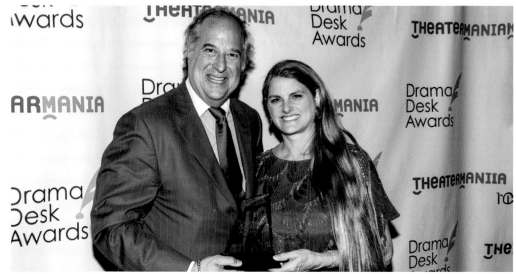

In London, Lane produced *Top Hat* which won him an Olivier Award, *Thoroughly Modern Millie* (Olivier Nomination), *Ragtime* (Olivier Nomination) and *Lobby Hero*. In Dublin, he produced the world premiere of *JFK: A Musical Drama*.

Expanding into film, Lane has produced over 25 stage-to-screen productions as well as movies such as *Brooklyn Rules* starring Alec Baldwin and Freddy Prinze Jr., *Romeo and Juliet* starring Orlando Bloom and Condola Rashad, and documentary *Show Business: The Road to Broadway*. Lane has also produced the Broadway production of *Company* starring Raul Esperaza and *Cyrano de Bergerac* starring Kevin Kline, for Great Performances on PBS.

Lane is the author of the books *Let's Put On A Show* (published by The Works of Art Library), *Jews on Broadway* editions one and two (published by McFarland & Company, Inc.), *Black Broadway* (published by SquareOne Publisher), and the plays *In the Wings* (published by Hal Leonard) and *If It Was Easy* (published by Performing Books and nominated for Best New Play by the American Theatre Critics Association). He also conceived and wrote the John Denver musical *Back Home Again*, for which he received the John Denver Spirit Award.

Lane has directed across the country with productions of *The Foreigner*, *The Gig*, *Ain't Misbehavin'*, *If It Was Easy*, *The Golden Age*, *Frankenstein*, *Final Appeal* with Chaz Palminteri and Stephen Baldwin, and *In the Wings* with Shannon Doherty.

He is the co-owner and operator of the Palace Theatre in New York City, and a partner in the Tribeca Grill Restaurant with Robert DeNiro.

Representing the Mayor of New York, Lane served on the Board of Directors at the New York State Theater at Lincoln Center and the Transitional Committee where

The Laurence Olivier Award, which Stewart Lane won in 2013 for *Top Hat*, recognizes excellence in professional theatre in London. The Olivier Awards are presented annually to honorees involved in *West End* and other leading non-commercial theatres based in London. Past recipients have included Andew Lloyd Webber, Stephen Sondheim, Dame Judy Dench, and Dame Maggie Smith.

he appointed both the Commissioner for Cultural Affairs and the Commissioner of Film, Theater & Broadcasting. Lane sits on the Board of Directors and the Board of Trusts of The Entertainment Community Fund (formerly known as The Actor's Fund of America), the Actors Fund Affordable Housing Committee, and is on the Board of Advisors for The American Theater Wing. Lane sat on the Board of Governors of The Broadway League for eleven years and remains an active member.

Lane is the proud recipient of the prestigious Ellis Island Congressional Medal of Honor, The Jewish National Fund Tree of Life Award, The Child Development Center of the Hamptons Reach for the Stars Award, The BU College of Fine Arts Distinguished Alumni Award, The Boston University Distinguished Alumni Award, a Doctor of Humane Letters from Five Towns College, the Paul Newman award for Services to the Arts and Children, a Certificate of Award from the town of North Hemstead, New York, and many other prestigious awards.

Giving back to the theater community, Lane has created scholarship funds at Columbia University Business Graduate School and Boston University College of Fine Arts Undergraduate School and has been a major support to the University of Massachusetts, Emerson College, and Fiorello H. La Guardia High School for the Performing Arts School. Five Towns College honored Lane with naming their business school the Stewart F. Lane School of Business for his contributions to the World of Entertainment.

Stewart Lane stands on the stage of the newly restored Palace Theatre after welcoming guests at the theater's grand reopening.

ACKNOWLEDGMENTS

I want to thank my wife, Bonnie Comley, for her love and support. I'd also like to thank those who have been so instrumental to the success of the Palace Theatre: the Nederlander Organization, James L. Nederlander, James M. Nederlander, Nick Scandalios, Bill Register. Thanks to all those who helped put this book together, including Diana Prince, Dominick DiNizo, Doug Reside, Philip Birsh, and the publishers and editors Jennifer Dorsey, Vanessa Campos, and Rich Mintzer. I should also give a nod of thanks to Martin Beck, without whom the Palace Theatre would not exist.

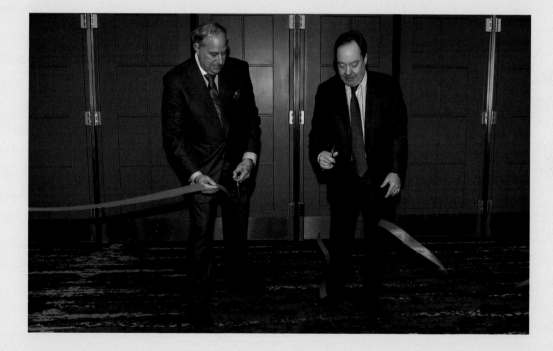

Stewart Lane and James L. Nederlander cut the ribbon at the reopening of the Palace Theatre on May 6, 2024.

ENDNOTES

1. Van Johnson was featured in movies such as *The Kane Mutiny, Brigadoon, State of the Union*, and *Yours Mine and Ours*. Peter Palmer was best known for his role as the original Lil'Abner in both the Broadway show and the film. Ed Herlihy was a newsreel announcer for many years, enjoyed a long radio career, and appeared in films such as *The King of Comedy* with Jerry Lewis and *Don't Drink the Water* with Woody Allen, Jackie Gleason, and Michael J. Fox.

2. The details of the original Palace lease come from Marion Spitzer's 1969 book *The Palace.* Spitzer worked for the theater in its early years. There were many rumors about how much Beck invested to purchase the property on the east side of Broadway from the corner of 47th Street southward to the center of the block, but a definitive amount of the sale, or initial lease, remains unconfirmed. Information on the lease can also be found from the Real Estate Records and Builders Guide from December 23, 1911 from the Columbia University website: http://rerecord.library.columbia.edu/pdf/ldpd_7031148_048_26.pdf

3. Vaudeville theater statistics come from John Kenrick's website, Musical101.com and David Monod at VaudevilleAmerica.com.

4. Minstrel shows became a popular form of American entertainment in the 1800s, thus representing African Americans as irresponsible and laughable characters from which stereotypes prevailed. This made it easier for white Americans to separate and disassociate from African Americans. As noted on the website of the National Museum of African American History and Culture, "By distorting the features and culture of African Americans—including their looks, language, dance, deportment, and character—white Americans were able to codify *whiteness* across class and geopolitical lines as its antithesis." From the mid to late 1900s, awareness of such unacceptable performance grew throughout America, and by the later years of the 20th century, laws and policies were enacted to combat racism and discrimination, and minstrel shows were widely recognized as deeply offensive and racist. Such performances are considered inappropriate and unacceptable.

5. Ethel Barrymore was the great-aunt of current movie actress Drew Barrymore. Unlike Ethel Barrymore, who appeared in over 50 Broadway productions. Drew, who rose to fame at the age of seven in the film *ET*, has not yet (as of the writing of this book) made her Broadway stage debut.

6. John Wilkes Booth was a stage actor in the mid-1800s who started his performing career in Baltimore and later became a member of a Philadelphia stock company. He was also a confederate sympathizer. On April 14, 1865, Booth assassinated President Abraham Lincoln at the Ford Theatre in Washington, D.C.

7. Actor Jack Haley, best known for his role as the Tin Man in *The Wizard of Oz*, was previously a vaudeville performer. His famous quote about being a vaudevillian appeared in his 1978 autobiography *Around the World in 80 Years* and in the 2005 Trav S.D.s book *No Applause ~ Just Throw Money.*

8. The story of the feud between Nora Bayes and Sophie Tucker appears in several places including Chapter 10 of *I am Sophie Tucker: A Fictional Memoir* by Susan Ecker and Lloyd Ecker, published by Prospecta Books in 2014, the website Sophietucker.com, Marion Spitzer's 1969 book *The Palace* from Atheneum Books and in an April 6, 1926 *New York Times* article called "The Screen: The Parisian Waif" www.the-screen-the-parisian-waif.

9. The fire in the Palace in 1932 was widely reported in the newspapers. According to the *New York Times*, as 1,900 people fled, seven were injured. The fire is also noted in the book *The Palace* by Marion Spitzer.

10. While the talent and antics of Eva Tanquay have been overlooked in the annals of great stage performers, she was considered one of the most significant performers of her generation. Amber Paranick wrote in a 2020 Library Congress blog about the Canadian-born star, "Eva Tanguay was the highest-paid [performer] and billed as the most outrageous star of vaudeville's golden age. Audiences had never seen anything like her before—her performances were described as ribald, ebullient, outlandish, and flamboyant—earning her the attention of newspapers the world over."

11. Bob Hope's opening night at the Palace review is from the Library of Congress website (loc.gov).
12. The Mercury Players were a theatre and radio ensemble that made a significant contribution to the works of Orson Welles. Besides the infamous *War of the Worlds* radio broadcast, they procured their own Mercury Theatre in New York City. One of their first theatrical productions, a 1937 modernized version of Shakespeare's *Julius Caesar*, generated controversy for paralleling events in Europe at the time.
13. Busby Berkeley was an American film director in the 1930s best known for flamboyant productions and "the elaborate dancing-girl extravaganzas that he created on film," as noted by britannica.com.
14. Stella Adler was one of the foremost acting teachers of the twentieth century. She established the Stella Adler Studio of Acting, later the Stella Adler Conservatory of Acting. Adler trained many notable actors.
15. Milton Berle's esteemed career spanned an astonishing 80 years. Starting as a child stage actor and dancer, he went on to perform and emcee in vaudeville. He then became a silent movie star, standup comic, songwriter and radio personality, and Broadway performer, producer, and lyricist before hosting NBC's *Texaco Star Theater*, for which he became immensely popular, earning the title of "Mr. Television."
16. Marlene Dietrich was a universally known, German-born film actress and singer. As noted by Britanica.com, her "beauty, voice, aura of sophistication, and languid sensuality made her one of the world's most glamorous film stars."
17. James Nederlander's comment about the Palace décor being "plush over plastic" came from Marion Spitzer's book *The Palace*. Many of the theaters of this time had a futuristic, minimalist décor in stark contrast to the lavish theaters of the early years of the twentieth century. Often this included fiberglass, which is made of plastic.
18. Nederlander's quote on *Sweet Charity* is from the "Spotlight on Broadway" video series.
19. Arlene Dahl's quote is from the "Spotlight on Broadway" video series.
20. As noted in numerous newspaper articles and columns, such as *The Georgetowner's* 2011 article by Jeff Malet, "Oklahoma! a Historical Perspective," the infamous quote by Mike Todd was overheard and written down by gossip columnist Walter Winchell. There are many theories as to the origin and accuracy of the quote, many of which are captured on a website called quoteinvestirator.com.
21. Attendance records come from Broadway League's Statistics Link: www.broadwayleague.com/research/statistics-broadway-nyc/
22. While there were already three Broadway theaters on the chopping block in 1982, the only Broadway theaters demolished in the 1970s were the George Abbot Theatre and the Colonial Theatre. Several other older theaters were still hanging on by playing movies.
23. In a 2017 Curbed.com article entitled "The Fallen Five," James Nevius references Joseph Papp, who was an iconic figure in New York City Theatre and later in American Theatre history. Papp championed the works and performers that were not accepted by the so-called theatre elite and knocked down barriers to accessible theatre by initiating free productions of Shakespeare in Central Park. He fought censorship at every turn and believed in rainbow casting, referring to casting people of all colors in his many productions which included *Hair* and *A Chorus Line*, which were hugely popular on Broadway.
24. Originally, *West Side Story* was a love story about a young Jewish boy and an Irish girl and the condemnation from their social circles. It was actually going to be called *East Side Story*. As it was, the project bore many similarities to the long-running 1920s Broadway hit show *Abby's Irish Rose*. As a result, *East Side Story* was shelved for several years. It wasn't until Arthur Laurents, Leonard Bernstein, and Jerome Robbins read newspaper headlines about the proliferation of gang violence, which was a growing concern on Manhattan's Upper West Side, that they recognized the raw power of a tension-fueled, culturally charged, Brand-new musical called *West side Story*.
25. According to nyctix.com "Broadway's total loss for the week of Sandy was considerable. Ticket sales dropped to less than $14

million (previous weeks had been consistently around $20 million). Fortunately, with the holiday season coming not long after the superstorm, the Great White Way managed to get back to business as usual within a few weeks.

26. According to a NY1.com article, "Data shows massive surge in NYC tourists in 2021" by Eric Feldman (from 3/30/22), the number of visitors to New York City went from 66 million travelers in 2019 to 22 million in 2020 to 33 million visitors in 2021. While the 11 million increase from 2020 and the height of the Pandemic was significant the number was still half of what it was in pre-pandemic 2019.

27. Robert Israel's quote on carefully monitoring every stage of the lift is from the *NY Times* article "How a 7000-Ton Broadway Theatre was hoisted 30 feet," by CJ Hughes. (5/28/22). Israel serves as Executive V.P. at L&L Holdings and directed all aspects of TSX Broadway project development design and construction activities and was one of the spokespeople often interviewed about the lifting of the renowned theater.